Paula D Rice
05/2008

A Time It Was

BOBBY KENNEDY IN THE SIXTIES

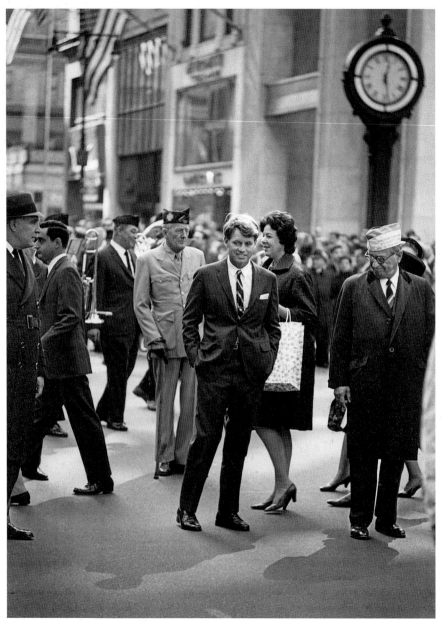

Senator Robert F. Kennedy, Columbus Day Parade, New York City, October 1966.

A Time It Was

BOBBY KENNEDY IN THE SIXTIES

Photographs and Text by
BILL EPPRIDGE

Essay by PETE HAMILL

Foreword by JOHN ELLARD FROOK

Edited by ADRIENNE AURICHIO

ABRAMS, NEW YORK

I do not run for the presidency merely to oppose any man, but to propose new policies. I run because I am convinced that this country is on a perilous course and because I have such strong feelings about what must be done, and I feel that I'm obliged to do all that I can.

—*Robert F. Kennedy, March 16, 1968*

Contents

The Last Campaign

PETE HAMILL

AROUND 8:30 THAT NIGHT, WE WERE IN SUITE 516 OF THE AMBASSADOR Hotel, glancing down through tall windows upon Wilshire Boulevard. The Los Angeles night was soft with fog and we could see a smear of red taillights below us and the ghostly halos of street lamps. As always, there were almost no pedestrians.

In memory, there were about thirty men and women in the long, windowed suite, talking in knots, most leaning forward, mouths to ears, like conspirators. They were wealthy California Democrats, big-time lawyers, movie executives (but no stars), political professionals, writers, including my friends Jack Newfield, Budd Schulberg, and Jimmy Breslin, and my younger brother Brian, then a twenty-two-year-old photographer. I remember seeing Warren Rogers from *Look* magazine and Sander Vanocur from NBC. This was June 4, 1968. We were deep into that great historical unraveling called the Sixties, which truly began with a presidential assassination in Dallas on November 22, 1963. The initial shock of the killing of Jack Kennedy had gone through stages: numbness, anger, rage. And things seemed to be getting worse.

By the first months of 1968, the Sixties had included the Tet Offensive in Vietnam, the rise of Eugene McCarthy, the exhausted farewell from Lyndon B. Johnson, the assassination of Martin Luther King Jr., and the dreadful riots that followed in most American cities. The enraged spirit of the world's young could be felt in many places, not all of them American. Generational anger was a driving force in the great changes of the Prague Spring in Czechoslovakia, and among a million revolutionary demonstrators in France in May, where union members joined the young to demand radical change. The slogan was often "sex, drugs, and rock 'n' roll," proclaimed in many languages.

But around 8:30 on this foggy June evening, there were no screaming protestors in suite 516 of the Ambassador Hotel, no acidheads, no Black Panthers, no Che Guevara T-shirts. Nobody wore an SDS button or insisted on the moral superiority of Mark Rudd. These were all grown-ups, in dark suits and well-cut dresses, speaking tensely in intimate tones, a few of them chuckling but never laughing out loud. There were no laptops yet in America, or cell phones, or BlackBerries, and no cable TV news either. So telephones rang insistently in the suite, were picked up, and names were called in stage whispers. Or the door would open, someone in shirtsleeves would arrive, murmur the latest news, then turn abruptly and leave. A few journalistic pilgrims carried Leicas or Nikons. One of them was a young man from *Life* magazine named Bill Eppridge. He had the kind of intense, focused eyes that were accustomed to actually seeing what was in front of all of us.

At the bar, a few people mixed drinks, gently clunking ice, while nib-

bling from plates of rolled-up room service ham and wedges of cheddar and Swiss cheese. There was no music. No Beatles or Stones, no Marvin Gaye, no Aretha. There was no dancing either. This was not, after all, a party. That would be later, after the results were in, at a place called The Factory. This gathering in 516 was politics. Big-time politics. Presidential politics. This was, in fact, the last stop for the campaign of Robert F. Kennedy in California. If he won here, he might become the Democratic candidate at the convention in Chicago in August. Downstairs, the ballroom was full, waiting noisily for news of a victory and a chance to roar for their candidate. That is, to roar for the man they called Bobby.

While we waited in 516 for the polls to close and the returns to come in, I talked for a while with the movie director John Frankenheimer. The advertising agency Papert, Koenig, Lois, Inc., had hired him in March to work with the Kennedy campaign on promotional material, including some commercials. He and Kennedy had become friends, and the candidate had spent the night before in Frankenheimer's home in Malibu. On this Tuesday, Frankenheimer had driven Kennedy from the beach to the Ambassador, where they arrived around 7:30 P.M. Like me, Frankenheimer was a native New Yorker, and I noticed that he referred to Kennedy as "Bob," as I did. Where we came from people named "Bobby" were either nine years old or professional ballplayers. We talked a bit about the town that spawned us, and then about Frankenheimer's great paranoid masterwork from 1962, *The Manchurian Candidate,* which starred Frank Sinatra and Laurence Harvey. It had been withdrawn from public viewing after the killing of Jack Kennedy in 1963 (it would finally be re-released in 1988). There was a decent reason behind the movie's disappearance: The story, based on a novel by Richard Condon, was about programming a man to assassinate a presidential candidate.

"Do you think it could happen in what is laughingly called 'real life'?" I asked Frankenheimer.

He smiled in a nervous way, and glanced at the door of the suite.

"Yeah."

Across the hall, in room 511, Robert Kennedy was waiting too. In 1968, only fourteen states held primaries; all other states left delegate choices to party professionals, most of whom favored Hubert Humphrey, the vice-president under Johnson. The part of Bob Kennedy that was a political professional (he had managed most of his brother's campaigns) knew that if he won the huge state of California he would prove to delegates that he had one virtue they loved above all others: electability. He had won in Indiana, Nebraska, and South Dakota. A week before, Kennedy had lost the Oregon primary to McCarthy, his first loss in the near-frantic campaign that started on March 16. If he lost tonight, it would be over.

He didn't look very nervous in room 511. It was, after all, too late to do anything about convincing any more Democrats to vote for him. His wife, Ethel, a few of his children, close family friends, some of the top professionals in the campaign: all went in and out of 511, some to deliver bulletins, others to provide laughter or diversion. Even Freckles, the homely Springer Spaniel who had become a star at Kennedy's side during the short, frantic campaign, had made it into 511. There, Kennedy sat in shirtsleeves, the cuffs turned up, his tie loose, grinning with a kind of dark Irish fatalism in his eyes. He had no way of knowing that he was living the last hours of his life, and neither had we.

I KNEW ABOUT ROBERT KENNEDY LONG BEFORE I EVER MET HIM. HE WAS, of course, a very public figure. He was the attorney general in his brother Jack's administration, with a reputation for being ruthless in the cause of

supporting his brother's career. In those days, John Fitzgerald Kennedy was always "Jack" and Robert Francis Kennedy was always "Bobby." Jack was eight years older than Bobby, a genuine war hero, a cautious member of the United States Senate before deciding to run for president in 1960. Jack was charming and smart, but seldom challenged any of the "smelly little orthodoxies" (as George Orwell called them) of politics. He never challenged the assumptions of the Cold War nor did he speak up against the racial inequality that still shamed the country. Bobby was the Kennedy who worked hardest behind the scenes for his brother.

But Bob Kennedy already had acquired his own political past before his brother Jack won his narrow victory over Richard Nixon in 1960 and appointed Bobby as his attorney general. He had worked for Senator Joe McCarthy in the early 1950s, when McCarthy was riding the white horse of anti-Communism, ruining lives and reputations with his demagoguery while catching no actual Communists. He had later worked for Senator John McClellan in his campaign against corruption in the union movement that sometimes appeared to be a crusade against trade unionism itself. McCarthy was a Republican, McClellan was a Democrat, and young Bobby worked for both. Many liberals never forgave him for working for Joe McCarthy, and with the infamous McCarthyite Roy Cohn (for a very short time). In 1960, they feared that Bobby with national power would be a dangerous man indeed.

He surprised the skeptical liberals with his actual performance. He was the first attorney general in history to tame J. Edgar Hoover, who ran the FBI as if it were his private fiefdom. He was the first attorney general to truly go after the Mob, which Hoover had ignored while engaged in his own paranoid obsession with domestic Communism (under Kennedy, convictions of Mob hoodlums increased 800 percent). He was also more concerned than any of his predecessors with civil rights for African-Americans

and quietly led campaigns to desegregate the government bureaucracy itself. He became a supporter of Martin Luther King Jr., and ironically approved requests to wiretap King and his associates for signs of Communist infiltration of the civil rights movement. The explanation of this action was more than a bit mushy: Kennedy approved the wiretaps to prove that King was *not* a clandestine crypto-Commie. In foreign affairs, nothing much changed. In Vietnam and Laos, American military engagement slowly escalated, and would play its own part in the great tragedy that lay ahead. Both Kennedy brothers were obsessed with Fidel Castro's Cuba, and approved plans to assassinate the Cuban leader. They went ahead with the disastrous 1961 Bay of Pigs invasion. But during the Cuban Missile Crisis in October 1962, which could easily have escalated into nuclear war, Bobby was the one urging common-sense solutions. By the third year of the Kennedy administration, Bobby was winning grudging respect from some liberals.

All of that became academic on November 22, 1963. By all accounts, Bobby was wrecked by the killing of his brother. When the rituals of public mourning were over, Bobby stayed on as Lyndon Johnson's attorney general, and did not discourage talk about serving as LBJ's vice president in the 1964 election. But he remained a realist, and knew that Johnson would never pick him. It was no secret in Washington that they loathed each other. At the convention in 1964, Johnson chose the liberal warhorse Hubert Humphrey as his running mate.

In the meantime, Bobby was emerging from his long numbness and melancholy. In 1964, he decided to run for the Senate out of New York State, where the incumbent Republican was an amiable man named Kenneth Keating. He resigned as attorney general. And though he continued living at the family mansion in McLean, Virginia (he and Ethel had eleven children), he also took an apartment in New York City. Many charged Kennedy with being a ruthless carpetbagger, and they were probably correct.

His campaign managers reminded the critics that as a boy he had lived from age two with his parents and siblings in Riverdale and Bronxville until going off to Harvard and the U.S. Navy Reserve during the war. In the end, it didn't matter. In November, Johnson won New York State in a landslide over Barry Goldwater and carried Kennedy with him.

I DIDN'T MEET KENNEDY UNTIL ST. PATRICK'S DAY, 1966. HE WAS IN Washington most of the time and my newspaper work didn't take me there very often. In October 1965, I started writing a column for the *New York Post* (where I had begun my newspaper career in 1960). The original intention was to cover New York City, its murders and disasters, its heroes and villains, its people and yes, its politicians. But in November of that year, the American army in Vietnam sent hundreds of men from the First Batallion of the Seventh Cavalry into the Ia Drang valley. The fighting was ferocious. The Americans eventually killed more than two thousand North Vietnamese soldiers, but lost almost three hundred of their own. Some fool at the "five o'clock follies" (as the daily press briefing in Saigon was called) insisted that the "kill ratio" made this a great victory. The American engagement in Vietnam had been slowly building from the days of Eisenhower (when hundreds of "advisers" were sent to the former French colony), grew larger under Jack Kennedy, and was now escalating swiftly and dramatically under Johnson. Each new surge in troop strength increased the commitment. But the casualties from the Ia Drang valley made one thing clear: We were at war.

I wrote a column saying that, and bushels of angry letters arrived at the newspaper. They weren't angry with me. The object of their anger was Lyndon Baines Johnson. By the end of the year, I was in Saigon, a tourist at the war, trying to see it clearly and write about it as best I could. At that time, there were two hundred thousand American soldiers and marines in

Vietnam. As surge followed surge, the number would rise to half a million. When I got home, weeks later, I carried in my luggage a muumuu for each of my small daughters (then aged four and two), bought in Hawaii while the airplane took on fuel. In my mental luggage, I carried much anger over the absurdity of the war itself. When I went to the newspaper a few days later, there were boxes of cards and letters waiting for me. One was from Bob Kennedy. "Just terrific work from Vietnam," it said. "Call me when you get back."

A few weeks later, I did.

In memory (for I kept no diaries then), we agreed to meet at a St. Patrick's Day breakfast at Charley O's, a restaurant near Rockefeller Center. The place was jammed, and all the non-journalist guests seemed intent on marching later in the morning. The place was full of the usual green ties and green cardboard derbies. I saw Kennedy across the room, talking to various people, including John Lindsay of *Newsweek*. He was better looking than he was in most photographs, the hair fashionably long, sometimes falling across his brow to be brushed back with a quick flick. He seemed taller than he actually was (he was five-foot-nine) and moved athletically. He was quick to smile a rueful smile, usually in a self-deprecating manner. But in his eyes, as I came closer to introduce myself, I could see an almost permanent sadness.

"How are ya?" he said.

I said I was fine, for this hour of the morning, and we began the friendship. In the few years that followed, I would see him fairly often, in situations that were off the record. He liked Jimmy Breslin, Jack Newfield, and me because we all originally came from the New York beyond Manhattan: Breslin from Queens, Newfield from Bedford-Stuyvesant, I from blue-collar South Brooklyn. He was curious about the working class people who'd shaped us, and the places we'd lived in—so different from the world

that had shaped him. He would often call us, one at a time, when he was in town, and take guided tours into those worlds. He didn't want to see New York from the back of a passing car. He'd want to pull over, approach a group on a summer stoop, or entering a church or an Irish bar. I introduced him to Jose Torres, on his way to becoming light-heavyweight champion of the world, one of the most intelligent people I knew, and a good writer in English and Spanish. Kennedy and Jose would go together to East Harlem or the South Bronx or the Puerto Rican neighborhoods of Brooklyn. He learned a lot from the people he met on those small journeys. And the people he met learned a lot from him.

At the same time, things were darkening in the United States. James Meredith was shot while engaged in a lonesome march down a road in Mississippi. He lived. And I joined dozens of reporters following Martin Luther King Jr. on the intended route of Meredith's march to Jackson. The following month, I was reporting from Chicago, where a man named Richard Speck had murdered eight student nurses. At the same time, I went to see Martin Luther King Jr., whose attempt to bring the civil rights cause to a northern city was clearly failing. The next month, I was in Texas to report on a former altar boy named Charles Whitman who had carried a trunk full of rifles and ammo to the top of a tower at the University of Texas in Austin and shot fourteen people dead and wounded thirty-one others before he was killed by the police. In New York, I covered the first deaths of several people who had tried to fly like Superman from the rooftops of buildings on New York's Lower East Side while blitzed on acid. Now heroin seemed to be everywhere in New York, and the crime rates began to soar. In October, I was off again to Asia, this time among the press corps accompanying President Johnson to a conference in Manila that took us to Cam Ranh Bay for photo ops with soldiers. There, Johnson urged baffled soldiers to "nail the coonskin to the wall." We were told off the record

that Johnson's commanding general, William Westmoreland, wanted troop strength to surge once again, this time to seven hundred thousand. I had begun to feel on that trip that this part of the story was being written by the Evelyn Waugh who gave us *Scoop*.

In between, every month or so, I would speak to Kennedy on the telephone, or visit him in his apartment near the United Nations. We talked about the world and human folly and kids and books and almost everything else, except Jack. He did tell me once, off the record, that as early as 1962 Jack wanted to get out of Vietnam and Laos, but would have to wait until after the 1964 election. He just couldn't do it before then because he didn't want to give any kind of gift to the Republicans, who would surely attack him for being "soft on Communism." Bob shook his head sadly when he told me this, and in that moment (and others) I sensed that one terrible lesson he had learned from his brother's assassination was a simple one: Don't wait. You might not have as much time as you think you have. That lesson surely accounted for the sense of urgency that was part of his life after 1965.

Then in the fall of 1967, I moved my column to *Newsday*, where Bill Moyers was the publisher. I also moved my family and my books to Washington. Or more precisely, to a rented house in McLean, not far from the Kennedys. Now we saw them both, along with the kids, and Brumus the big dog and Freckles the smaller one. I started to look at Washington in a more sustained way. What I saw repelled me.

On all sides, positions were hardening and the mood was souring. Those who supported the war sneered at those who opposed it. Each side demonized the other. In October, there was a march on the Pentagon, at which Norman Mailer was among the hundreds who were arrested, a march Mailer wrote about with passionate brilliance in *The Armies of the Night*. Some of the demonstrators were repulsive: self-righteous, snarling, judgmental

in the worst way. (I was against most ideologies by then, because ideologies were not a form of thinking: They were a substitute for thinking.) But Johnson seemed paralyzed. The supporters of the war were repulsive in a different way, prepared to fight to the last young man. At the same time, the usual Washington hustlers kept hustling, working the lobbies of power, corrupting politicians, preventing all political movement that was not intended to put money into bank accounts. In public, rhetoric turned more vicious. Day after day, it felt as if the country was coming apart.

Kennedy sensed this too, but was also frozen. He should have been shaping a run against Lyndon Johnson. It seemed to many of us that the war could only be ended by someone who had not been involved with its escalation. But all the political Kennedys were a combination of reform and regular Democrats. Their mother, after all, was the daughter of John "Honey Fitz" Fitzgerald, a classic regular Democrat from Boston. And it would have been a violation of all the rules to turn publicly against your own party. Kennedy also knew (as Newfield once pointed out) that Vietnam was "liberalism's war." Put together by liberals. Defended by liberals. Sold by liberals. Including Jack Kennedy.

A few times I ranted to Bob Kennedy about where the Goddamn War was taking us.

"I know, I know," he said, with anguish on his face, and I knew it was time to change the subject.

There was another factor in my loathing of the war. In May 1967, my brother John joined the army a few weeks before the Beatles released *Sgt. Pepper's Lonely Hearts Club Band*. He was seventeen. John was against the war, but felt that he had no right to criticize it unless he was willing to fight in it. His opposition, that is, was not part of a strategy to avoid being shot at. I disagreed with John about his decision, but admired his sense of honor. He did basic training at Fort Gordon, Georgia, then went to Fort Sam

Houston in San Antonio for medic training (the trip there was his first on an airplane). Then he was off to Fort Benning, Georgia, for airborne training (his second trip on a plane). The third time he was on an airplane, he was jumping out of it. In short, he didn't seek to be a clerk somewhere. He was sent to Vietnam, arriving on the fourth anniversary of the assassination of Jack Kennedy. Medics always went where soldiers were bleeding. So he went to Dak To, Anh Khe, Pleiku. He was slightly wounded on October 15 (before Tet) in a place called Kontum. He was in the coastal city of Tuy Hoa when the Tet Offensive began. I hadn't prayed for many years, but each night, when the lights were out, and my daughters were asleep, I thought about John, far from home, and hoped that he would be safe for one more day.

IN THE LAST WEEKS OF 1967, I GAVE UP THE COLUMN AND RESIGNED from *Newsday*. I hated what I'd been writing, for its bitterness and darkness. I was a natural optimist, a son of Irish immigrants who had come through the Depression and the War without giving up their belief that things would soon be better. If not tomorrow, then the day after tomorrow.

I had written part of a novel set in Rome, and decided that we would go to Ireland for as long as it would take to finish it. I went to tell Bob Kennedy. He kept shaking his head, saying little, holding his chin with his bony hands. "God damn it," he said. "God damn it all to hell."

We found a nice small house in Howth just north of Dublin, with hills behind us, and the sea a short walk from the front door. I was relieved to be away from the States and threw myself into the novel. This worked for about a week. The war would not go away. It was on the front pages of the Paris *Herald Tribune* and the serious British and Irish papers. It was on the Irish radio too, and the BBC. Eugene McCarthy was making his own run for the presidency now but was given no chance by the experts. In late

January, Kennedy said again, very clearly, that he would not run against Lyndon Johnson.

Then, at the end of January, news came about the Tet Offensive. The Communists—North Vietnamese and Viet Cong from the south—had risen everywhere in South Vietnam, including Saigon. The great Eddie Adams photograph of General Nguyen Ngoc Loan shooting a Viet Cong suspect in the head on a Saigon street would appear everywhere in the world, including Ireland. My brother John was in the middle of all of this. John, who was nine years old when I took him to see this fellow Jack Kennedy at a rally in Manhattan. I listened to the BBC for news late into the night, and in the morning sat down and wrote a letter to Bob.

It said:

Dear Bob:

I had wanted to write you a long letter explaining my reasons why I thought you should make a run for the Presidency this year. But that's too late. I read in the Irish Times *this A.M. that you made a hard announcement, and that small hope is gone, along with others that have vanished in the last four years.*

I suspect that all nations have their historical moment, some moment when it all seems to have been put together as an idea: our moment was 1960–1963. I don't think it's nostalgia working or romanticism. I think most Americans feel that way now.

The moment is gone now, and we have grown accustomed to living in a country where nobody would protest very much if Jack Valenti replaced John Gardner.

I wanted to say that the fight you might make would be the fight of honor. . . . I wanted to say that you should run because if you won, the country might be saved. . . . If we have LBJ for another four years, there won't be much of a country left. I've heard the arguments about the practical politics which are involved. You will destroy the Democratic Party, you will destroy yourself. I say that if you don't run, you might destroy the Democratic Party; it will end up nationally, the way it has in New York, a party filled with decrepit old bastards like Abe Beame, and young hustlers, with blue hair, trying to get their hands on highway contracts. It will be a party that says to millions and millions of people that they don't count, that the decision of 2,000 hack pols does. They will say that idealism is a cynical joke; that hard-headed pragmatism is the rule, even if the pragmatists rule in the style of Bonnie and Clyde.

I wanted to remind you that in Watts I didn't see pictures of Malcolm X or Ron Karenga on the walls. I saw pictures of JFK. That is your capital in the most cynical sense; it is your obligation in another, the obligation of staying true to whatever it was that put those pictures on those walls. I don't think we can afford five summers of blood. I do know this: If a 15-year-old kid is given a choice between Rap Brown and RFK, he might *choose the way of sanity. It's only a possibility, but at least there is that chance. Give that same kid a choice between Rap Brown and LBJ, and he'll probably reach for his revolver.*

Again, forgive the tone of this letter, Bob. But it's not about five cent cigars and chickens in every pot. It's about the country. I don't want to sound like someone telling someone that he should mount the white horse; or that he should destroy his career. I also realize that if you had decided to run, you would face some filthy politics, and that there are plenty of people in the country who resent or dislike you.

*With all of that, I still think the move would have been worth making, and I'm sorry you decided not to make it.**

* This version of the letter is from Jack Newfield's *Robert Kennedy: A Memoir*, first published by E. P. Dutton in 1969. I don't have a copy of the original. I'm not sure I would have used initials such as RFK and LBJ, but this version is certainly true, in its apocalyptic tone, to the young man I was in those days.

I learned later, from Newfield and others, that my letter had been placed intentionally on top of a pile of unread mail by Frank Mankiewicz, Kennedy's press secretary. He wanted Bob to read it first. Apparently, Bob was moved and disturbed. For weeks, he carried it around in his briefcase, showed it to others, including those who didn't want him to run (former Jack Kennedy speechwriter Ted Sorenson and the president's press secretary, Pierre Salinger, among others). I knew nothing of this. I kept writing my novel, often with my daughter Deirdre on my shoulder or my lap as I typed the manuscript. I finished the draft on March 13. It was a thriller about a plot to assassinate the Pope.

The next day I received a telegram from Bob Kennedy. He was, he wrote, taking my advice. "Please come home," he wrote. "I need your help."

I FLEW BACK TO NEW YORK THE FOLLOWING DAY, AND MY WIFE AND children followed me a few days later. Since the California primary would be the most important of all in the time that was left, we took a rented house on top of a hill in Laguna Beach. We bought some furniture and a station wagon and moved in. After the gray damp of Ireland, the kids loved it, with the view of the vast Pacific, the walls of bougainvillea, and flowers throbbing with color everywhere.

I didn't like the life as much as they did. I had never worked for a politician before and had trouble adjusting. I liked many of the people: Adam Walinski and Jeff Greenfield, who wrote most of the candidate's speeches; Mankiewicz, a son of Herman Mankiewicz, who wrote most of the screenplay for *Citizen Kane*; Fred Dutton, who was intelligent and calming when things got frantic. I wrote some short speeches that Kennedy delivered in various appearances. But the work wasn't for me. I didn't like the sharp elbows that were part of the life. I didn't like the raw ambition of some of the players. I can't remember how long I lasted. Three weeks? Maybe longer.

Then I went back to work at what I did best. Going places and writing about what I saw. I covered the Kennedy campaign for the *Village Voice*, and corrected the manuscript of my novel. I wasn't a politician. I didn't even want to be an exclusively political journalist. I was a writer, a generalist. I wanted to write about Kennedy on Monday and Mick Jagger on Wednesday.

From time to time, I caught up with the campaign when Kennedy came to Los Angeles. I found my way to the campaign headquarters at one hotel or another, talked with Kennedy, or Walinski and Greenfield, along with reporter friends, then joined the motor caravans that went to rallies. Sometimes this wasn't easy. The mayor of Los Angeles, a character named Yorty, seemed to hate Kennedy and refused him police protection, in a time when the Secret Service did not protect politicians who were not yet their party's chosen candidates. Yorty's valiant police also gave campaign vehicles more than 150 tickets. Great fella.

But in some places there was near-frenzy in the air. In Boyle Heights and other parts of East L.A., the Mexican-American crowds roared in two languages and tried to touch Kennedy or hug him or kiss him. They knew that he had reached out to Cesar Chavez, who ran the farmworkers' union, and Dolores Huerta, another community organizer, but there seemed to be something else at play too in his time with Mexican-Americans. It was something I had learned about when I was a student in Mexico on the GI Bill from 1956–57, and it was all about defiance in the face of death. Kennedy and Mexican-Americans shared a fatalism about life. A sense that in the end we all die. There might have been a shared emotion too over the murder of Jack. At various rallies, I asked about such matters, in English and Spanish, but could never get a clear answer. I just knew it was there. I could see it.

When the campaign had taken Kennedy elsewhere, I often talked by

telephone to some of my itinerant friends. Newfield called once from Indiana, very excited because during that day's campaigning he had met Tony Zale, the old middleweight champion who had won two of his three fights with Rocky Graziano. He was one of the toughest fighters either of us had ever seen and there he was, in Gary, pushing hard for Kennedy. (He's the white guy on the far right on page 87 of this marvelous book.)

Kennedy was in Indianapolis on the evening of April 4, 1968, when word came that Martin Luther King Jr. had been assassinated an hour earlier, on the balcony of the Lorraine Hotel in Memphis. Kennedy was scheduled to speak to a large crowd in what in those days was called "the inner city." That meant an area inhabited by black Americans. Some urged Kennedy to cancel the event. He insisted on keeping his appointment. He went to the rally and soon realized that most of the men and women did not yet know what had happened to King. He climbed up on a flatbed truck, and in the center of harsh lights, he began to speak, without a prepared script.

"I have some very sad news for all of you," he said, "and, I think, sad news for all of our fellow citizens, and people who love peace all over the world; and that is that Martin Luther King was shot and was killed tonight in Memphis, Tennessee."

His voice sounded wounded. His hair was loose in the darkening light.

". . . In this difficult day, in this difficult time for the United States, it's perhaps well to ask what kind of a nation we are and what direction we want to move in. For those of you who are black . . . you can be filled with bitterness, and with hatred, and a desire for revenge. We can move in that direction as a country, in greater polarization—black people amongst blacks, and white amongst whites, filled with hatred toward one another.

"Or we can make an effort, as Martin Luther King did, to understand and to comprehend, and to replace that violence, that stain of bloodshed that has spread across our land, with an effort to understand with compassion and love.

"For those of you who are black and are tempted to be filled with hatred and distrust at the injustice of such an act, against all white people, I can only say that I feel in my own heart the same kind of feeling. I had a member of my family killed, but he was killed by a white man. . . .

"My favorite poet was Aeschylus. And he once wrote, 'In our sleep, pain which cannot forget falls drop by drop upon the heart until, in our own despair, against our will, comes wisdom through the awful grace of God'"

It was an extraordinary speech, spontaneously finding language to console (and even quoting Aeschylus). That night and in the days that followed the murder of King, riots erupted in more than one hundred American cities. Indianapolis remained calm. Was that because Bob Kennedy had brought to the shocking news a proper note of sorrow and tragedy, rather than anger? We didn't know then, and we will never know now. But in distant California, I felt a darkness growing within me, a trembling, a kind of blurry fear. Someone had managed to kill John F. Kennedy in Dallas. Someone had managed to kill Malcolm X in the Audubon Ballroom in New York. And Medgar Evers in the driveway of his own house. There were millions of guns in the United States, and any idiot could buy one. And it was the convention of American political campaigns that a candidate must appear in large open places or in convertible automobiles, open to the glancing embrace of those who loved him, open to a sniper's bullet.

In the days before the California primary, I traveled with the Kennedy campaign, writing for the *Village Voice*. I witnessed passion for Kennedy in many places, and passion against him. The Mexican-Americans loved him openly, without shame or embarrassment. As did the blacks we interviewed. The McCarthy people, most of them university kids, were more given to

a kind of virulent middle-class radicalism paid for by Daddy. Kropotkins with credit cards. After leaving one California college (in Van Nuys), the Kennedy cars were pelted furiously with stones and bottles, most of which missed, and caused other cars to swerve in jerky ways. Hitting the candidate would have been a lot easier with a rifle. The right-wing haters were quieter, more sullen, more ominous, standing with arms folded or jammed in pockets, waiting. Waiting.

And each night now, in the hour after midnight, when my wife and my daughters were asleep, I would lie in the dark thinking about the violent possibilities. Sometimes I would whisper the line from William Butler Yeats: *What made us dream that he could comb gray hair?*

That line had come to me before, in November 1963.

ON THE AFTERNOON OF JUNE 4, PRIMARY DAY, MY BROTHER BRIAN WAS going to drive the two of us north from Laguna Beach to watch the events in Los Angeles. As we pulled out onto Blue Bird Canyon Road, my daughter Adriene, then five, began to run after us, frantically calling *Daddy, Daddy, don't go, Daddy.* Brian pulled over and stopped and I got out, and hugged her, and squatted down to look in her glistening brown eyes. She couldn't explain why she was so afraid. I told her I had to go, that I was working, but I'd be back tonight, no matter what, and tomorrow we'd go to the beach. I walked her back to the house, holding her hand, until we saw her sister, then three, who also looked anxious but said nothing. Their mother came out and took their hands. I kissed them each, and went back to the car. I kept waving until I couldn't see them anymore, but they added an ominous note to the unfolding day.

In Beverly Hills, we picked up Budd Schulberg and his wife, the actress Geraldine Brooks. We were all friends. Schulberg had founded the Watts Writers Workshop after the riots of 1965, and before that had written a screenplay based on Kennedy's book *The Enemy Within,* about labor union corruption. Schulberg was a passionate Kennedy supporter. He was also a true son of Hollywood (his father, B.P. Schulberg, ran Paramount Pictures when Budd was young) and talked with fondness and laughter about the times when the biggest stars flocked to the Coconut Grove, the fabled nightclub that was once part of the Ambassador. Then Brian parked the car and we all went into the lobby, glanced at the crowded Embassy Ballroom where Kennedy would eventually make a speech about victory or defeat, and then took the elevator up to the fifth floor.

I kept thinking: What did my little daughter know?

BY 11 P.M., IT SEEMED CLEAR THAT KENNEDY HAD WON CALIFORNIA, a huge triumph that would erase the comparatively minor shame of defeat in Oregon. Now we were in Kennedy's own room: Schulberg, Brian, Cesar Chavez, Newfield, Breslin. I remember squatting with my back against a wall. Kennedy was on the floor, back to a sofa, one arm resting on a raised knee, the other leg stretched out. Others came and went. Frank Mankiewicz handed him a sheet of paper. Maybe words for a speech. Maybe more results. The TV set was on, the sound off, showing Kennedy ahead. Most people had glasses in their hands. Beer. Harder stuff. Soft drinks.

The mood was light, almost giddy. Kennedy smiled and smiled, and laughed out loud at Breslin's terminal New York joking. Then someone said, glancing at a watch, that it was time to go down. Kennedy stood up, buttoned his cuffs and his collar, went into the bathroom, closing the door behind him. Everybody else was standing now. Some went back to the larger room across the hall where TV might offer a better view. Kennedy came out of the men's room. He had combed his hair and donned a jacket. He was smiling broadly.

"Let's go down," he said.

I WAS PUSHED WITH OTHERS TO THE SMALL BANDSTAND WHERE KENNEDY would talk. I was beside George Plimpton in the back row. There were drapes behind us and we both tried opening them and discovered there was no wall behind the drapes. It was about a two-foot fall. "For God's sake," Plimpton warned everyone else, "don't lean on the *drapes*." Kennedy arrived, his wife, Ethel, beside him, and moved to the microphone. He could see hundreds of red and blue balloons rising toward the gilded panels of the ceiling and three immense chandeliers. Young women wearing plastic Kennedy boaters were chanting, but in the general din, I couldn't hear the words. I counted eleven TV cameras aimed at the stage, and still more photographers, including my brother Brian, and somewhere, Bill Eppridge, moving through the sweaty human stew. Kennedy began speaking.

"I'd like to express my high regard for Don Drysdale," he said. The great Dodger pitcher had just won his sixth straight shutout and the room roared. Kennedy smiled broadly and said: "I hope we have *his* support in this campaign." He thanked the football player Rosey Grier and the decathalon champion Rafer Johnson, who were indeed part of his campaign. He thanked the Democratic boss Jesse Unruh, who was given timid cheers, and Cesar Chavez, who got huge cheers, and then thanked the staff and the volunteers and the voters, and the ballroom crowd cheered mightily for all of them. The California victory, of course, was not definitive. The nomination would have to be settled now in August, at the Democratic convention in Chicago. But Kennedy had proven to the party that he could be elected. He had proven to many that he would be a better candidate than Hubert Humphrey.

"I thank all of you," he was saying now. "Mayor Yorty just sent a message that we have been here too long already." Loud laughter. "So my thanks to all of you and now it's on to Chicago."

Kennedy thrust a thumb in the air, brushed his hair, made a "V" with the fingers of his right hand. The crowd was chanting now. *We want Bobby! We want Bobby! We want Bobby!* Plimpton and I went down three steps off the side of the stage, through a gauntlet of Kennedy volunteers and brown-uniformed private security guards. We turned left. At the other end of the stage, people turned right. *On to Chicago. On to Chicago. . . .*

We entered a long grungy area called the pantry. I would write later that it was the sort of place where Puerto Ricans, blacks, and Mexicans usually worked to fill white stomachs. Fluorescent ceiling lights, bare sand-colored concrete floors, pale dirty walls. A rusting ice machine. Shelves filled with dirty glasses. Through an archway to the left, we could see the main kitchen. A small group of Mexican-American cooks and busboys waited for Kennedy. To shake his hand. To murmur about luck, and thank him for coming. Against the left wall, three steel serving carts stood end to end. At the far end of the long pantry, two doors led to an improvised press room where Kennedy would speak to the press about the primary.

Kennedy moved slowly into the area, shaking hands with people from the stage behind him, at the head of a platoon of reporters, photographers (including Eppridge), campaign staffers, TV men, and the curious. I was walking backward, facing Kennedy, scribbling notes. I saw him turn to his left to shake hands with a smiling young Mexican man (we learned later that his name was Juan Romero and you can see him in this book starting on page 139). We could still hear chants from the Embassy Ballroom. *We want Bobby. We want —*

Then a cruel messenger arrived. Curly-haired. Pock-marked face. In a pale blue sweatshirt. Blue jeans. His right foot was forward. His right arm was straight out. He was firing a small gun.

Then, a ferocious brawling moment: Grier, Plimpton, Rafer, Schulberg, Barry, me. Others. All of us trying to get the gun. Or the hand that held it. Or the arm. The young man still firing, so that some people behind

Kennedy were hit in the legs. Then the gun was out of the man's hand, and he was being lifted, slammed onto the line of steam tables, dragged toward the exit to the press room, someone yelling, *Don't kill him, don't kill him, no Jack Ruby!*

And there was Kennedy on the floor, at the foot of the ice machine, his eyes open, a kind of sweet accepting smile on his face, as if he knew it would all end this way. Eppridge captures it perfectly, the stark black and white, the sense of an American pietá. There was blood on the fingers of Kennedy's right hand, and blood on his chest, so I thought he had been shot just below the neck. But because his head was turned to thank Juan Romero, the first shot hit him behind the right ear and his hand brushed reflexively at the wound as he crumpled to the floor.

Ethel came to comfort him, and seemed to know that he was forever beyond comfort. Juan Romero came to him too, as shown in the extraordinary photographs Bill Eppridge made in that awful pantry. My notes told me later that Kennedy was shot at 12:10 A.M., and was carried out of that grubby kitchen at 12:32. It seemed a lot longer.

Brian and I found each other and ran outside. A large enraged man was heaving chairs into the swimming pool. Another was punching a hotel pillar with a bloody right fist. Weeping Kennedy volunteers were all around us. We kept hearing a single word, repeated in many variations. *Why? Why?* In my own head, I blamed some dark hole in American life, but I was wrong. The origins of this killing—for Bob was sure to die in a matter of hours—lay in the Middle East. The gunman was a Palestinian immigrant named Sirhan Sirhan. He was twenty-four. His rage was fueled by the Six Day War the previous year and by Kennedy's support for the sale of jet fighters to Israel. The motives didn't truly matter. One crucial fact was simpler: He was able to get a gun. Brian and I drove to the Good Samaritan Hospital, where Kennedy was dying in a room on a high floor. Along the way, we bought a bottle of whiskey. It didn't help.

Early in the morning, Brian drove south in the California night. I dozed and felt sick and not from the whiskey. When we came through the canyon into Laguna Beach, I could see the colors of the sky brightening as the sun pushed over the mountains. Flocks of birds rose from the darkness. We reached the house and I went in and turned on the TV set and looked at the latest bulletins. I sat facing the set and the sea. Brian and I drank some more whiskey and then he went off to sleep. I looked up and saw my daughter Adriene staring at me in a baffled way. My face must have been a ruin. She came over to me, tears in her eyes, and touched my face. I started to weep for her, for her sister, for my Irish parents, for my friends, for America. Out there. Sea to shining sea. I held her tight, wondering what would become of all of us.

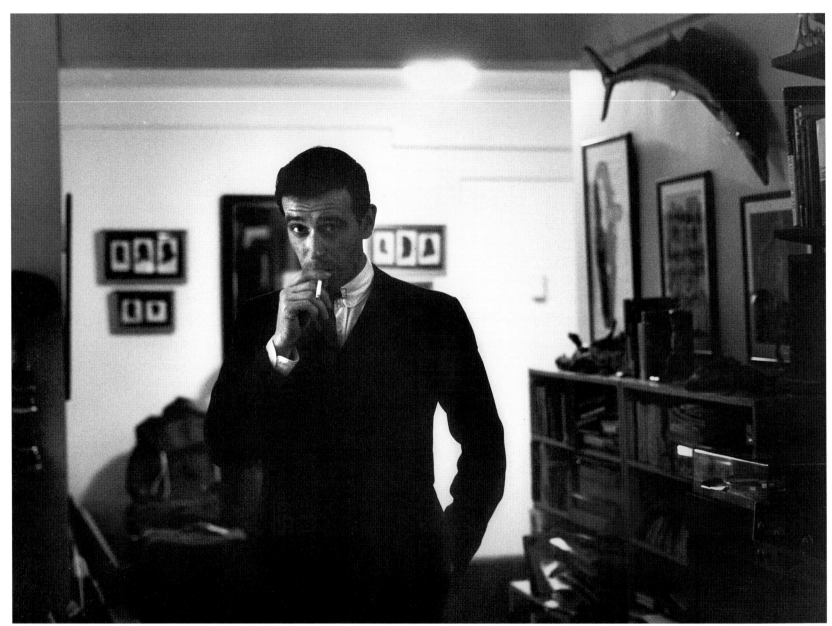

Bill Eppridge, New York City, 1968.

Foreword

JOHN ELLARD FROOK, LOS ANGELES BUREAU CHIEF, *LIFE* MAGAZINE, 1968–1972

BILL EPPRIDGE, A *LIFE* MAGAZINE PHOTOGRAPHER, was taking pictures throughout the uncertain decade of the 1960s. Events brought him into the company of Robert F. Kennedy during his first term as a U.S. senator, and later when he was a candidate for the highest office in the land. This book is an homage, a photographic history of one of the nation's most compelling figures.

Bill Eppridge's passport reads like a current events scorecard. There are pages and pages, stamps and visas. And sometimes no travel documents were required—or so he thought. Sometimes youthful exuberance was enough—or so he thought.

It is 1956. The people of Hungary are in full revolt. They demand withdrawal of Russian troops. It is too much for the Russians. They send in six thousand tanks and tens of thousands of troops to put down the insurrection.

Eppridge is studying archaeology at the time at the University of Toronto. Or is he? He has fallen for a Leica camera and is making pictures for the student newspaper, *The Varsity*, under the assumed name Antoine Tzinkevitch. This is to flummox his father, who can see no future for his son in photography.

The editor of the school paper, a Hungarian, decided *The Varsity* should cover the revolution. He arranged for a plane. He arranged to have automatic weapons waiting in Hungary for the ten or twelve staffers who would make the trip. College kids! A few days before the "journalists" were scheduled to depart, someone raised the question: Does everybody have a passport?

"We looked at each other," Bill remembers. "Those of us who were American . . . not one of us had a passport. We were told unless we had a passport we wouldn't get back into Canada or the U.S. after our Hungarian visit. What a disappointment. That was the end of my first war."

Not all he turned his eye to during the *Life* years (1961–1972) was riot and revolution. Between wars he was making pictures. Not taking . . . making. Taking pictures is what amateurs do.

We come to 1971. And here he is, footloose and fancy free, a young, good looking, single guy living in Los Angeles. And a *Life* magazine photographer to boot. He has a place up in one of the hippest hippie canyons, a Porsche in the garage, a gang of friends who held the patent on partying.

Which perhaps explains why I am standing on one foot and then the other waiting for him to show up. I have hired a helicopter and arranged for the door to be removed so Bill can get at the pictures we're hoping will open up below us when we take to the air.

It's motorcycles we've come for. Six hundred and fifty motorcycles. It's the cross-desert motorcycle race from Barstow, California, to Las Vegas, a rampageous, 150-mile, flat-out free-for-all.

My impatience finally gets the better of me. I jump in my car and head for Laurel Canyon. He's home all right: his slick little Porsche Targa is in the garage and he's in bed, still asleep in his clothes.

I wake him, and not gently. I shove him into the shower, help him get dressed, and gather up

everything that looks as if it might be useful in taking pictures.

We make it to the start line with minutes to spare. The noise of throttles is deafening. There are baggers and belly-shovers and barn queens here this morning. All of them revving and raring.

We are finally airborne. Bill gets down on his belly, a camera up to his eye. He is—most of him at least—inside the helicopter. I have him by the ankles.

The gun!

Up here, even over the *thwap*, *thwap*, *thwap* of the chopper, I can hear them. Seeing them is quite another matter. It's a brown haze down there.

But Bill sees something. He talks to himself, answers himself, turns, and gives me a long look. His first word of the morning: "Yeah."

He goes back to his camera.

And that's the way it was done. Bill clicking away and squeaking out small expressions of joy.

The next day—it was Monday—I walked into the photographer's lounge. Bill was bent to a light table, a loupe to his eye. He had a wastebasket by his left foot and was methodically filling it with rejects. I was alarmed. I fished out two or three transparencies and held them up to the light streaming through the window.

"Here, take a look at the selects . . . the really good ones," he said. He got up and handed me the loupe. They were not just good, they were extraordinary. And not just one. By the dozen, they were extraordinary. Motorcycles belting across the Mojave, frozen in a gauzy brownness, riders like the knights of old sitting stiff on iron horses.

It ran in *Life* across one page and half of another. One of the great sport pictures of all time. A classic. It bears looking at—design, pattern, composition—again and again. And always something new.

The camera has two senses, those of light and line. Only these can be recorded in any one pic-

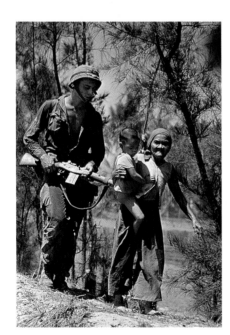

American Marine and Vietnamese woman and child, 1965.

President Lyndon B. Johnson working the handshake line of supporters, 1966.

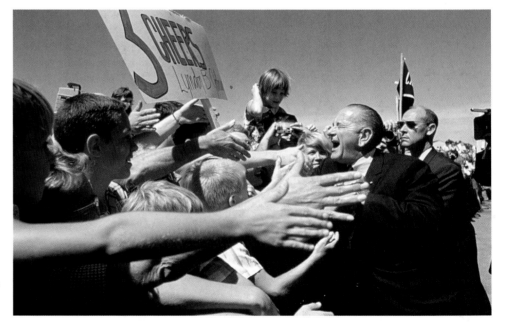

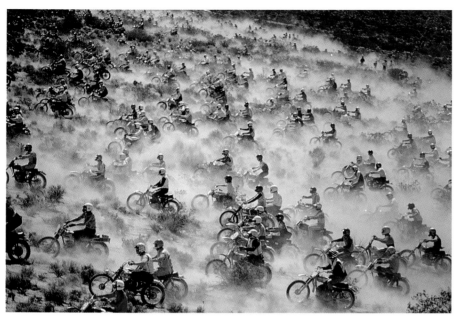

Cross-country motorcycle race, Mojave Desert, California, 1971.

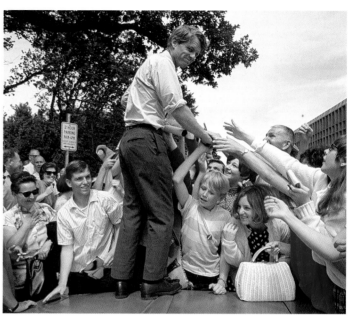

Senator Robert F. Kennedy during the 1968 presidential campaign in Oregon.

ture. Just look at Bill Eppridge's photographs of Robert F. Kennedy. Thousands of exposures, tens of thousands. Pictures round and whole and solid and alive. Two men, each of whom saw something in the other. They became and remained, if not friends, then familiar and comfortable with one another. Neither crossed the line. Bill Eppridge was what he always was, a photographer and a journalist. When he picked up his camera he set aside his thoughts and feelings. Truth is essential to his craft.

He tells the story about the time Bobby invited him to his New York apartment for an evening of "Irish roistering." The *New York Daily News* columnist Jimmy Breslin was there, full of blarney and blasphemy. "Bobby was like a kid who invites friends over when he knows his mom's away. Yes, Ethel was away. He wanted me to experience Breslin . . . nothing held back."

The next day it was business as usual. Arm's length. No residual, nothing owed.

And then there is the picture. An image that is, all by itself, a volume of American history. A photograph seared into the American conscious-

ness. You will see it in this book along with other photographs. Most have never been published, having been discovered recently. They were taken during Bill Eppridge's two-year assignment for *Life*. The assignment being: Robert Francis Kennedy. Every waking moment.

Bill Eppridge was a Kennedy favorite. There would be a gesture, a look, a nod, and Bill would be invited in. Closer. The preferred position. A whispered word. Special dispensation. It shows in his photographs. Intimacy. Respect. Trust.

See for yourself.

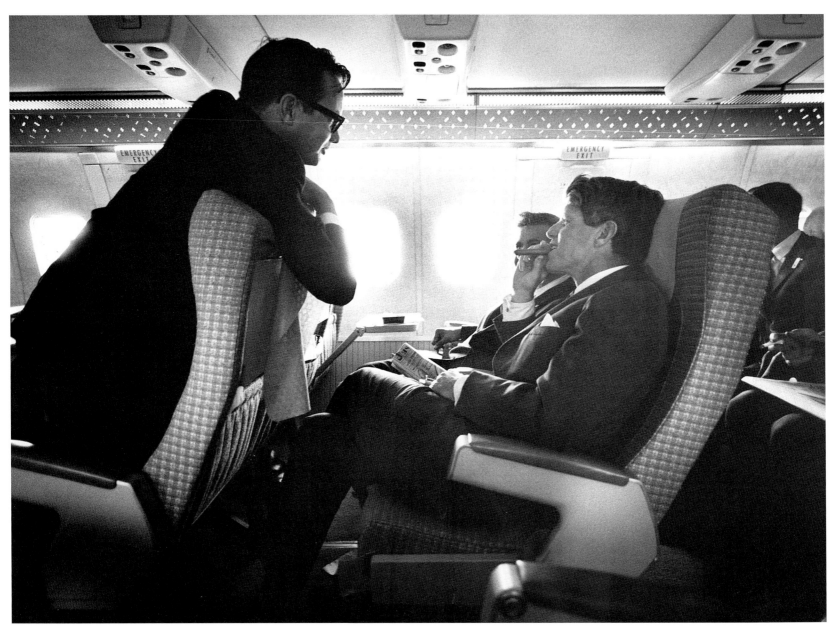

Bill Moyers and Senator Robert F. Kennedy aboard Air Force One during President Lyndon B. Johnson's Northeast campaign tour, August 1966.

Prologue

BILL EPPRIDGE

FORTY YEARS AGO, IN 1968, I PHOTOGRAPHED A great tragedy, and the vision of it has stayed with me for all this time. Our country was going off course, with a war overseas, racial inequality, and far too much poverty in relation to the amount of wealth that existed. A man emerged to lead us out of this: Robert F. Kennedy. For the short amount of time that he existed on this earth, he inspired a generation, who to this day still remember the excitement and hope that he brought. He died too young, too tragically, and this book is a photographic essay of that brief, euphoric time in our history.

Photographers as journalists are generally on a different wavelength than reporters and writers. We are still journalists, but from another viewpoint. Reporters listen, photographers look. If you are doing your job seriously as a photojournalist your sight must be the primary sense that you use at all times. You must see one hundred percent, sometimes to the total exclusion of the other senses—your attention must be entirely focused on that image in the viewfinder.

My good friend Bob Jones used to argue with me about humans and instinct. I always insisted that we have a visual instinct, that the sense of sight becomes more and more instinctive with training. Sometimes if I am looking at a person, and I am talking with them, I find that I move and unconsciously put myself into a position where I frame the picture automatically without using the camera.

I had seen Robert Kennedy in 1965 during an assignment on board Air Force One with President Lyndon Johnson. This was the first time that a *Life* photographer was allowed to document an entire trip with the president of the United States. It just so happened that Yoichi Okamoto, Johnson's personal photographer, had been a mentor, teacher, and a friend of mine from the University of Missouri.

Okamoto's close relationship with the president allowed me virtually the same access that he had, and I was able to do whatever I wanted during that trip. At one point I noticed Bobby Kennedy sitting across the aisle from me. He was smoking a cigar. Now, I knew that politicians do not like themselves photographed smoking cigars. I was mentally framing a picture of him when Bill Moyers, the president's press secretary came down the aisle, stopped, leaned over the seat in front of him, and started a conversation. I picked up my camera very slowly, leaned forward a bit to more properly frame the picture, put it up to my eye, and took two frames. That was it, I put it down. *Life* published the picture, small, in the magazine, and I forgot all about it.

MEETING SENATOR KENNEDY A FEW MONTHS LATER, I told him that *Life* wanted me to follow him for the rest of the 1966 Democratic campaign trips. He looked me right in the eye, got a funny little smile on his face, and said, "OK, but no cigars!"

It was only then that I remembered the picture that had run in *Life*.

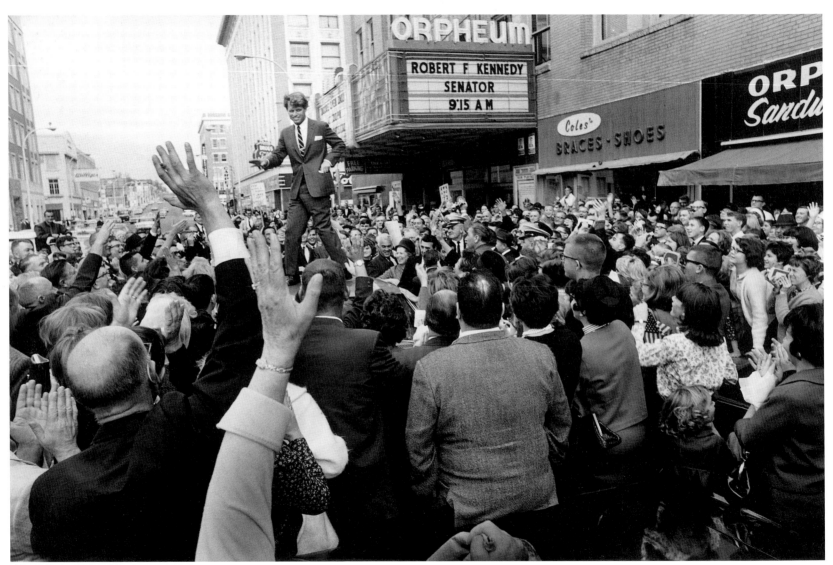

At a rally in Sioux City, Iowa.

NEW YORK'S SENATOR ROBERT F. KENNEDY CAMPAIGNED FOR OTHER DEMOCRATIC candidates in 1966, and I was there to photograph it for *Life* magazine. What I saw in 1966 was, I believe, a reaction to his late brother, President Kennedy. The crowds of people were coming out to see who this younger brother was and whether he was possibly an answer to something they were looking for, and yearning for.

When the 1966 political campaigns started, it was obvious that Senator Robert Kennedy was going to be an important factor in American politics. *Life* wanted a major piece on Kennedy and asked me to photograph it. The fact that I had never covered politics didn't matter.

Testing the Waters

BOBBY CAMPAIGNS ACROSS THE COUNTRY TO BUILD SUPPORT FOR A 1968 PRESIDENTIAL RUN

In early 1966 my boss, Dick Pollard, the director of photography, called me into his office and he said, "You've been to wars, riots, and revolutions. We think maybe it's time that you did a Kennedy campaign. You're ready. You wanna do it?"

Of course I said yes, and then asked him, "What do you want me to do?"

"We've got a piece here that's been written by Penn Kimball [writer and historian], and we want you to shoot it," Pollard explained.

I wanted to read the story, but Pollard wouldn't let me. He wanted me to see the senator through my own eyes and not be influenced by anyone else's thoughts.

He told me that *Life* wanted to see if both of us found the same thing. "We want to

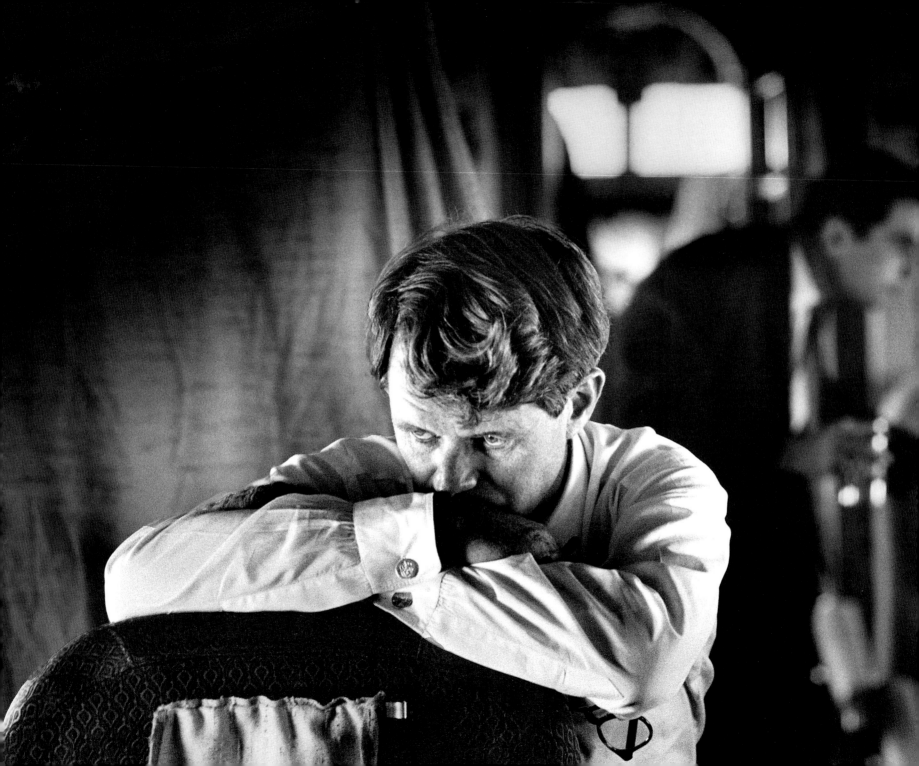

see how the people feel about him. "We want to see if he really is the keeper of the Kennedy legacy. We think he's going to run for president. Will he run into the same problems his brother did? Now, you know that he and Lyndon Johnson do not like each other at all. We need a picture of him with Lyndon, somehow. The rest of the press are all over the place on this. Get something."

That year Bobby was hopping around the country working for other candidates. Although he was not up for election, his trips had all the trappings of a full-blown presidential campaign. The Kennedy name was magic, and the man was controversial.

I spent three months campaigning that year with some carefully preconceived ideas in mind. I knew what we wanted to say, but had to watch and wait for the moment and be ready when the precise situation arrived. Our cover picture—Bobby applauding in front of an almost ghostly portrait

of JFK—happened so fast that I had time to make only three frames. The situation never repeated itself. This was the one and only time during the entire period that there was any kind of visual connection between the two.

To photograph the enmity between RFK and LBJ was difficult indeed. Only one time during those three months were the two near each other. It was at a bridge dedication in New Jersey. Kennedy knew how to control his expressions and emotions, but just once allowed his feelings to show.

It was easy to see Bobby's popularity in crowd shots, but the graphic quality of the Kennedy silhouette before a Berkeley crowd said it differently and with more visual impact.

The most important factor in these pictures was time. The magazine had given me enough time to thoroughly understand my subject—to be able to anticipate his handling of a situation and to be there—ready—when the picture happened.

A rare quiet moment en route to another campaign stop to aid local candidates.

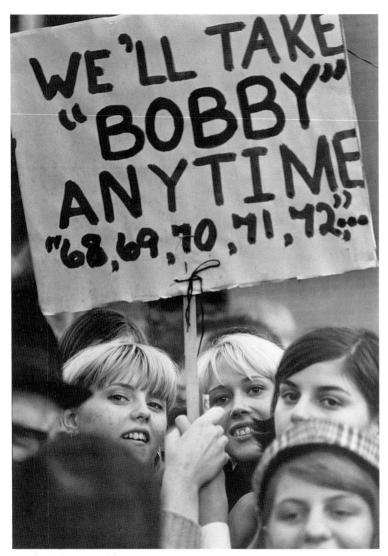

Young female supporters.

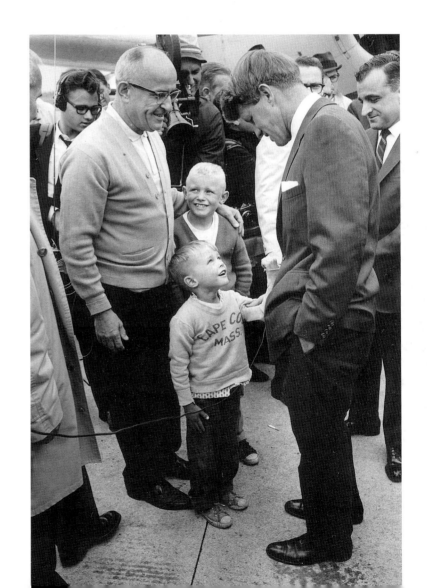

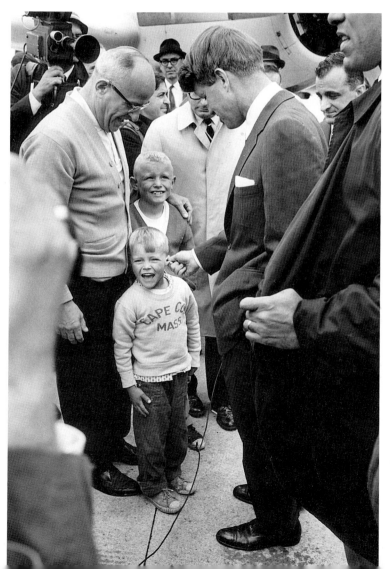

At an airport, a man presents his two grandsons.

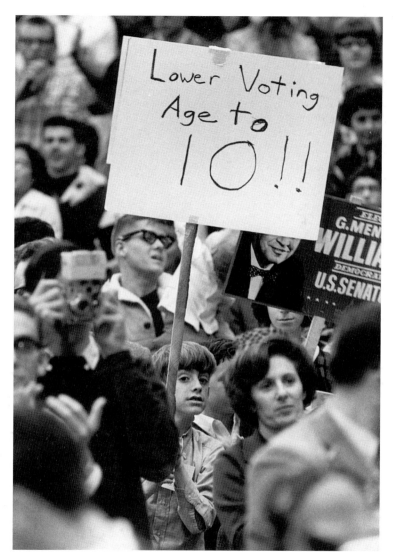

Bobby's fondness for kids was reciprocated. Here, a boy at a rally in Michigan, October.

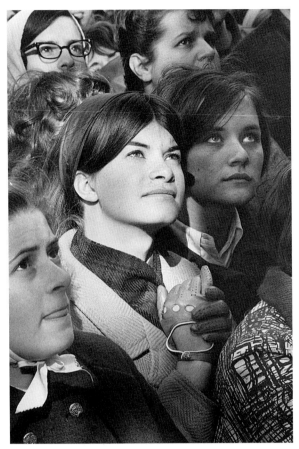

A face lights up in the crowd.

Three Benedictine nuns at a small Midwestern airport.

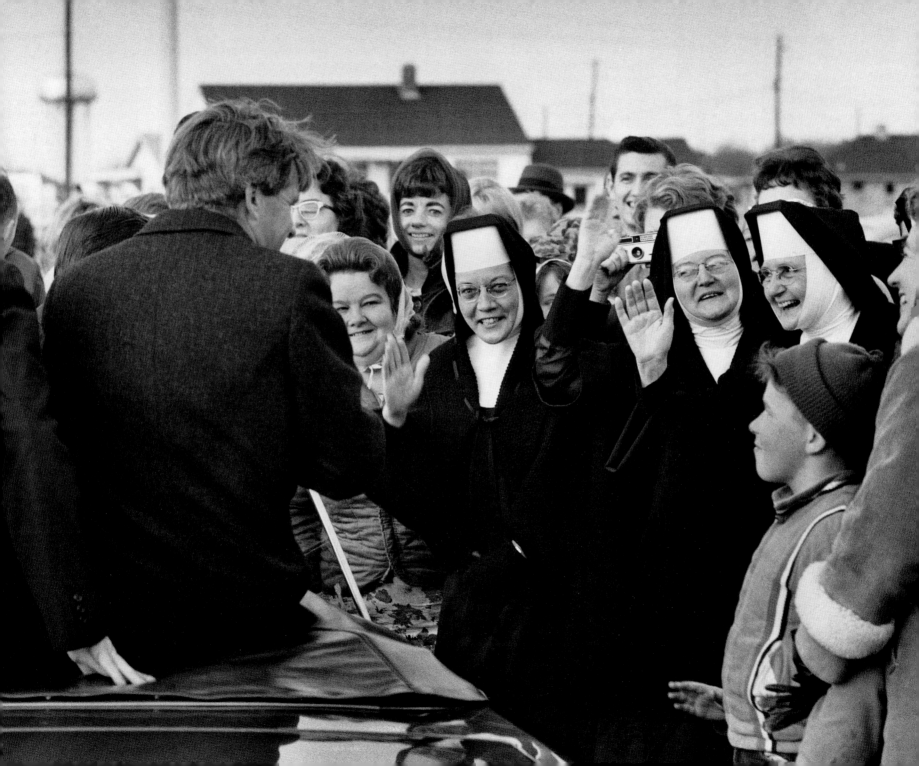

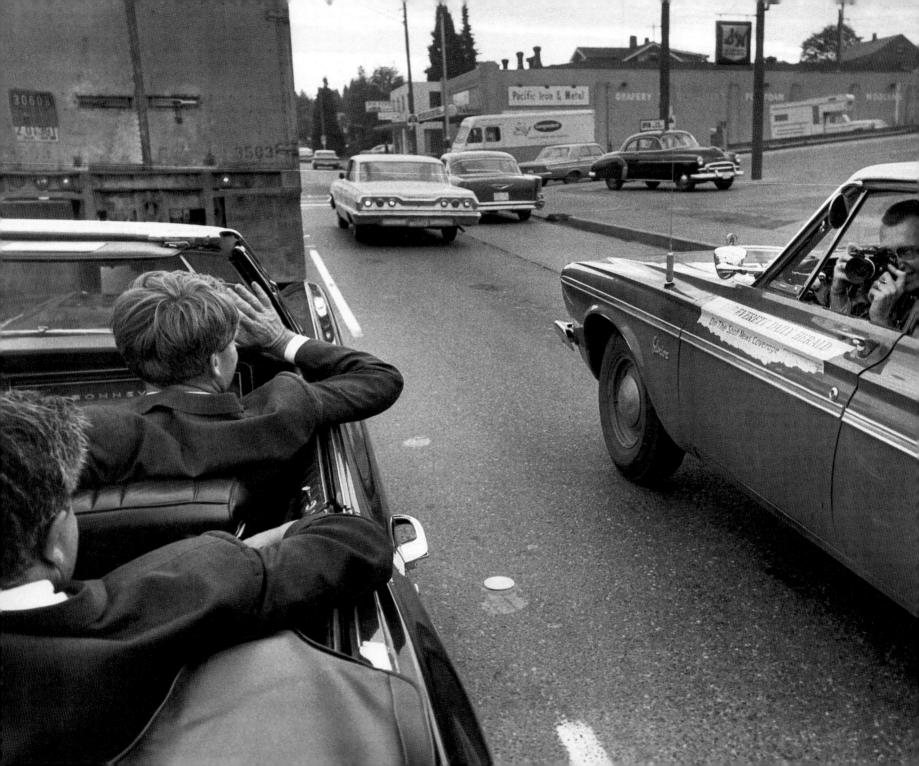

A newspaper photographer takes his hands off the wheel and eyes off the road to snap pictures of Bobby.

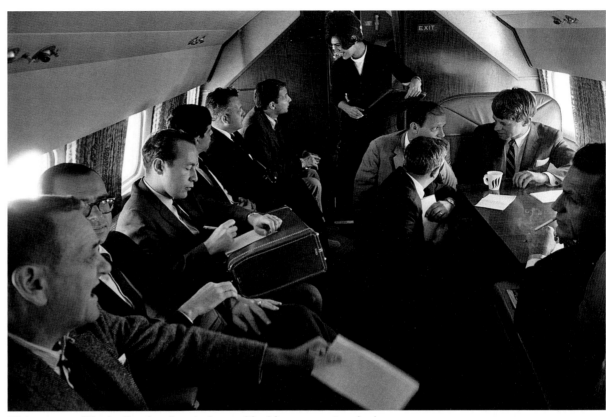

Flying to a political rally, planning strategy with aides as reporters look on.

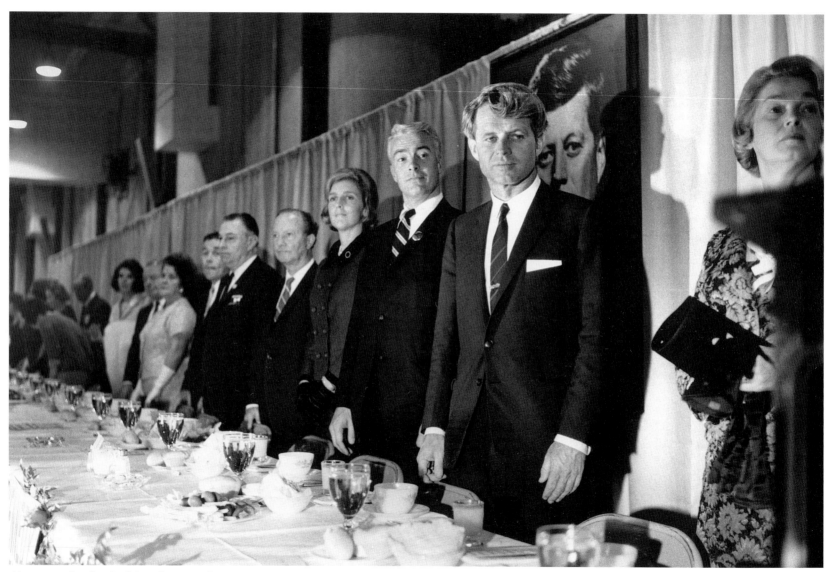

At a campaign fund raising dinner at the Ohio Fairgrounds in Columbus, the senator stands before a photograph of his brother.

Our cover picture—
Bobby applauding
—happened so
fast that I had
time to make only
three frames. The
situation never
repeated itself.

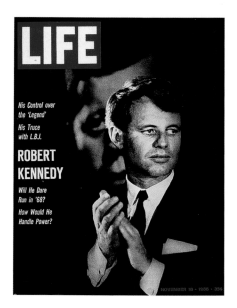

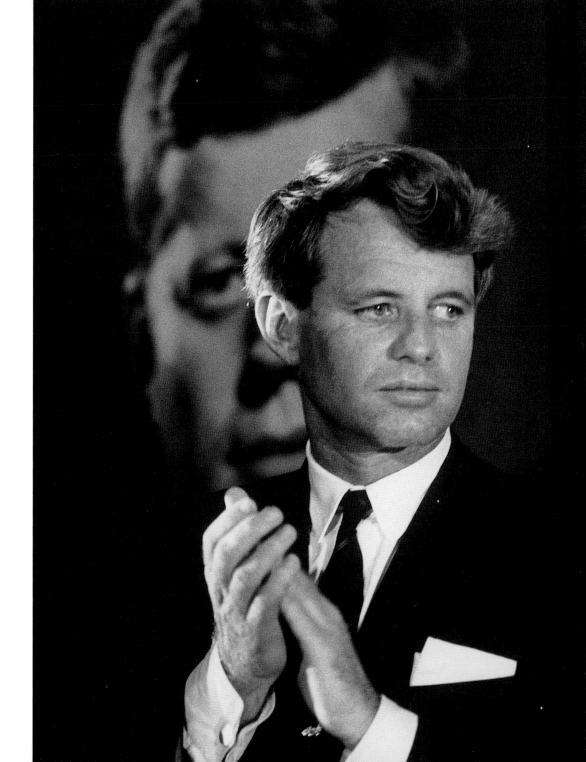

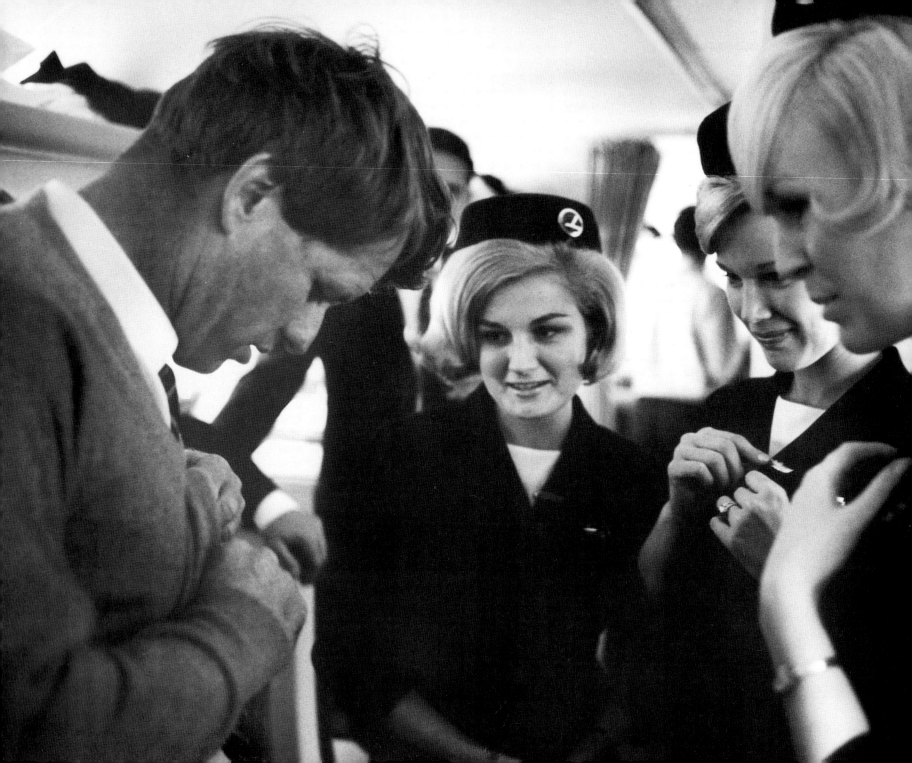

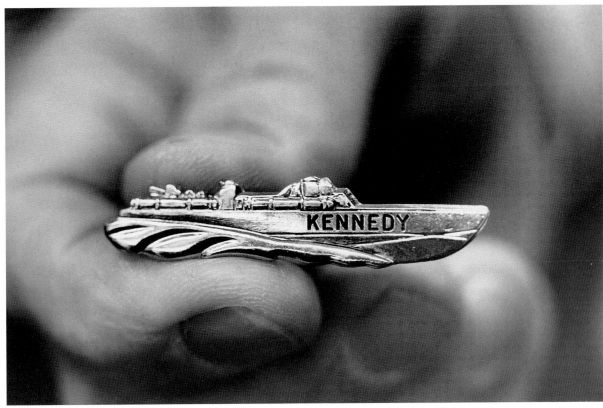

Bobby gives PT-109 pins to three airline stewardesses while on a nationwide swing in support of Democratic candidates. JFK had done the same during his presidential campaign.

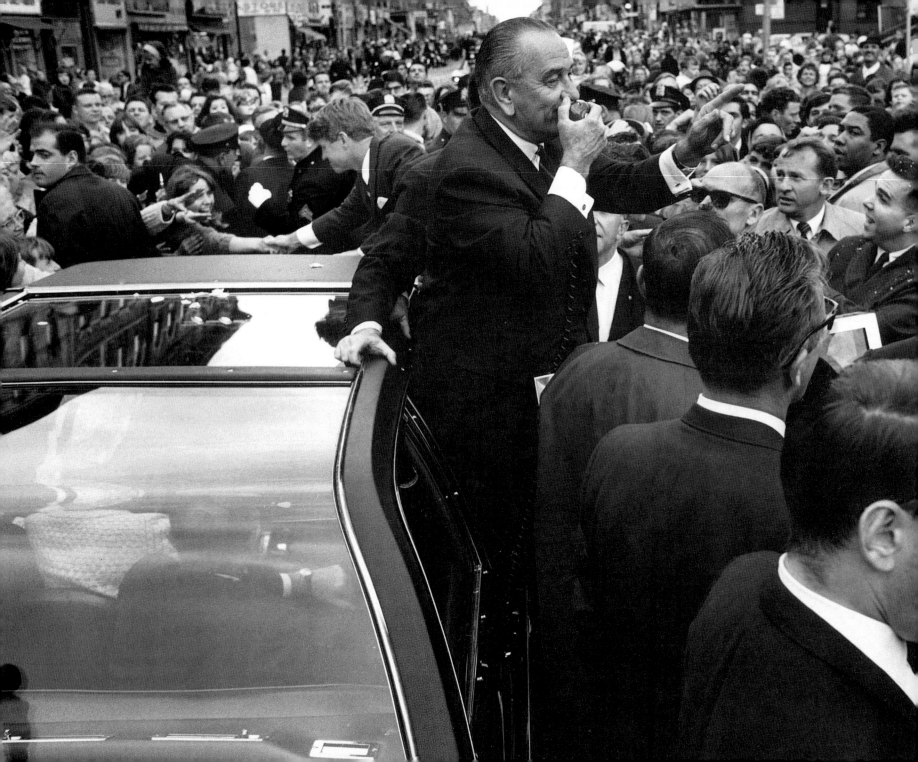

President Lyndon B. Johnson delivers a speech from the presidential limousine in Bay Ridge, Brooklyn, at the dedication of the Verrazano-Narrows Bridge. Bobby, the junior senator from New York, shakes hands at the other end of the car.

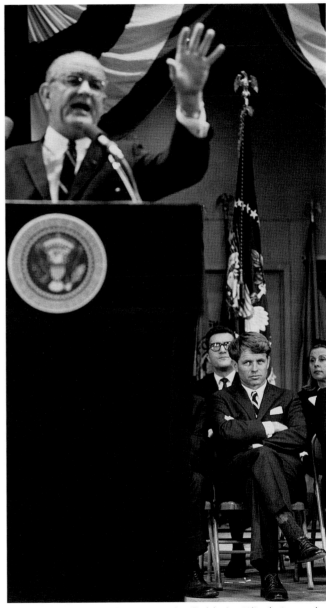

Later that day, as Johnson speaks, Bobby's attitude toward the president is clear.

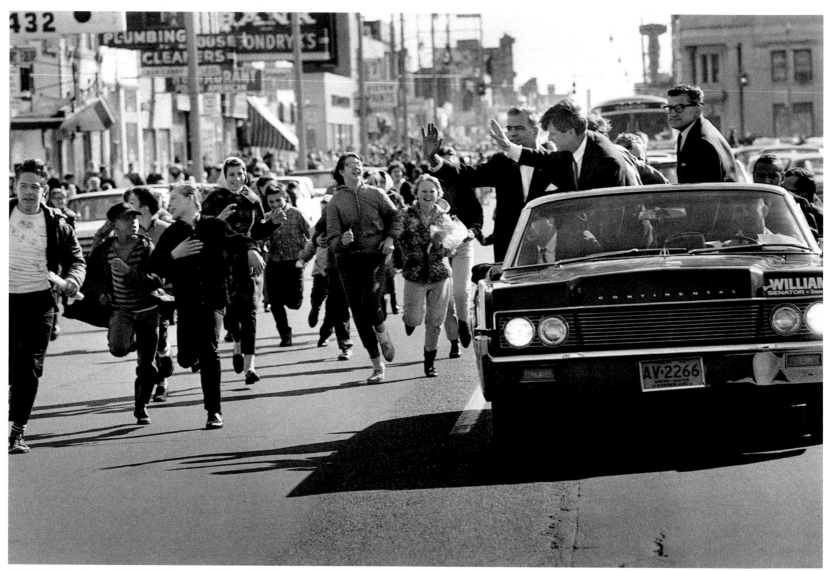

Kids running alongside Bobby's convertible while he campaigns for Governor G. Mennen "Soapy" Williams's senate race in Michigan.

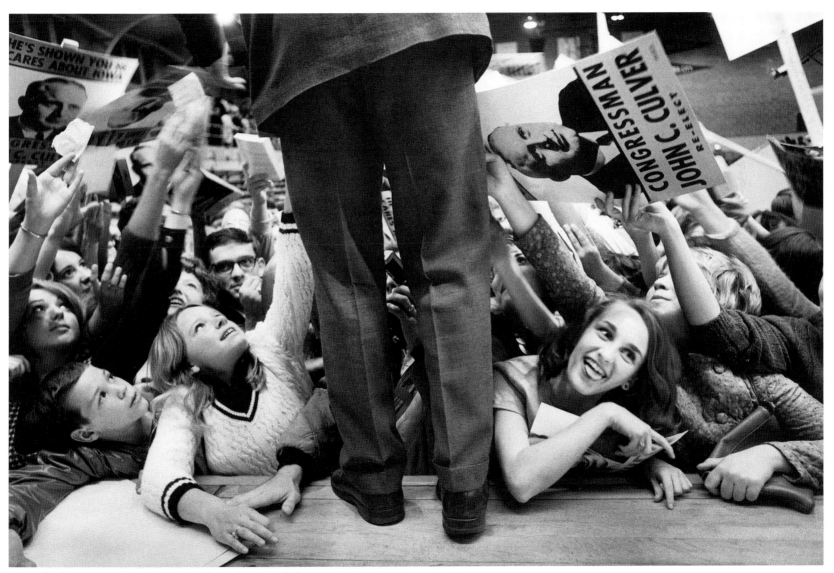

A crush of young supporters at the edge of a stage in Iowa.

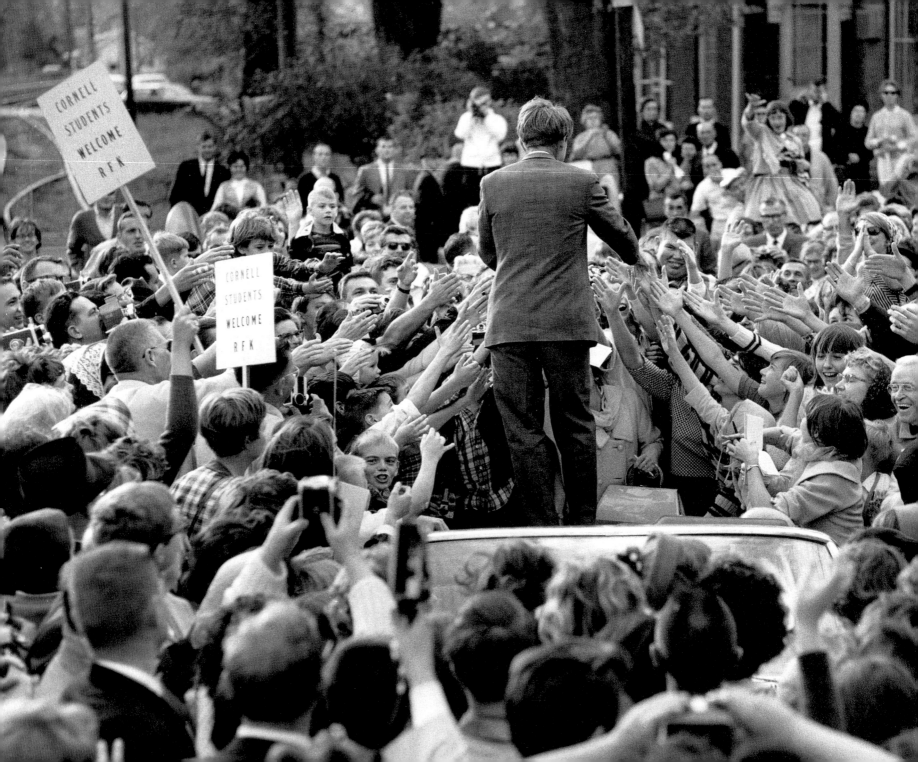

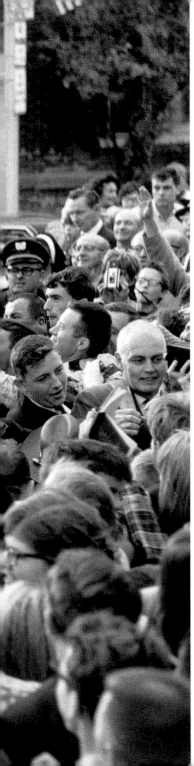

Standing above a sea of hands in Marion, Iowa.

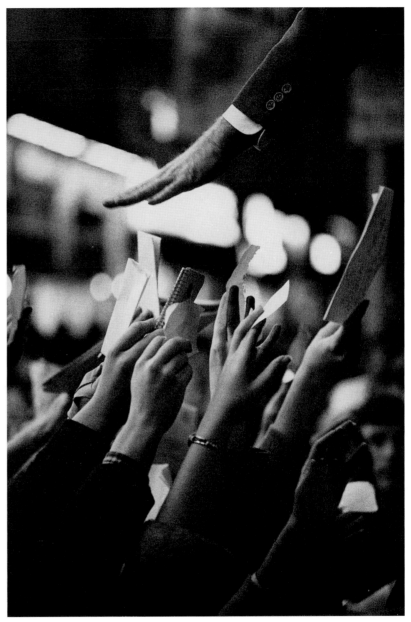

People reach out to Bobby with slips of paper for him to sign.

Although he was not up for election, his trips had all the trappings of a full-blown presidential campaign. The Kennedy name was magic, and the man was controversial.

Bobby drew mixed, sometimes ominous, reactions from crowds in Los Angeles.

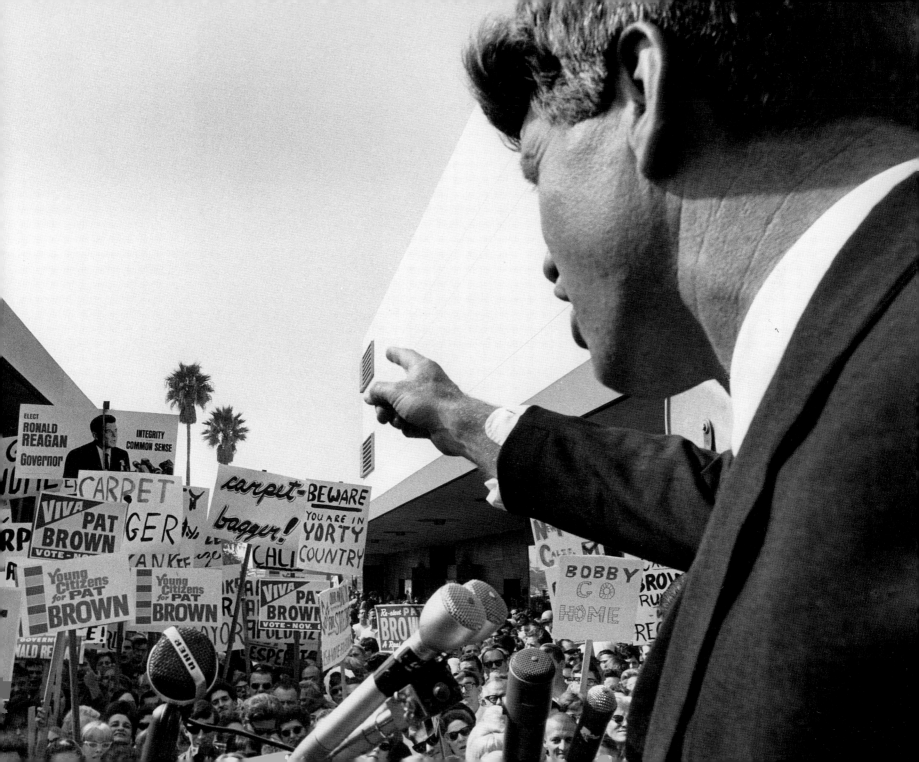

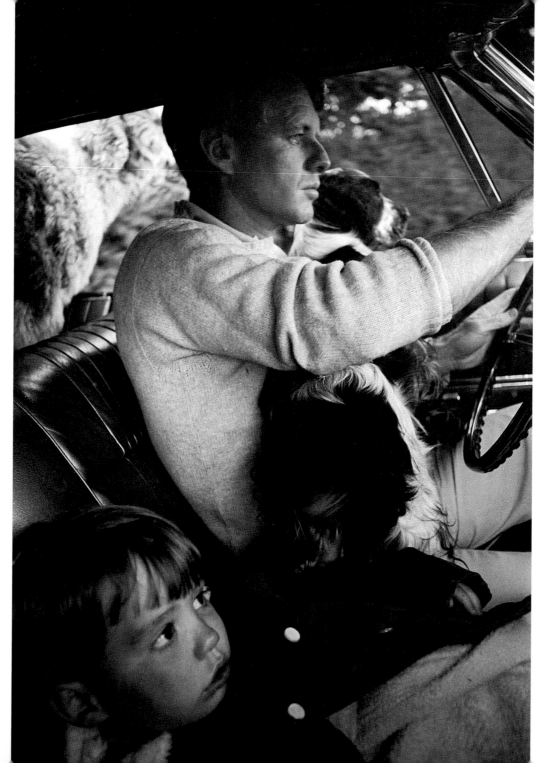

*A drive in Virginia
with son Max and
dog Freckles.*

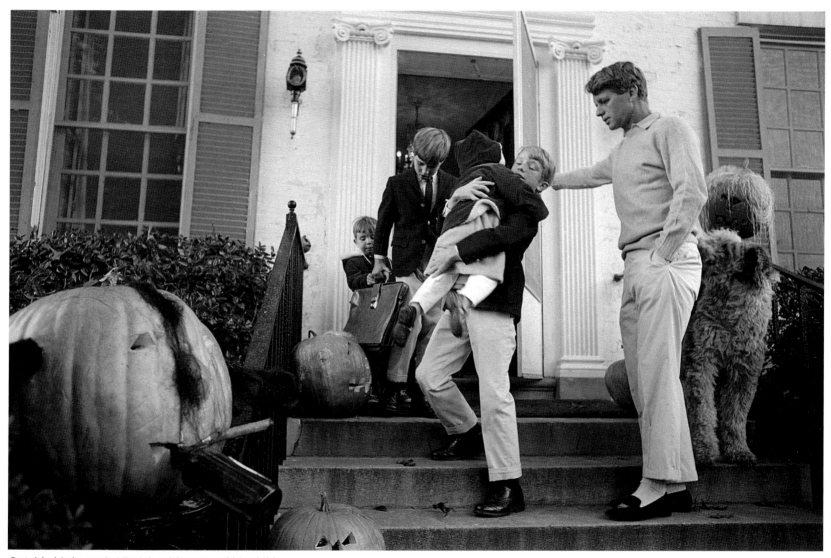

Outside his home in Virginia with some of his children.

Following pages: *In California, Berkeley students fill a stadium to hear Bobby talk on dissent, extremism, and Vietnam.*

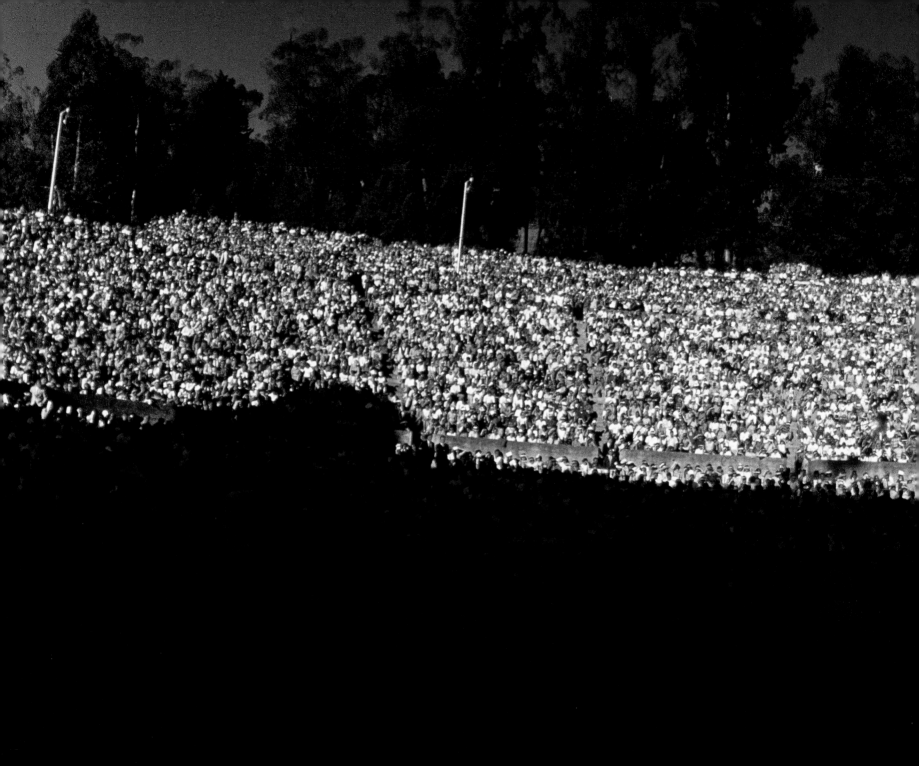

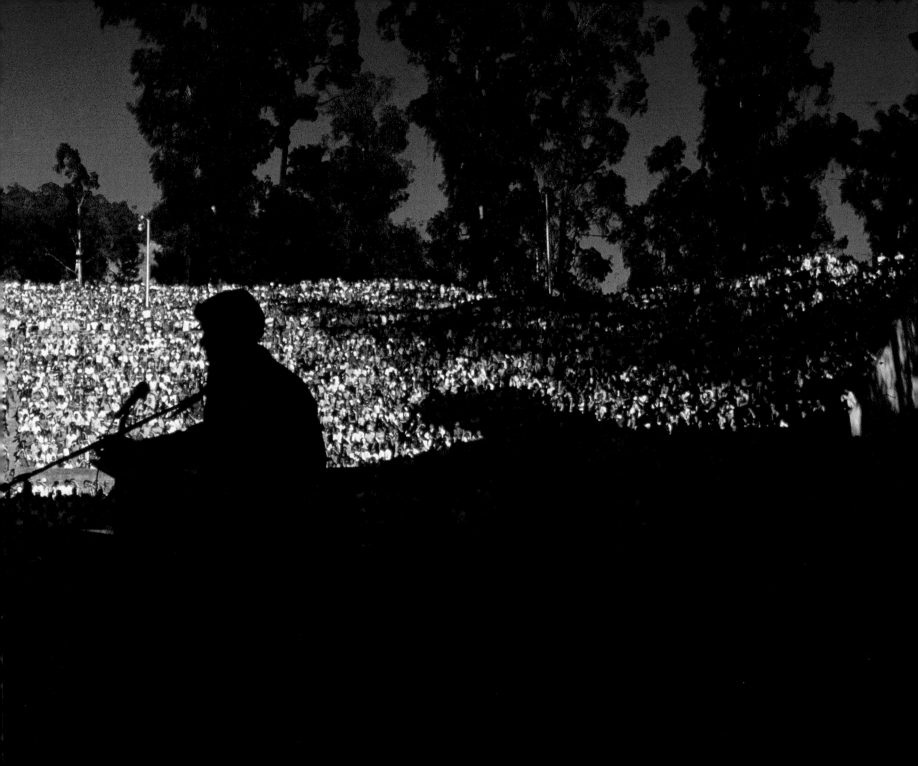

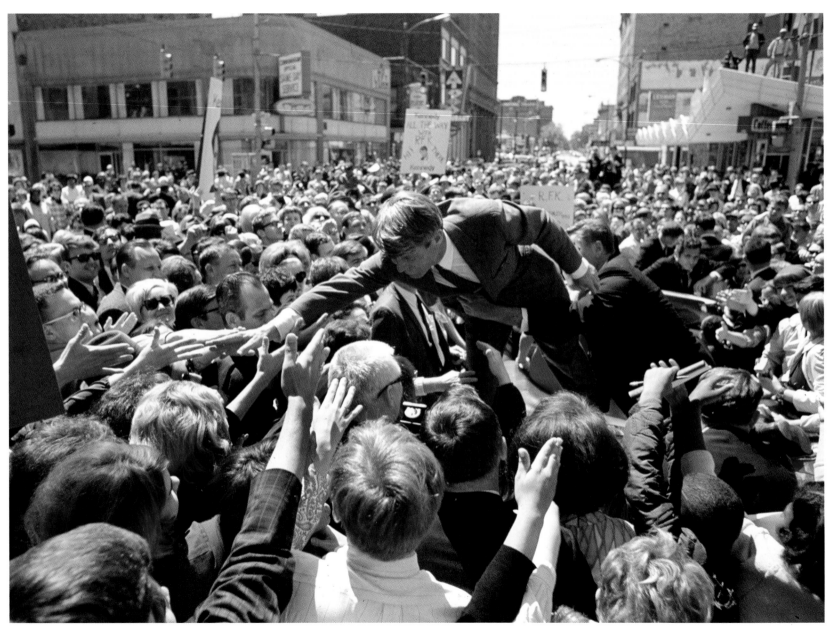

Surfing the crowd in a Midwest city shortly after entering the 1968 presidential race.

I WAS IN THE COLORADO ROCKIES LISTENING TO THE NEWS ON A TRANSISTOR RADIO WHEN I first heard that Robert F. Kennedy had announced his candidacy for president of the United States. Immediately, I jumped into my rented jeep, and drove twenty miles down four-wheel-drive-only trails to a phone so that I could get my bid in to be *Life*'s permanent photographer on the Kennedy campaign. My boss at *Life*, Dick Pollard, was happy to hear from me because none of the other photographers were interested in the long hours, the hassles, and the mobs of people that would come with this assignment.

Life's attitude was different this time. This was the real campaign and I was doing straight news coverage as part of a three-person writer-reporter-photographer team. There was not much time to look for carefully thought-out concepts as we had done in 1966. Weekly deadlines had to be met. And deadlines weren't our only problem. We were fighting for space against other *Life* teams who were with the Eugene McCarthy and

Campaign, 1968

BOBBY'S PRESIDENTIAL RUN BEGINS AS LYNDON JOHNSON DECLINES TO PURSUE A SECOND TERM

Richard Nixon campaigns. We were also fighting the Republican leanings of Time Inc.'s management. (*Life* later editorially endorsed Nixon for president.)

The general feeling on the campaign wasn't that different from 1966. Bobby was the same man, but this time he seemed more driven, and it seemed that he had a direction. Almost overnight, he had assembled his own advance team and backup staff with full funding.

The campaign started well, and Bobby was running full tilt. He had forced Lyndon Johnson to announce his retirement and was catching up with McCarthy—antiwar candidate and poet. When we started to hit the first towns on the campaign trail, we all noticed that the signs in the crowds finally, in unison, said, "Bobby for President." We knew then he wasn't working for other campaigns, and he wasn't endorsing other politicians. He was going for it—the presidency—and his message against the war in Vietnam rallied the crowds.

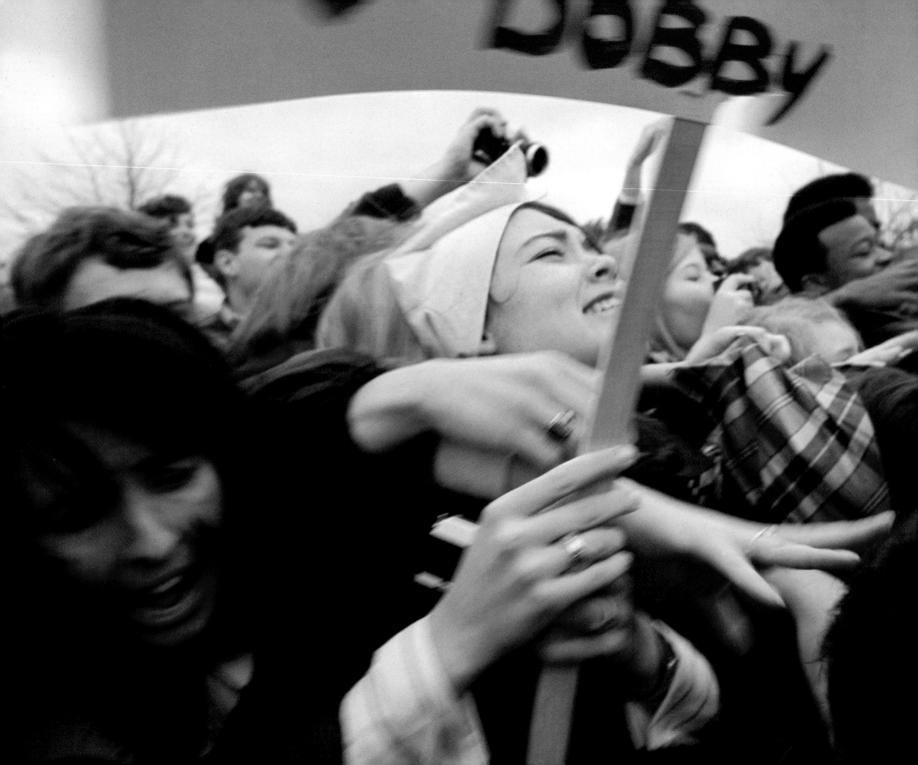

In Indiana, the crowds were huge and unruly, requiring police presence.

At each campaign stop, we no longer wondered what the crowd reactions would be. Everyone sensed that this man was a great figure. People wanted to see Bobby, and they came out in large numbers. Somehow within the span of those two years his reputation seemed to have grown. He was now acknowledged as his own person. So we all knew when we got to a town that we were going to work, and work hard. There were thick crowds to get through and crowds to photograph. Very few people were anti-Kennedy like the ones we had seen in California in 1966. We were prepared for the work that we had to do, and it was joyous.

Fun happened on the campaign trail, as when Freckles, Bobby's dog, became as much a member of the staff and press corps as anybody else. He got to sleep with the candidate on the floor of the plane. Quite often when we made a campaign stop, the doors of the plane would open, and the first one off the plane would be Freckles. He would take off, and the Kennedy kids would scream, "Where's my dog?" So somebody got smart and gave the dog a press credential. Then, when he disappeared into the crowd everybody knew who he belonged to, and he always made it back to the plane on time one way or the other.

Bobby kept winning. Week after week his ratings went up in the polls. His primary victories were impressive, but there was a certain uneasiness in the press corps. This was too much of a good thing. We started nervously looking at windows and rooftops during motorcades. There were several rumors that "a man with a gun" had been seen, or had been picked up by local police. None of this could be substantiated.

There was no Secret Service protection for candidates at that time. To get through crowds cameramen had to form a wedge and actually run interference in front of the candidate. Our wedge was composed of a three-man TV crew in the center and a still photographer on either side, forming, as it were, a human spear point. We would walk backward into the crowd, which would provide the candidate with an open path to the podium and it also gave us picture situations. When people got knocked about, they blamed the press and not the candidate. It worked out well all the way around, but we had to expect a few bruises for our efforts.

Of course, Bobby had no official protection. He refused to have uniformed police close around him. Bill Barry, an ex-FBI agent and a Kennedy family friend, came along, but he was only one person. Eventually, the senator was convinced that he should let Roosevelt Grier and Rafer Johnson, and occasionally other pro-football players, come along.

Presidential candidates now all use bomb-proof and bullet-proof cars. The ultimate trust that Bobby had in his fellow human beings showed itself in the fact that he demanded convertibles.

A convertible was the proper place to make great photographs of Bobby because you could

Campaigning at dusk in Hammond, Indiana.

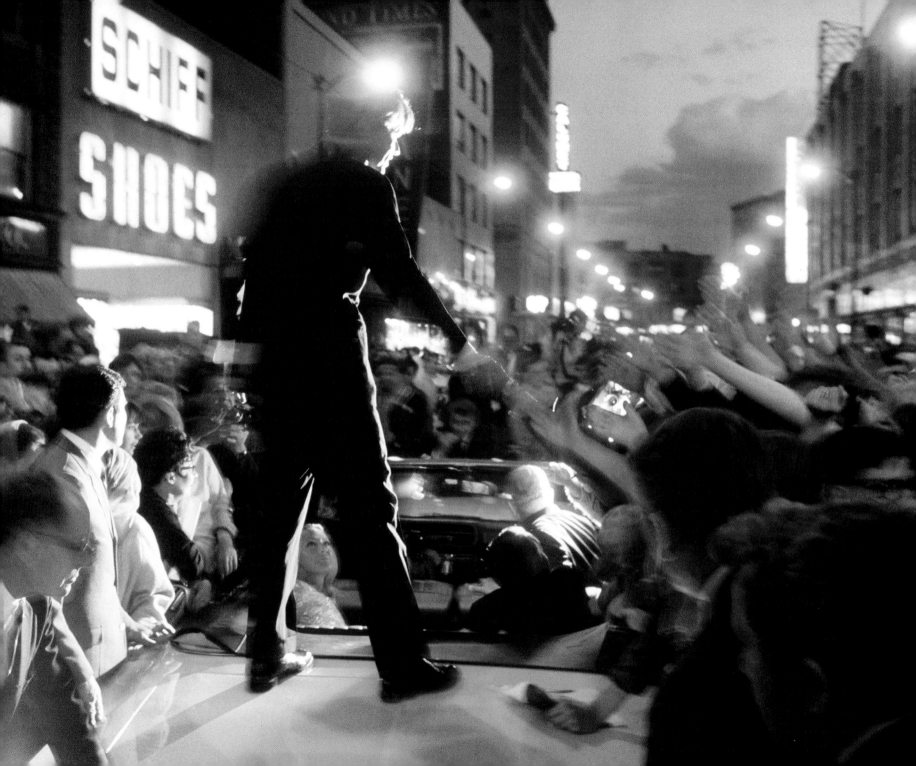

stand on the front, the back, anywhere you wanted. I remember the time that Walter Dumbrow, a cameraman for CBS, was standing on the hood of Bobby's car, filming him as the motorcade started to move. He was held around his legs by his sound man and his electrician, and they were standing pretty rock solid, the three of them. After the car reached a certain speed, Walter figured he had enough footage and should get off the hood. Walter and his two compatriots then instantly swiveled as one in such a way that they did not tangle their wires, jumped off the car in unison, and landed on the ground running forward to the camera car, which was directly in front of Bobby. When they reached the camera car, they jumped, again as one entity, swiveled in the air, and landed on their butts on the trunk of the camera car, sliding forward. Those of us in the backseat reached and grabbed them by their belts and pulled them on board. It was a press corps ballet.

Bobby never showed any fear, he always had a smile on his face, like he was really enjoying the hell out of the huge crowds. When he was on a car or platform, people wanting to shake his hand would actually pull him off and into the crowd. Bill Barry was Bobby's only bodyguard, and part of his job was to keep him from being pulled into the crowd.

As the campaign moved into late May, there was sometimes open discussion among the fifty-odd members of the press corps about the possibility of an attempt on Kennedy's life. CBS assigned a second camera crew permanently to the campaign.

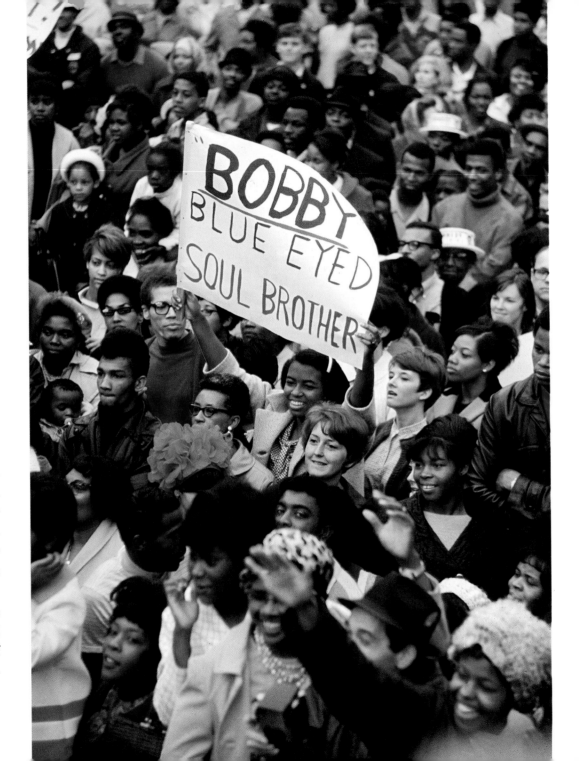

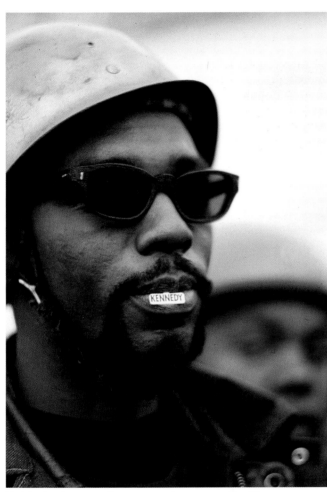

Bobby had tremendous support among minorities, who came out in large crowds for him.

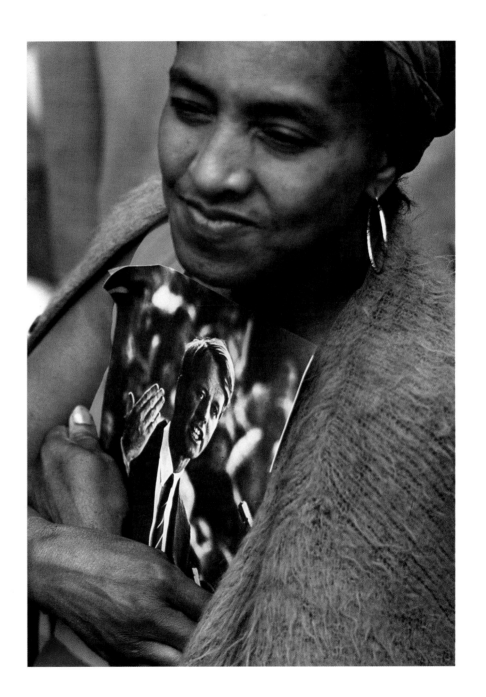

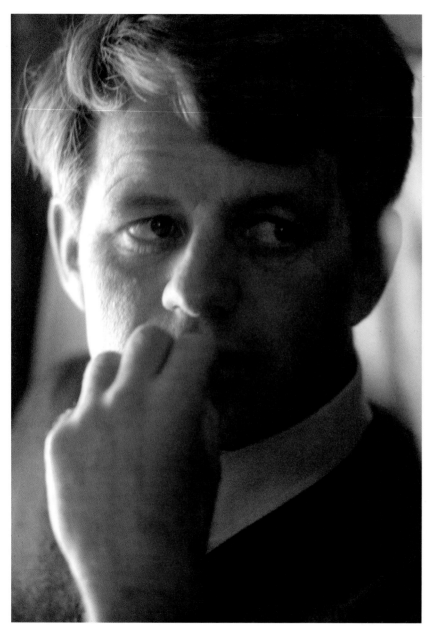

Crowds greeting the senator were huge and uncontrolled. In most cities, police escorted campaigning political groups, but Los Angeles provided no such escort for Robert Kennedy.

There were portents. The day before the primary in San Francisco, someone in Chinatown threw a packet of firecrackers at the senator's convertible. There was a split second of frozen terror on his face then he dove for the floor of his car. Cameramen in the preceding and trailing cars were unable to move. Nobody made any film of that incident, but it did serve to reawaken all our fears.

For the working press on the campaign, it was a series of airports, crowds, and hotels. Often, Bobby would come down to the bar in the late evening and seek out the photographers to find out how we were and how the pictures were looking. He was quite aware of what our jobs were, and he liked talking to us. The subject of Vietnam usually came up, and he wanted to know about it from those of us who had been there. He wanted to know what we had seen and felt. Almost always at the end of these informal sessions he would get around to saying that when he was president—not if—the country would be out of Vietnam on that day. We believed him.

On board the campaign plane, headed to another city.

The senator having a cup of tea as a mix of coffeeshop patrons and campaign aides stand nearby.

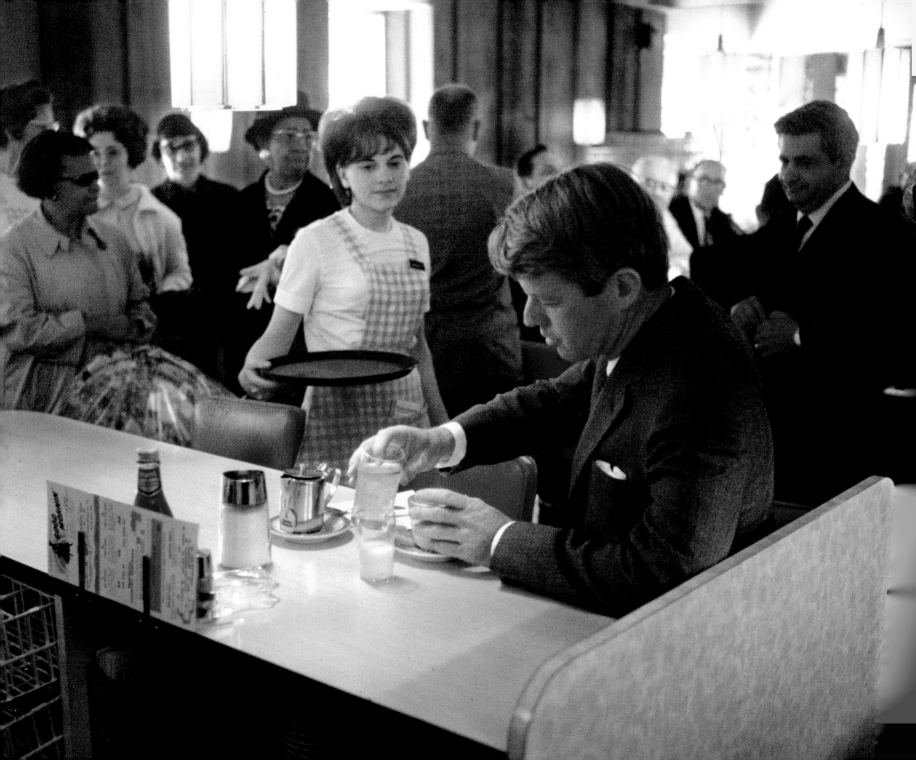

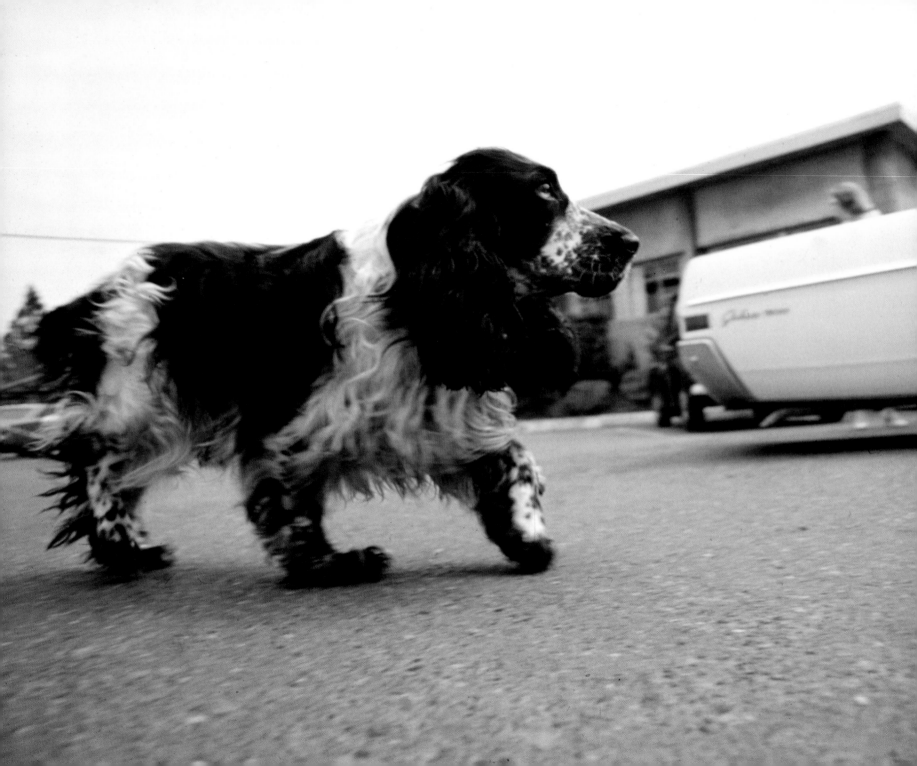

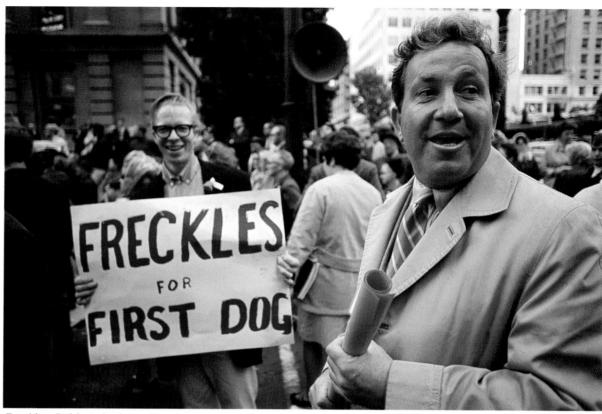

Freckles, Bobby's Springer Spaniel, was a constant presence on the campaign trail. Dick Tuck, a Kennedy advance man, made sure that signs supporting Freckles were present.

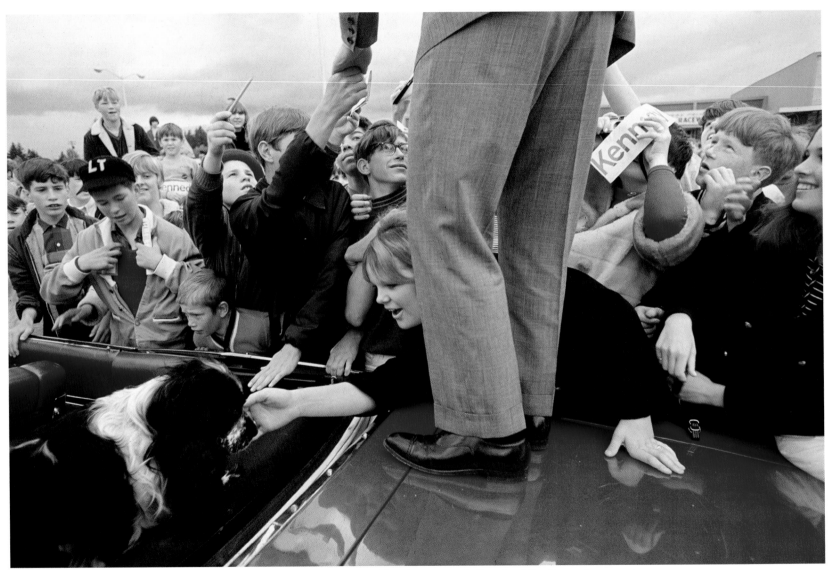

Freckles had his own supporters and spent many hours in the convertibles that were a hallmark of the Kennedy campaign.

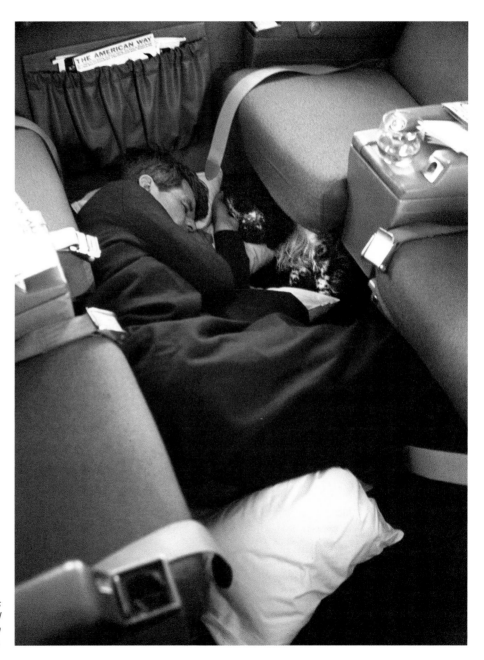

Bobby and Freckles catch a nap on board the plane between campaign stops.

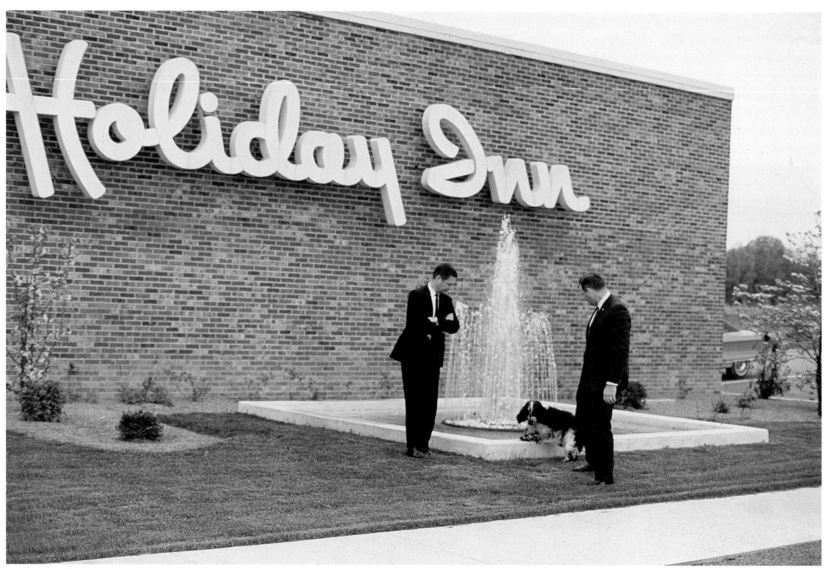

Freckles takes a fountain break at a Holiday Inn.

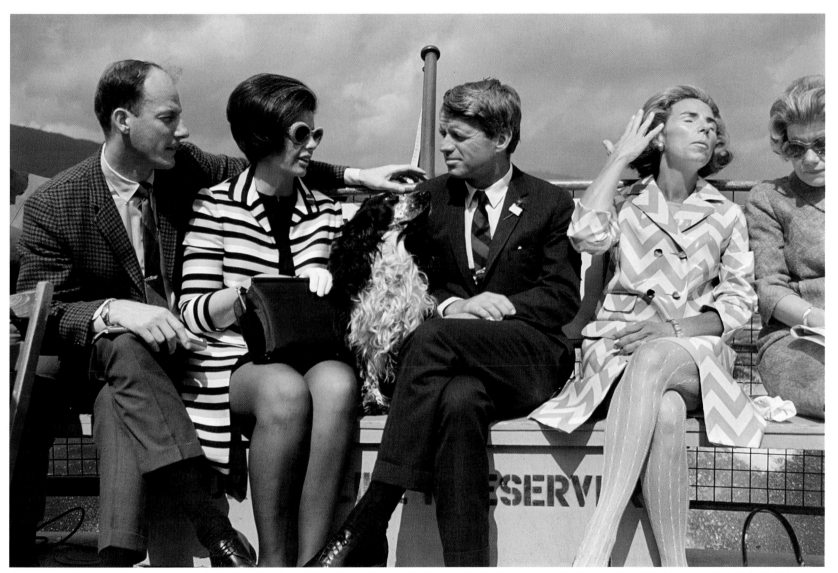

On board a ferry on the Oregon coast, Bobby, Ethel, and Freckles with Jim Whittaker (far left) and Mary McGrory of the Washington Post *(left, in the striped coat).*

Early spring campaign stops always involved convertibles.

Small Midwest airports usually had a crowd of supporters waiting for the senator.

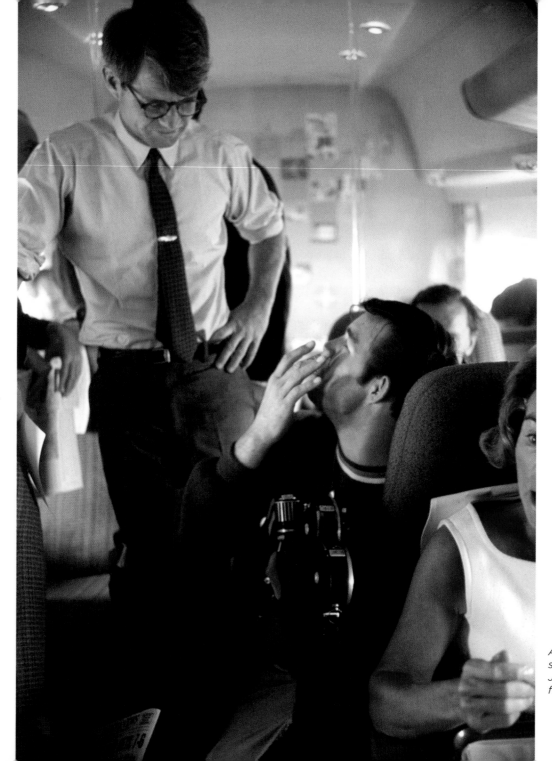

After conferring with the senator, CBS cameraman Jimmy Wilson playfully films Ethel at close range.

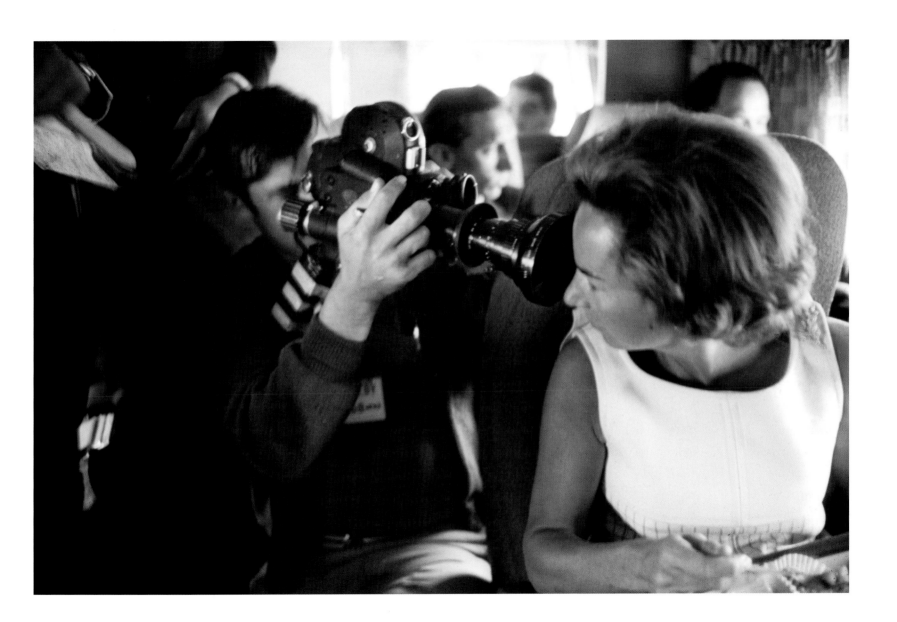

The campaign plane was home away from home for staff, press, and family.

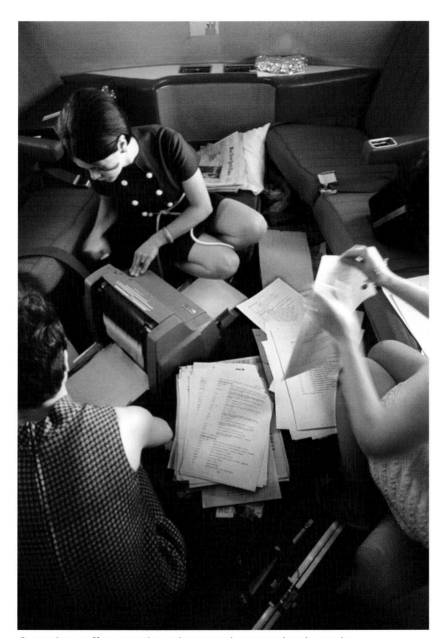

Campaign staffers sort through press releases and make copies.

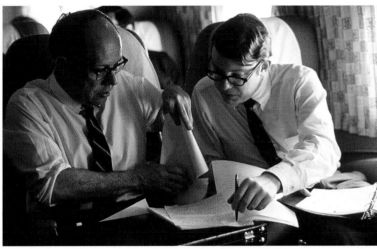

Campaign staffers Fred Dutton (left) and Jeff Greenfield go over speeches.

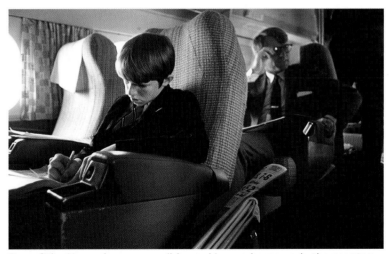

One of the Kennedy sons possibly working on homework, the senator seated behind him.

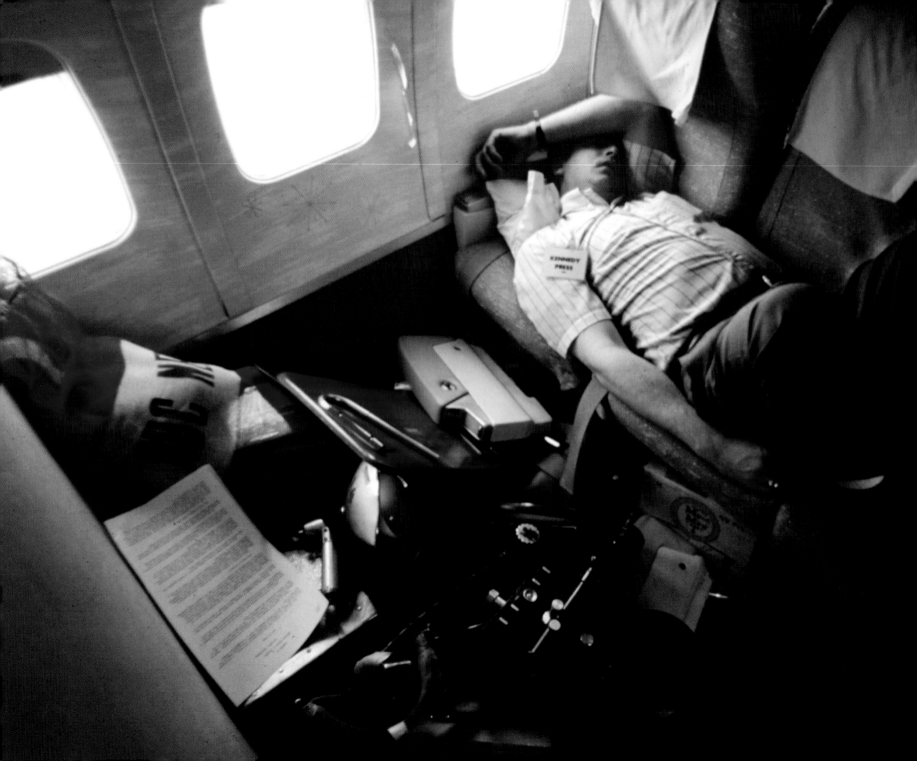

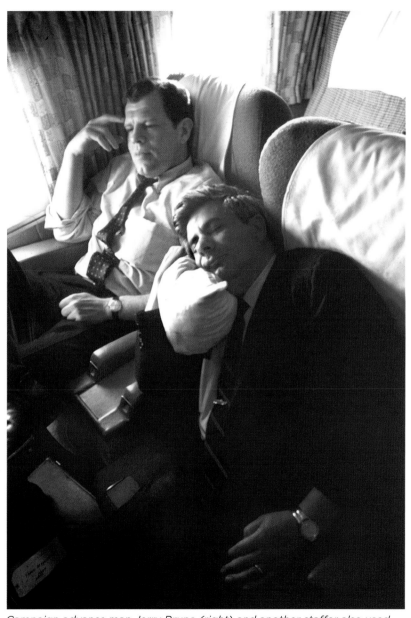

An NBC cameraman sleeping on the plane between campaign stops.

Campaign advance man Jerry Bruno (right) and another staffer also used the time between stops to catch up on sleep.

Bobby was the same man [as in 1966], but this time he seemed more driven, and it seemed that he had a direction.

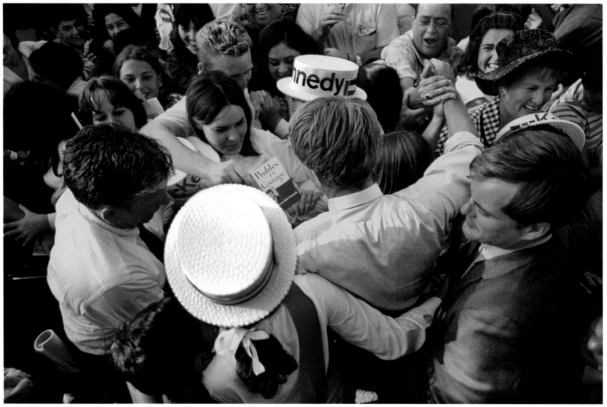

The senator would quickly be surrounded by supporters at most stops. His bodyguard, Bill Barry, is aided by San Diego Chargers wide receiver Lance Alworth (right).

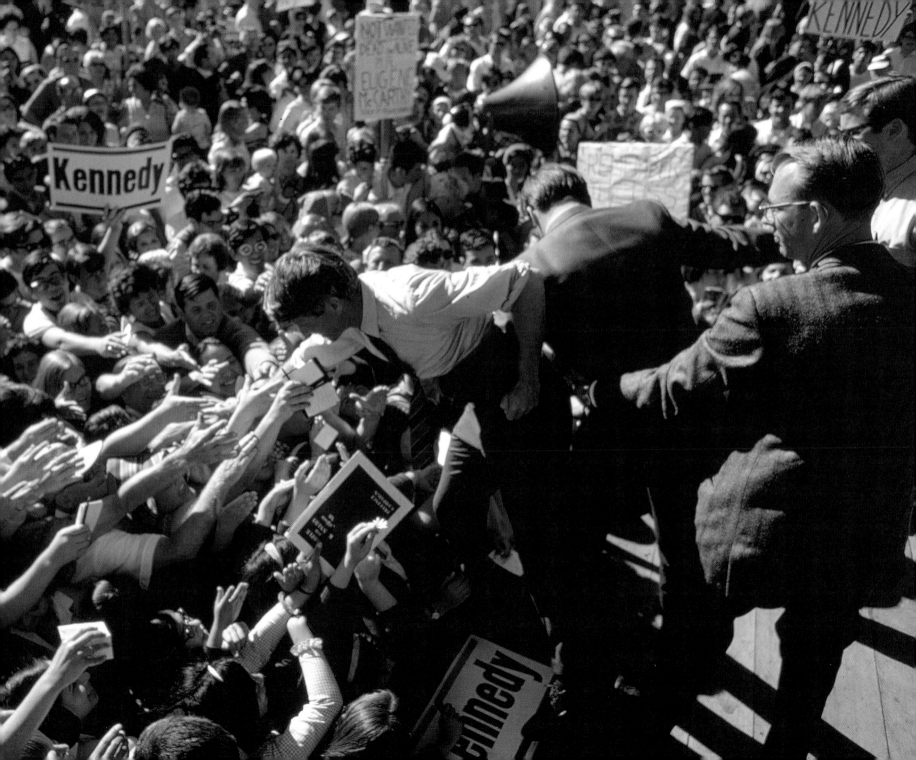

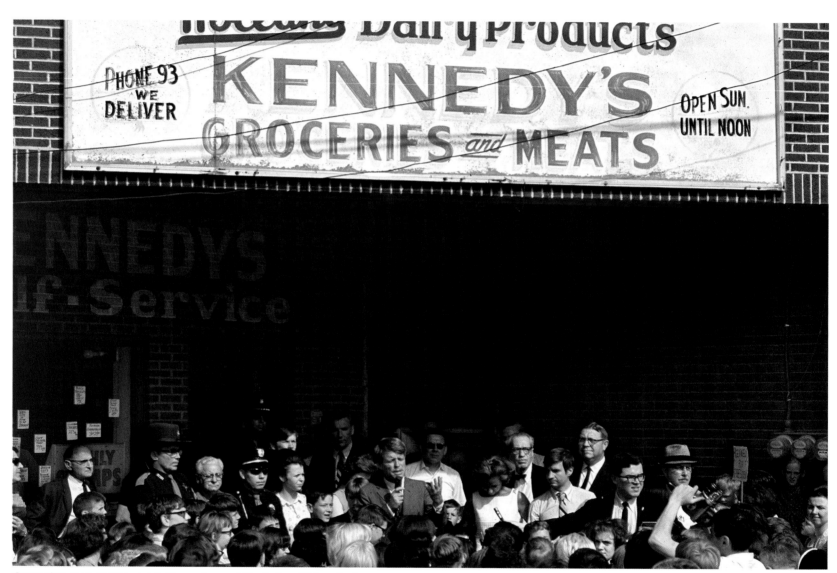

Campaign stop at Kennedy's Groceries and Meats in a Midwest city.

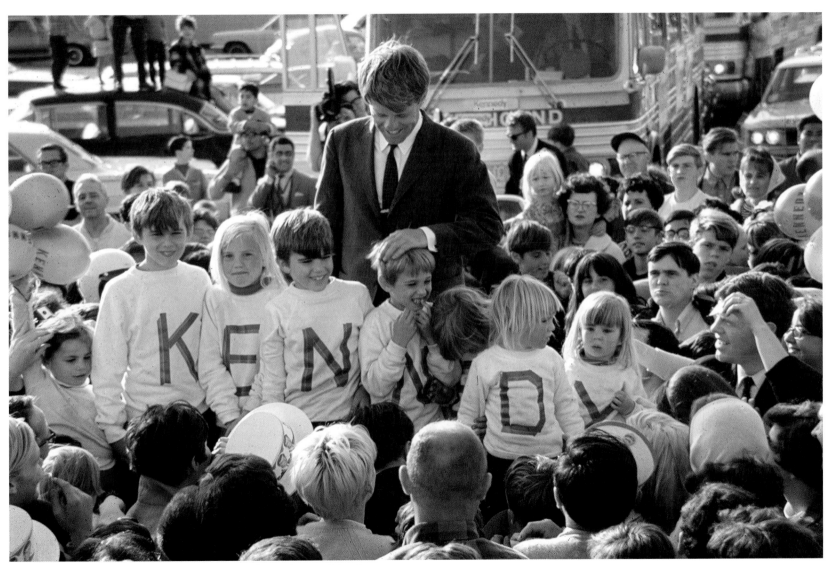

Seven children wearing lettered shirts that spell out the candidate's name.

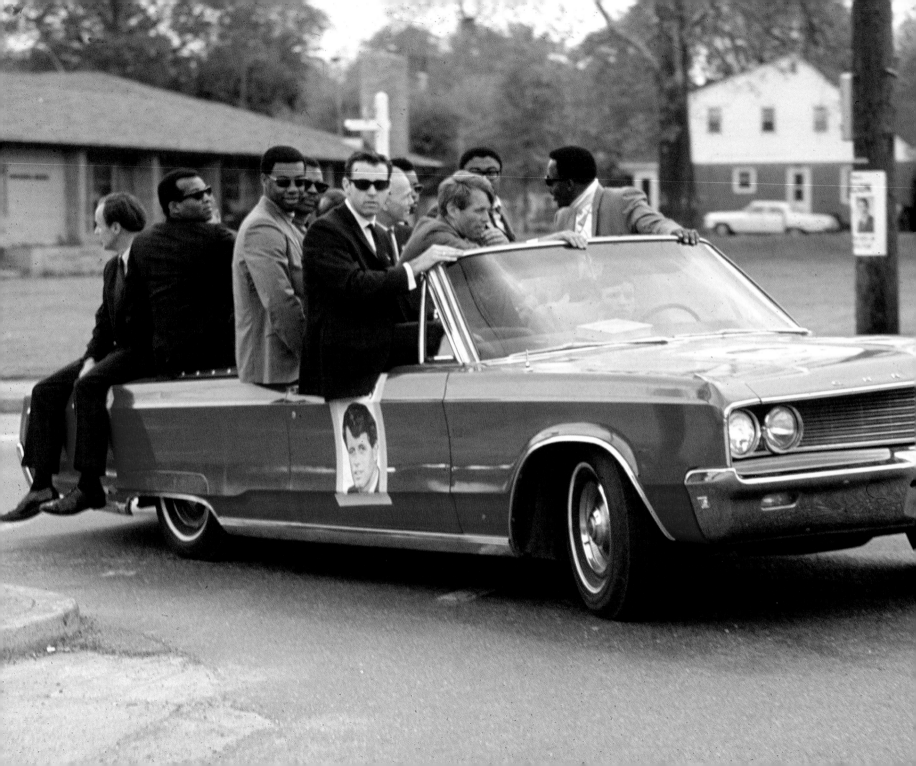

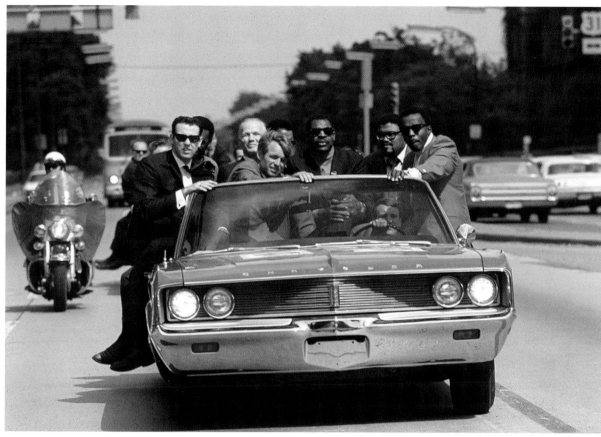

A red campaign convertible loaded beyond capacity edges out into traffic in Indianapolis, Indiana. The drivers of these cars did not hesitate to drive at highway speeds.

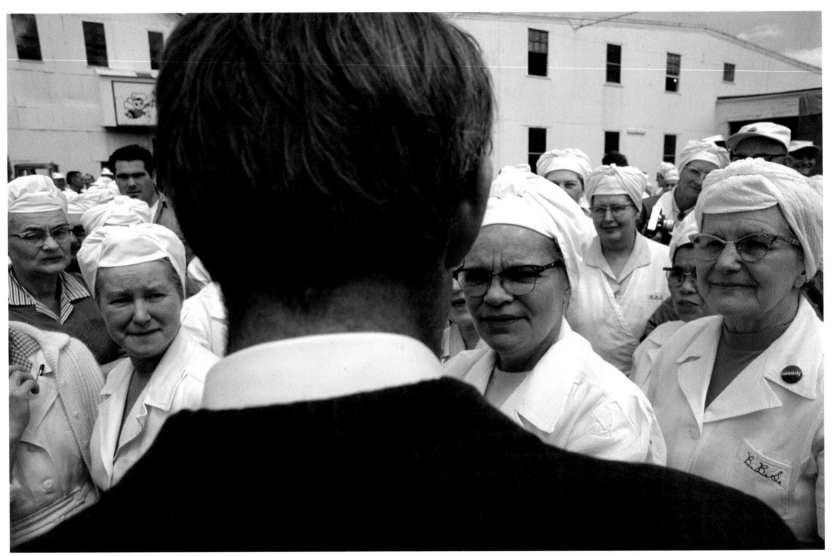

The senator greets workers at a Bumble Bee tuna packing plant in Oregon.

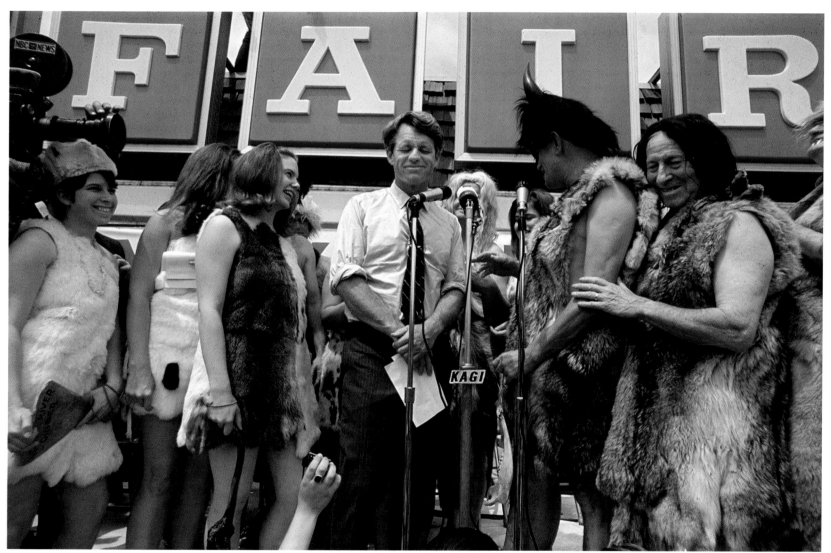

At another stop in Oregon, a group of cavemen and cavewomen surround the candidate.

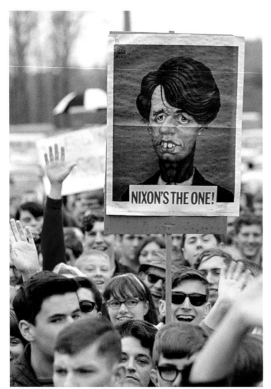

It wasn't all in Bobby's favor. At some stops, Richard Nixon supporters came out to greet him. In another town he topped the list of the "Ten Most Dangerous Men in America."

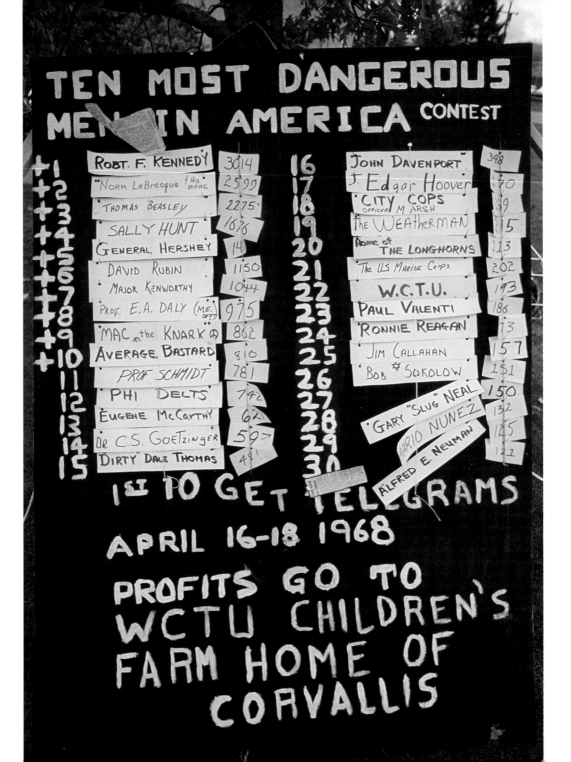

Oregon Democratic voters supported Senator Eugene McCarthy.

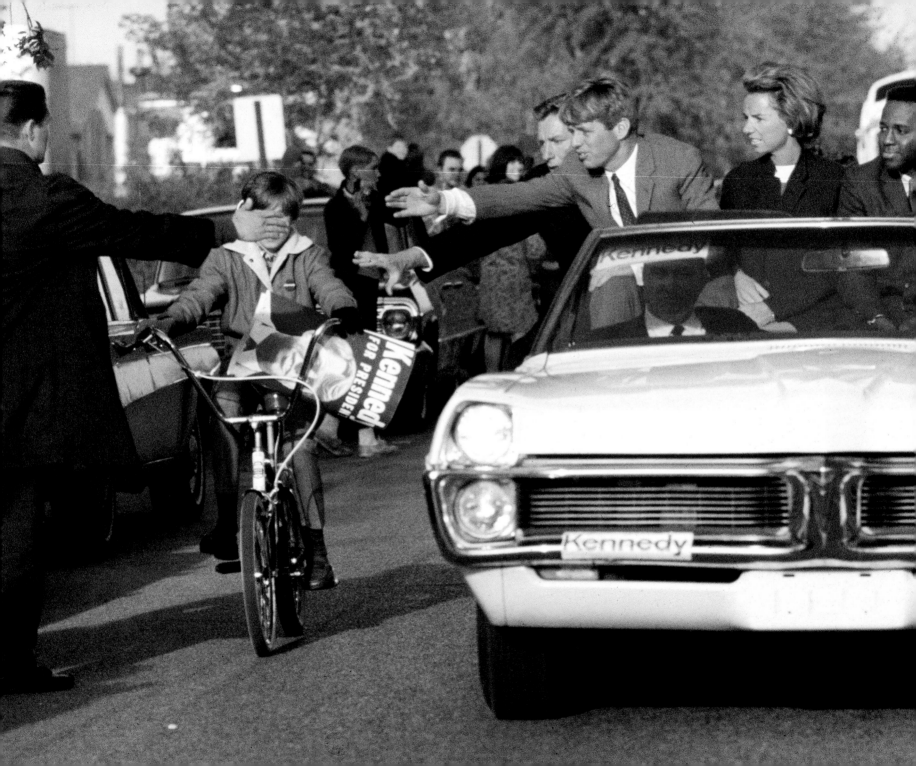

The ultimate trust that Bobby had in his fellow human beings showed itself in the fact that he demanded convertibles.

The campaign convertibles took a beating, and most had to be repainted.

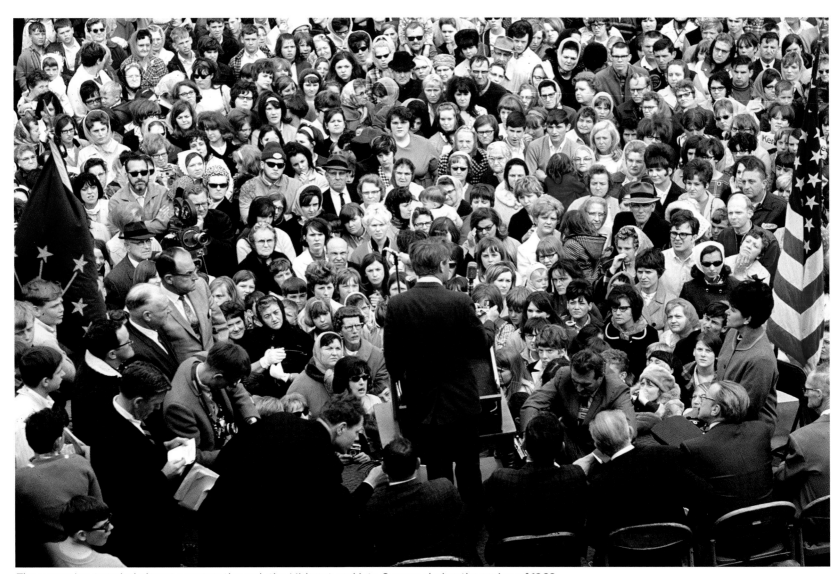

The campaign traveled almost nonstop through the Midwest and into Oregon during the spring of 1968.

Press Secretary Frank Mankiewicz types outside as a group of women try to get a closer look.

Bill Barry takes a needed break in Oregon as the candidate speaks to a crowd.

Bobby never showed any fear, he always had a smile on his face, like he was really enjoying the hell out of the huge crowds.

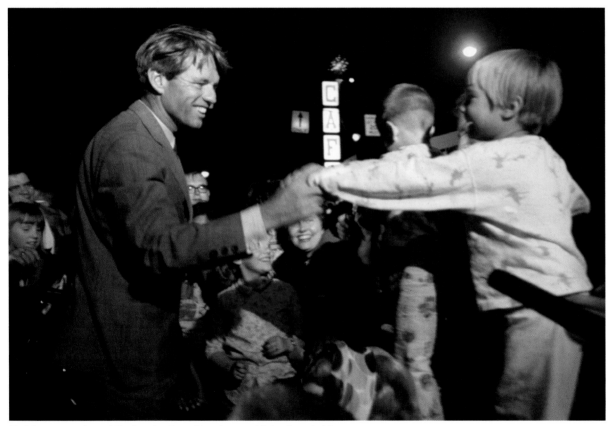

Bobby campaigned tirelessly day after day, and into the night.

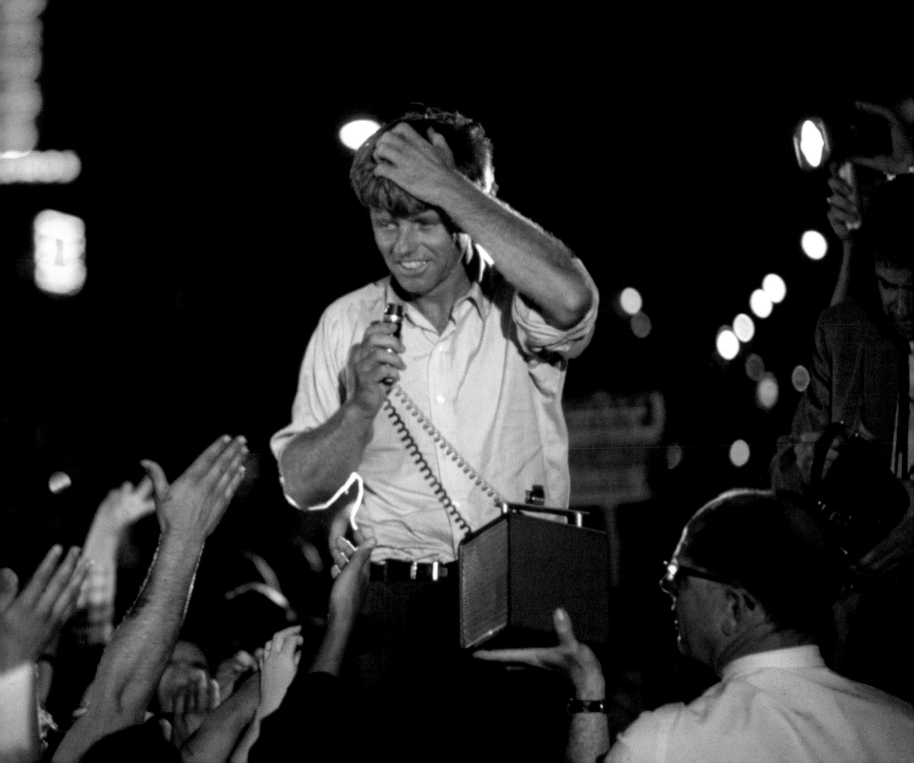

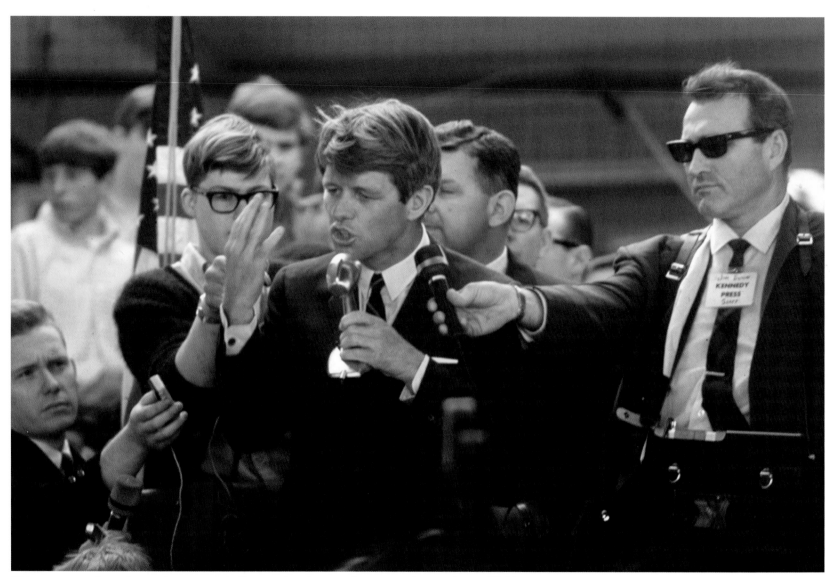

The press was allowed very close access to the senator at every stop, appearing on stage with him.

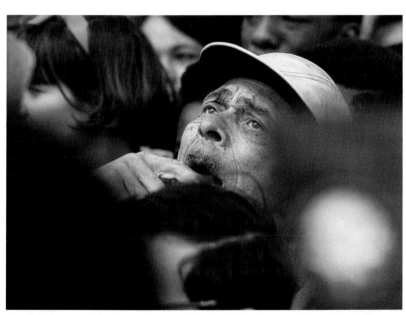

An elderly man tries to get a good look, while a woman is captivated by Bobby.

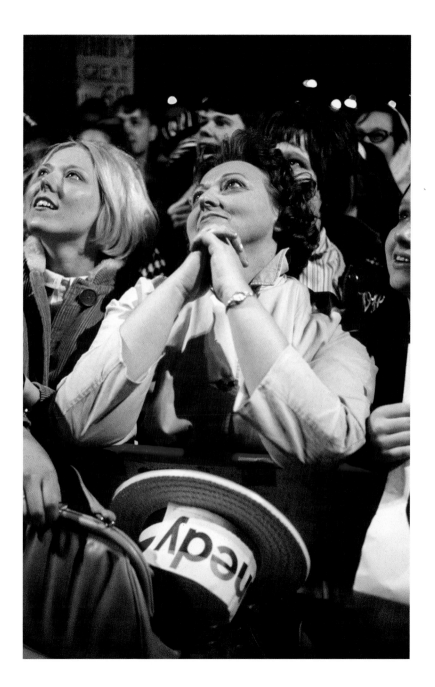

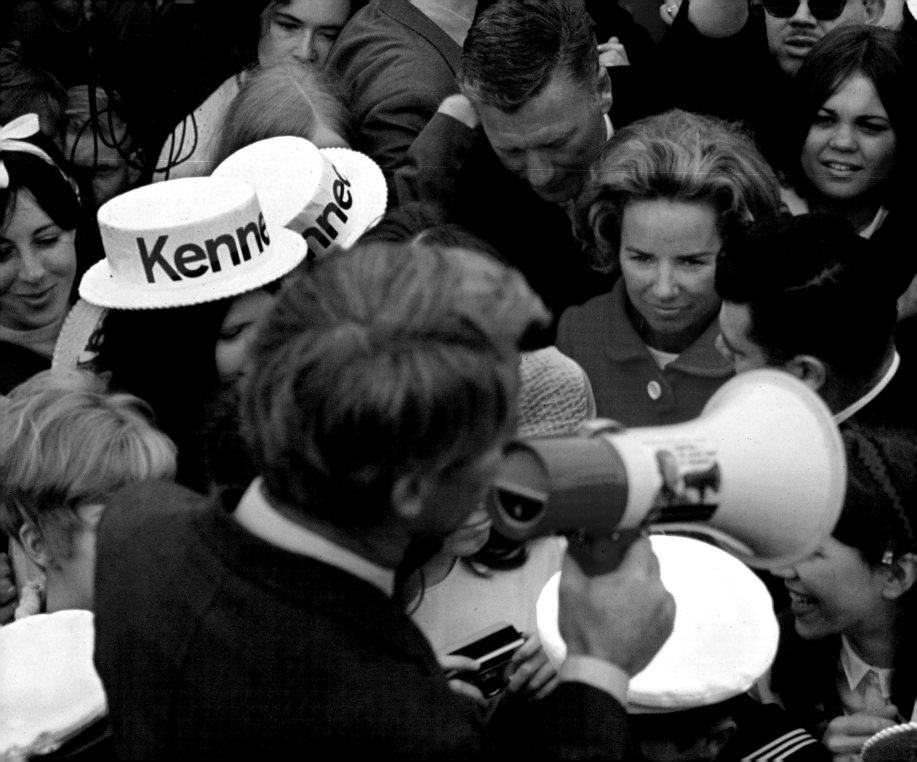

Ethel watches from the crowd as her husband delivers his message.

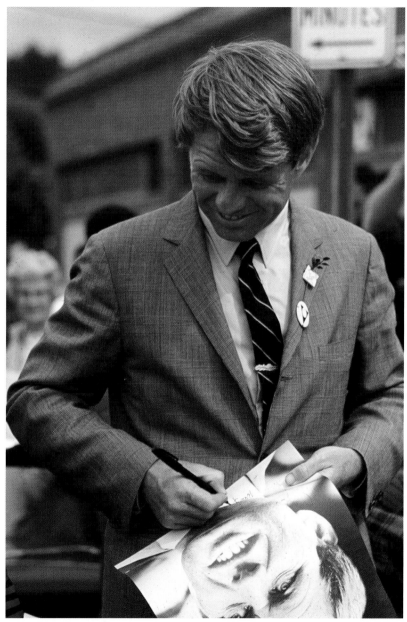

Taking time to sign a campaign poster.

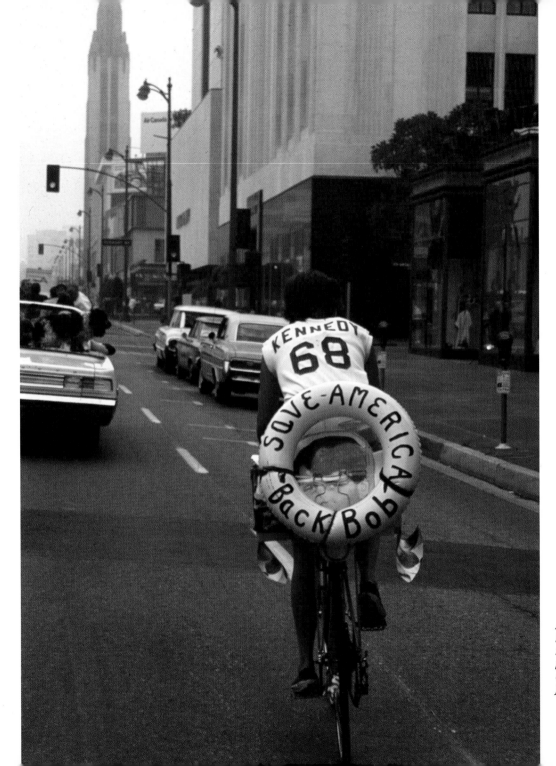

A bike rider shows her support with a message on a life preserver. The candidate's car is just ahead.

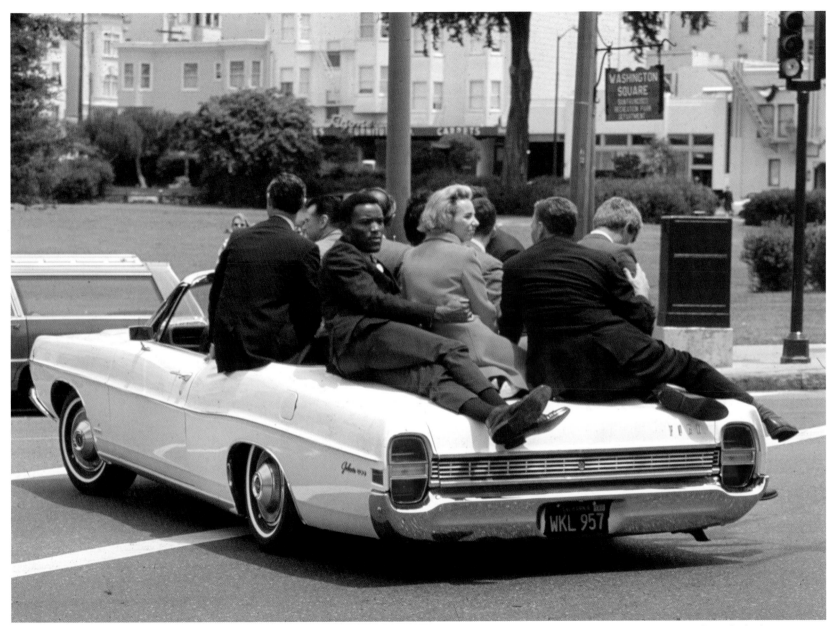

Ethel and Bobby—held by Rafer Johnson (left) and Bill Barry (right)—hit the streets of Los Angeles as the California primary campaign winds down.

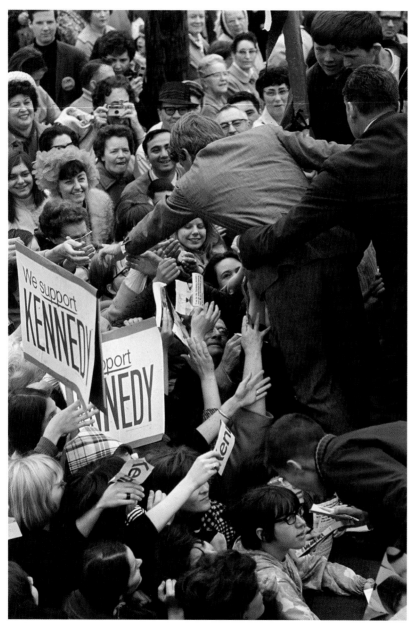

The crowds would sometimes envelop Bobby, and he had to be pulled out.

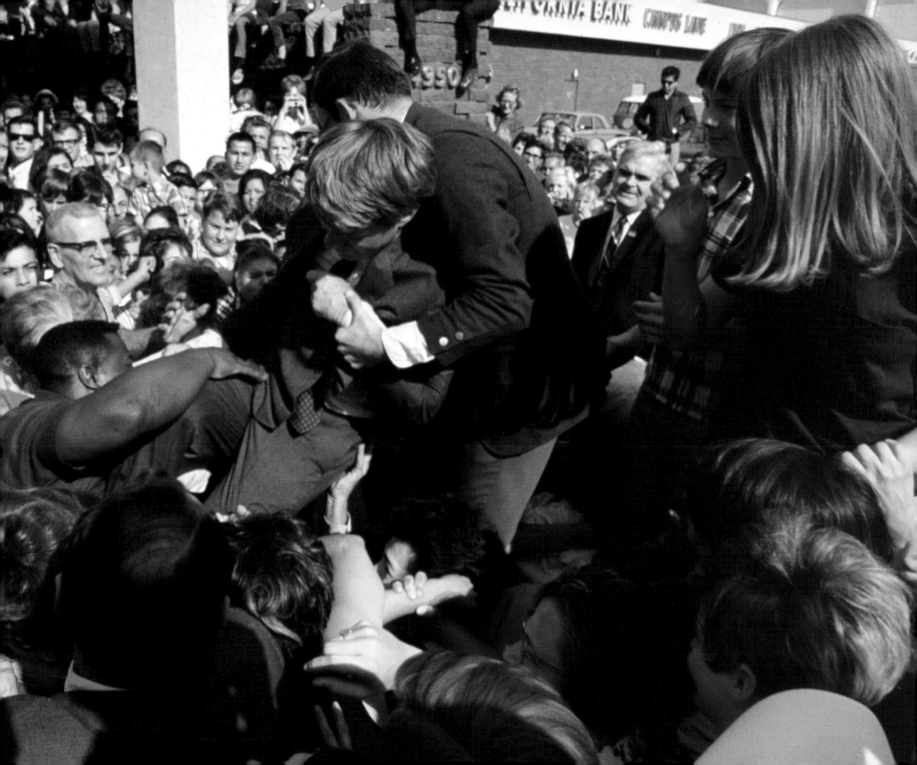

Smaller airports
had few amenities.
Here, a forklift provides
an exit from the plane.

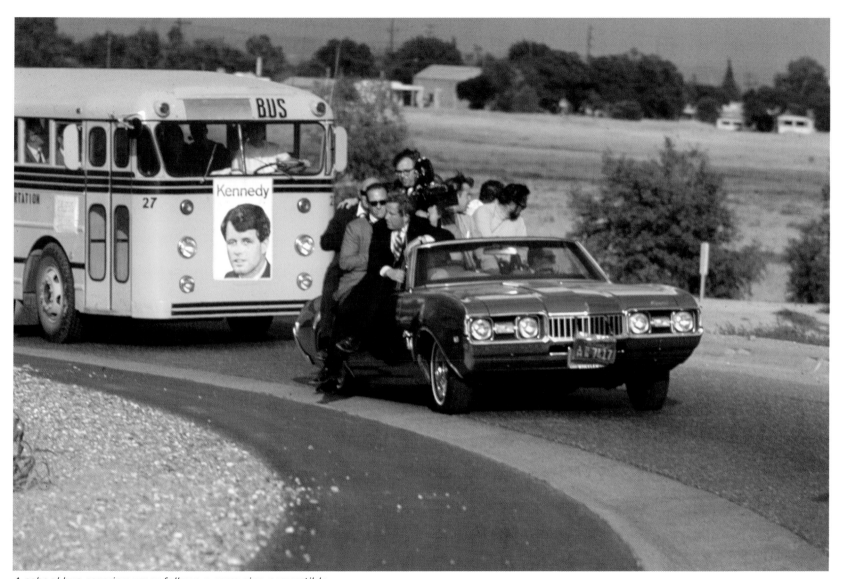

A school bus carrying press follows a campaign convertible.

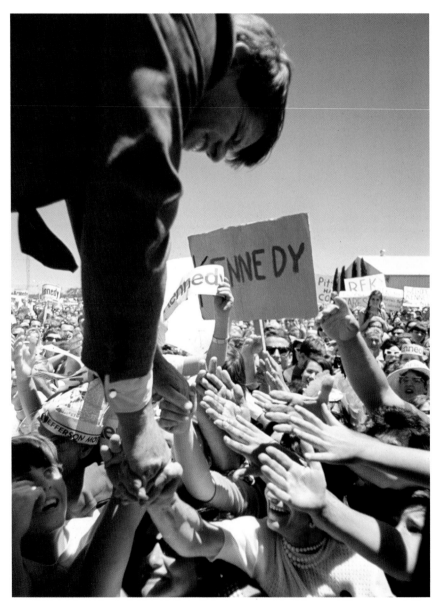

The campaign for the California primary takes the candidate and the press through much of the state. There was a particularly huge turnout for Bobby in Santa Barbara.

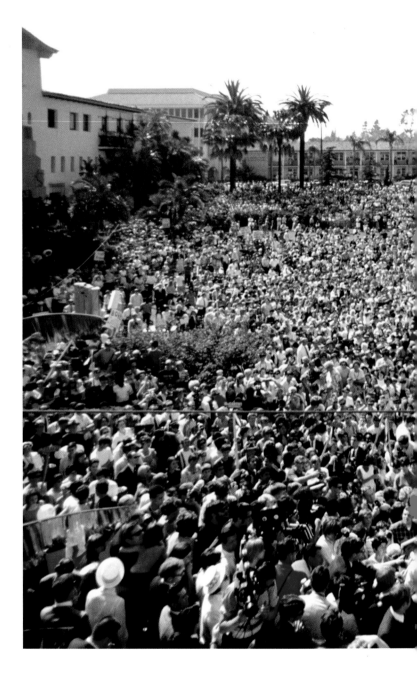

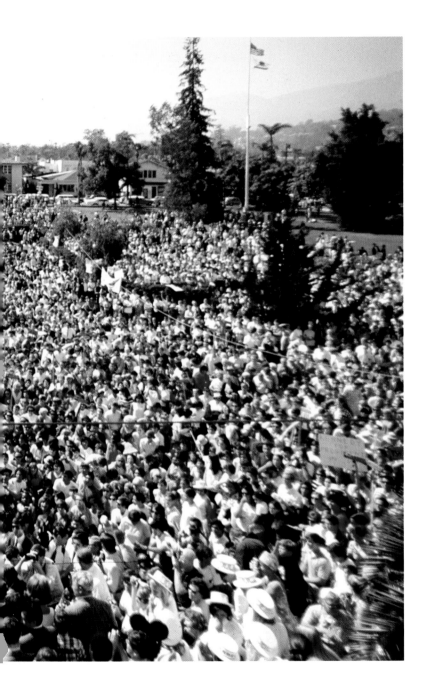
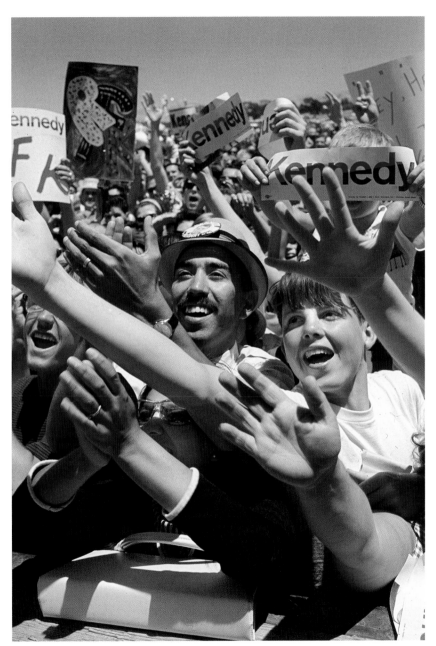

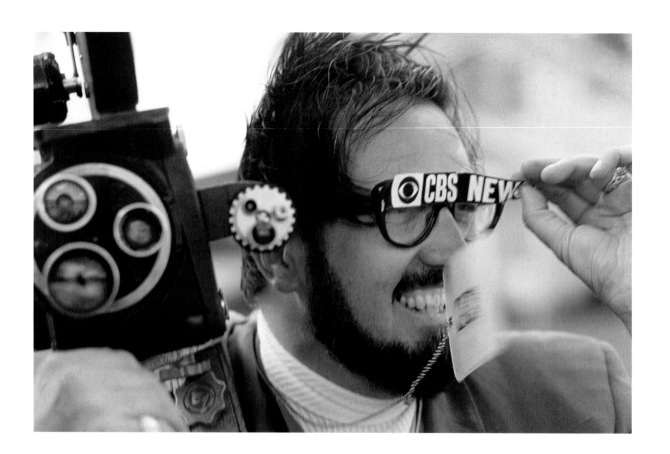

The press and the
candidate ride
through Oregon
on another
convertible.

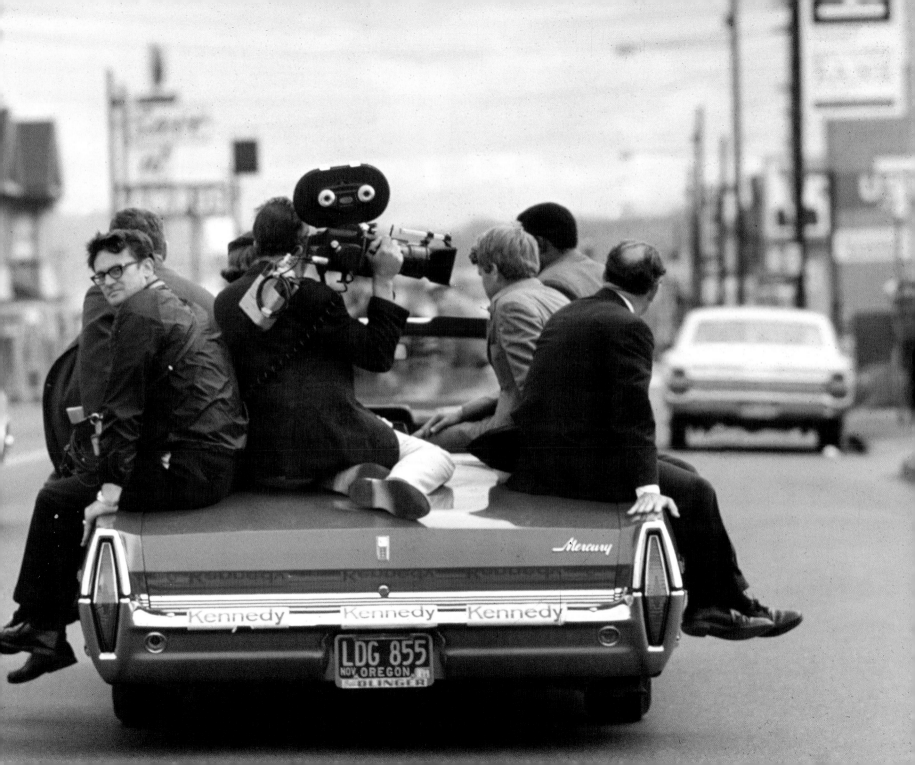

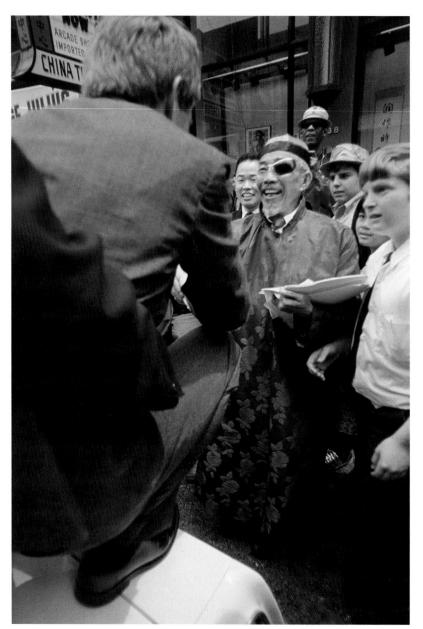

Bobby greets the crowd in San Francisco's Chinatown.

Supporters hold signs while they wait for the candidate to appear.

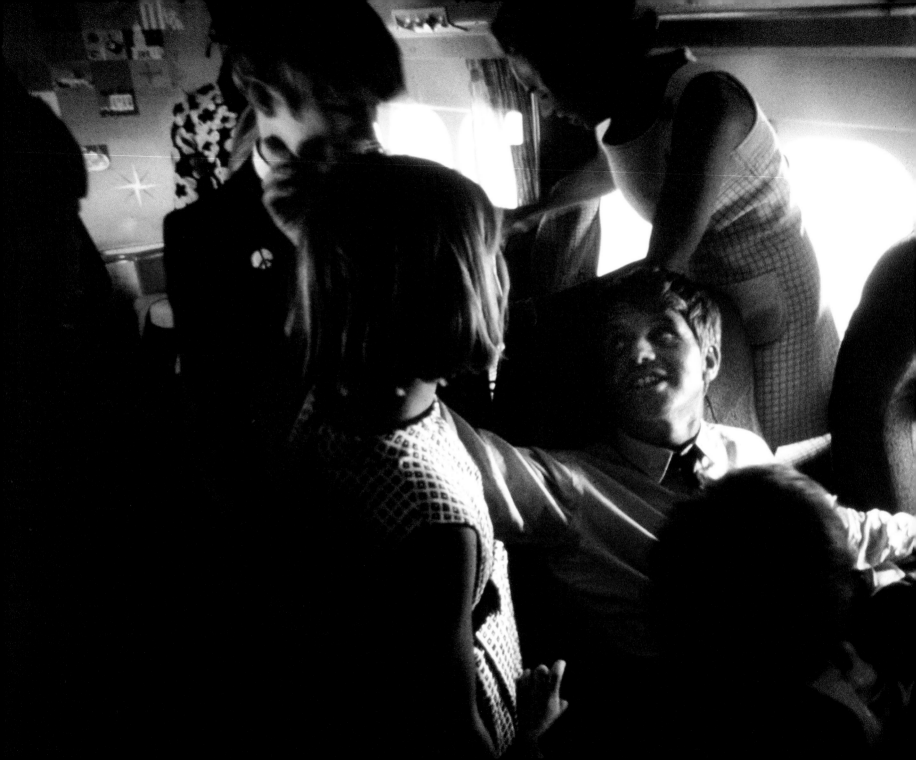

*Bobby and Ethel
spend time with their
children just before the
California primary.*

*Talking with advisers in the Fairmont Hotel in
San Francisco.*

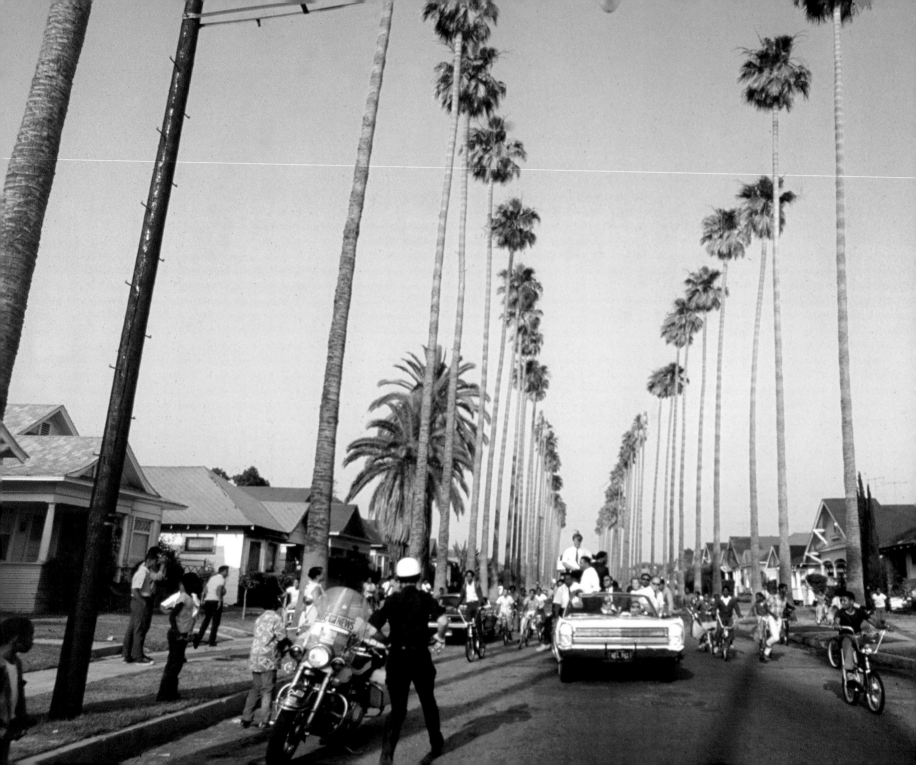

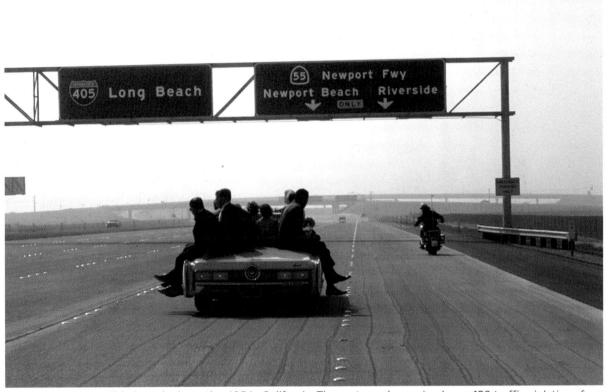

A campaign convertible barrels down the 405 in California. The motorcade received over 150 traffic violations from the LAPD.

The Kennedy campaign drives through a Los Angeles neighborhood on the last day of campaigning before the primary.

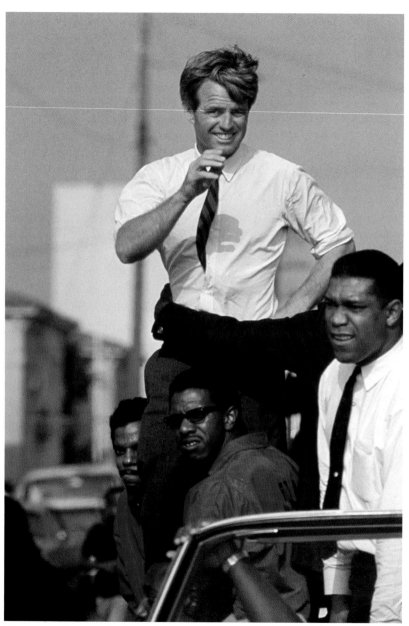

The campaign travels through the Watts section of Los Angeles.

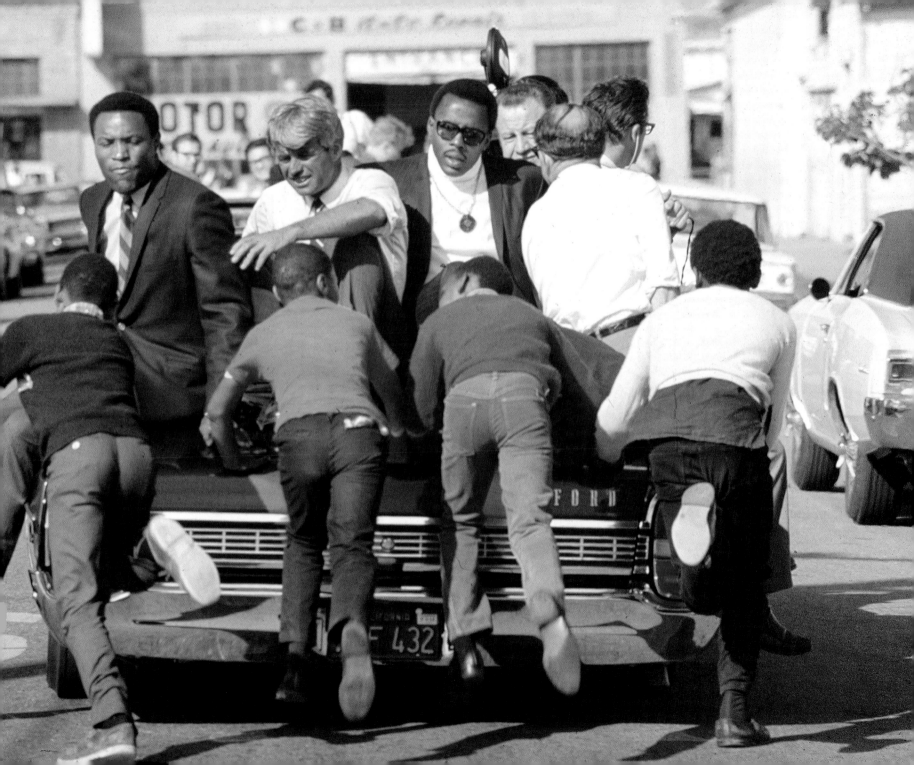

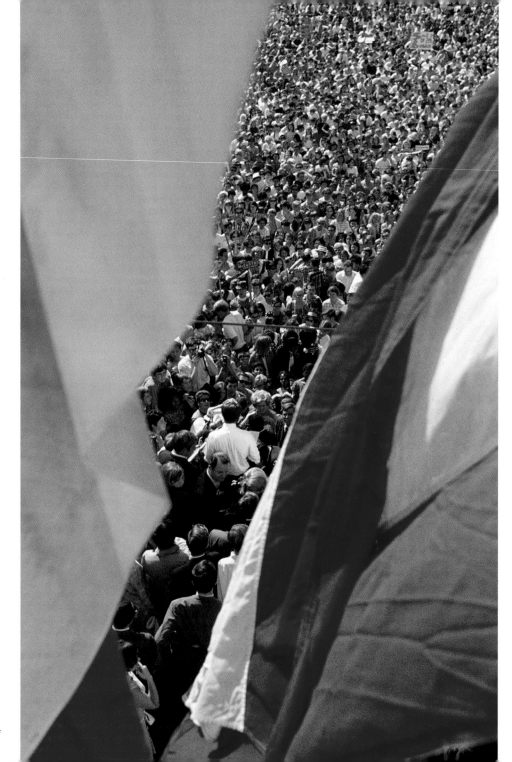

Bobby whistle-stops on the San Joaquin Special through the Central Valley of California, all the way to Sacramento.

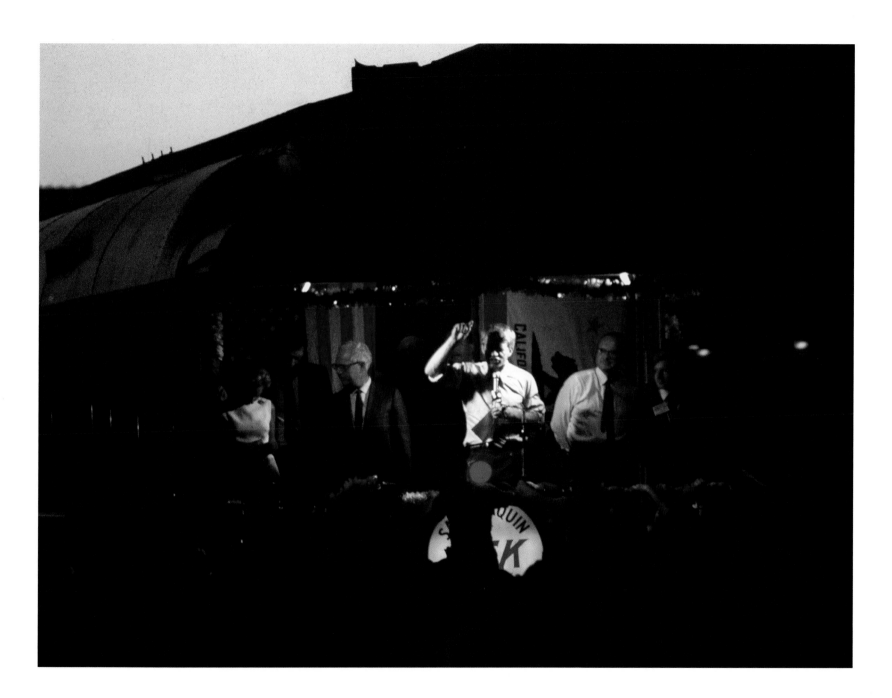

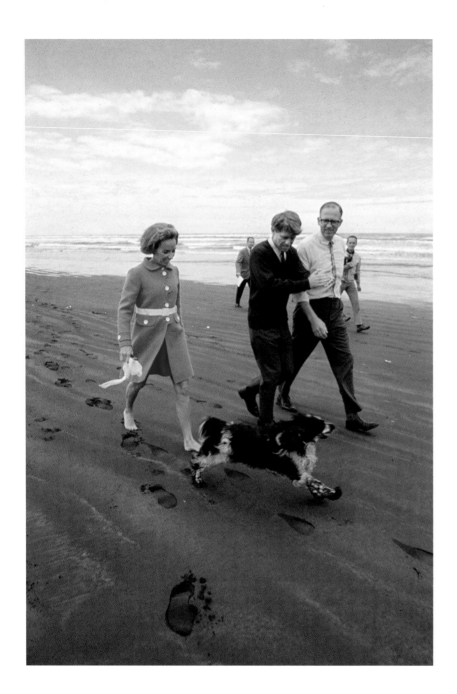

SENATOR
ROBERT F.
KENNEDY

JUNE 14 · 1968 · 35¢

Bobby and Ethel walk on the beach
in Oregon. Bobby wanted to swim,
but did not want the press to
photograph him.

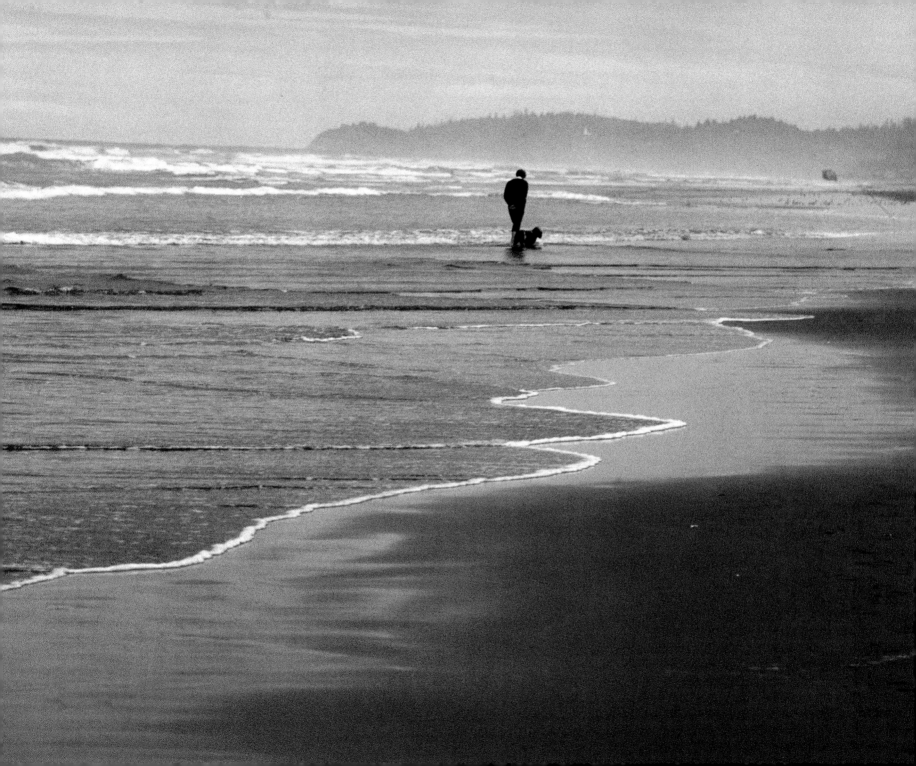

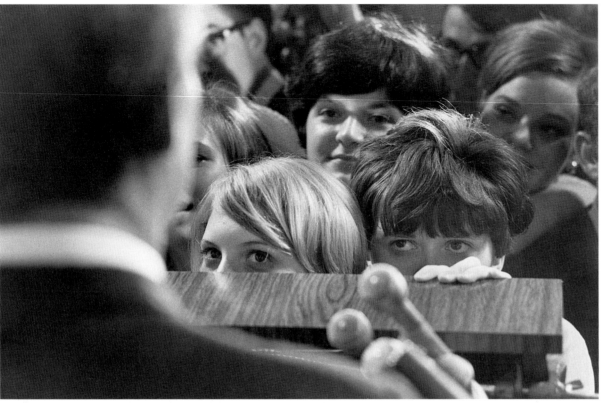

Disappointed campaign workers watch the senator concede defeat in the Oregon primary.

*A dispirited Bobby
and his entourage leave
Oregon the next morning
en route to Los Angeles.*

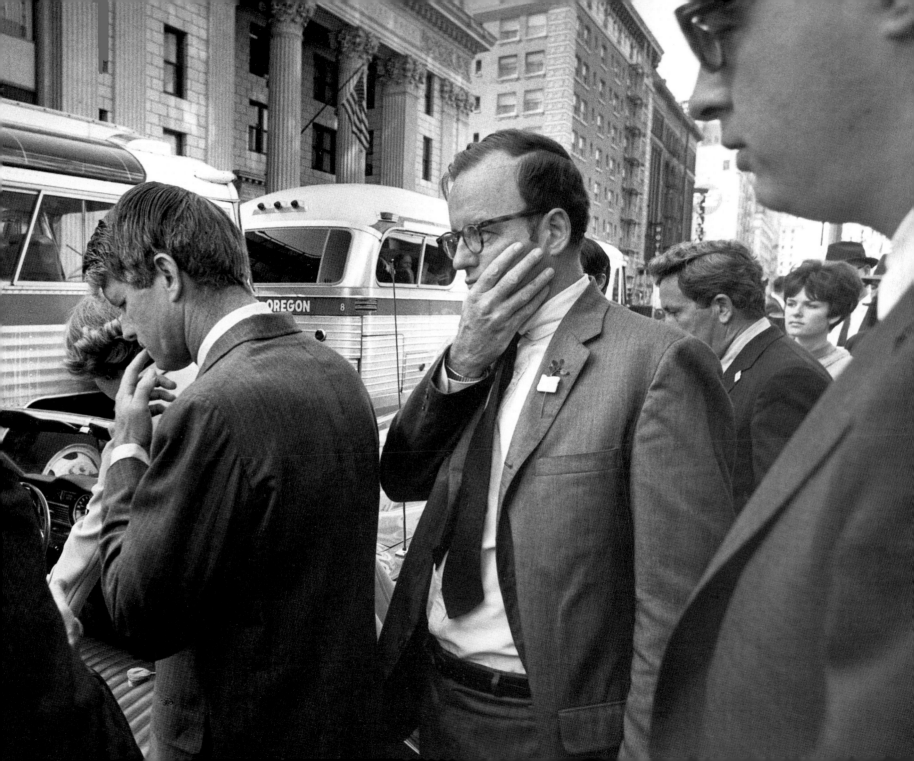

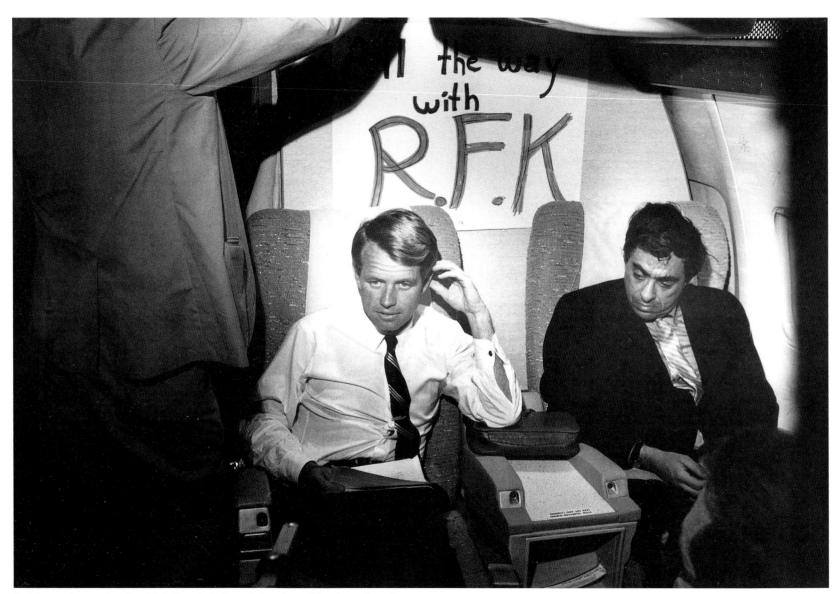

Bobby and speechwriter Dick Goodwin in a state of semishock on the plane.

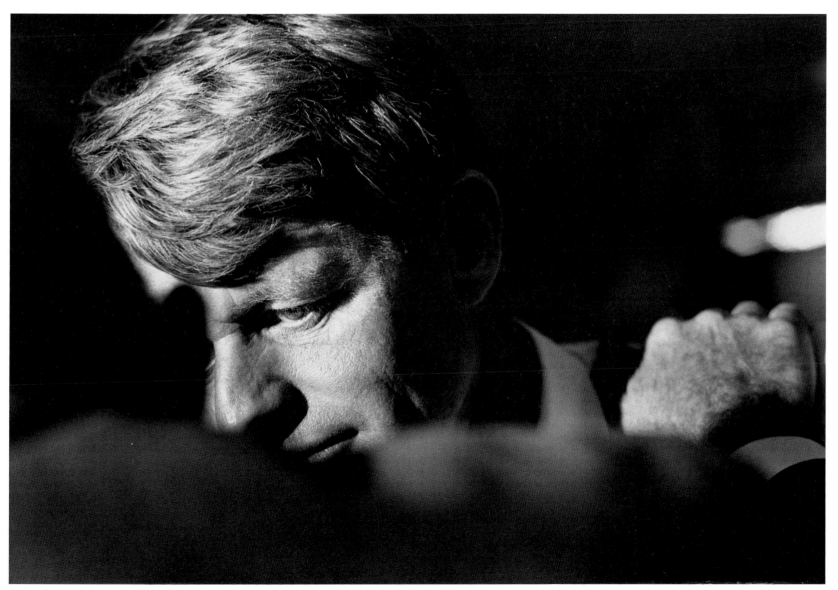

Consoling words from writer Theodore H. White aboard the plane.

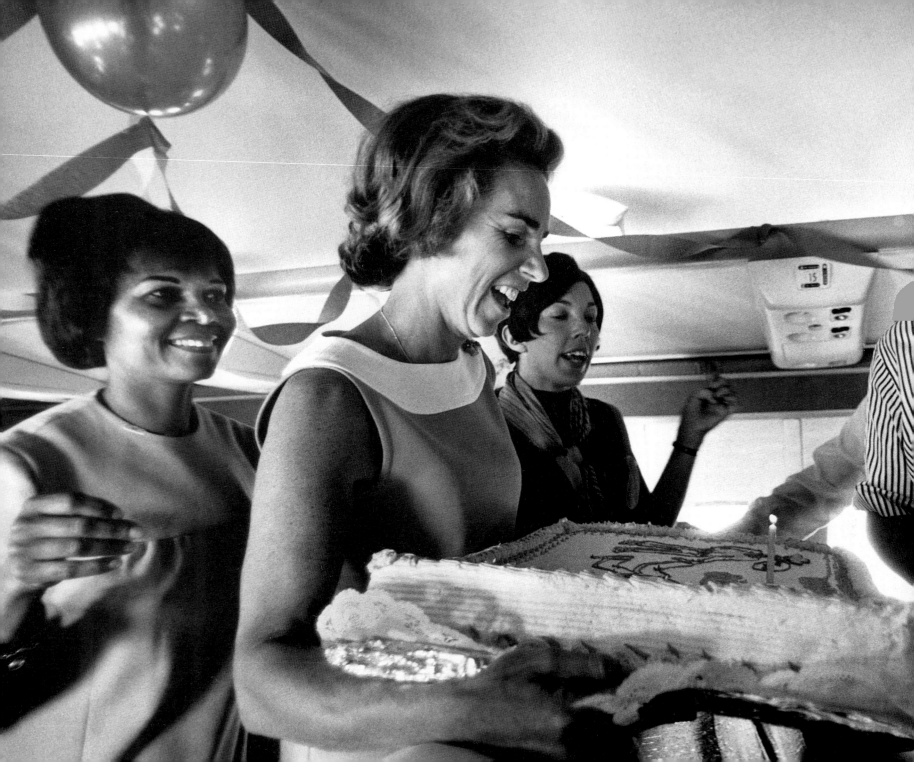

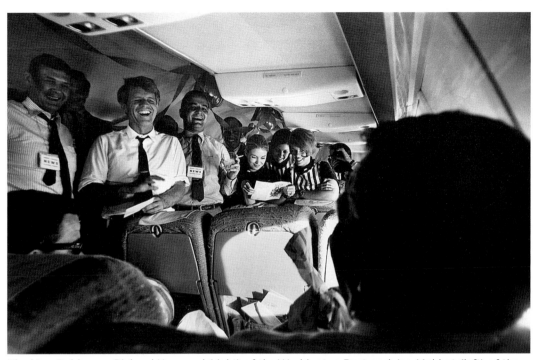

Flanking Bobby are Richard Harwood (right) of the Washington Post *and Joe Mohbat (left) of the* Associated Press.

Bodyguard Bill Barry's birthday provides needed relief after the Oregon loss. On the flight back to California, Ethel and Dick Tuck bring the cake down the aisle of the plane.

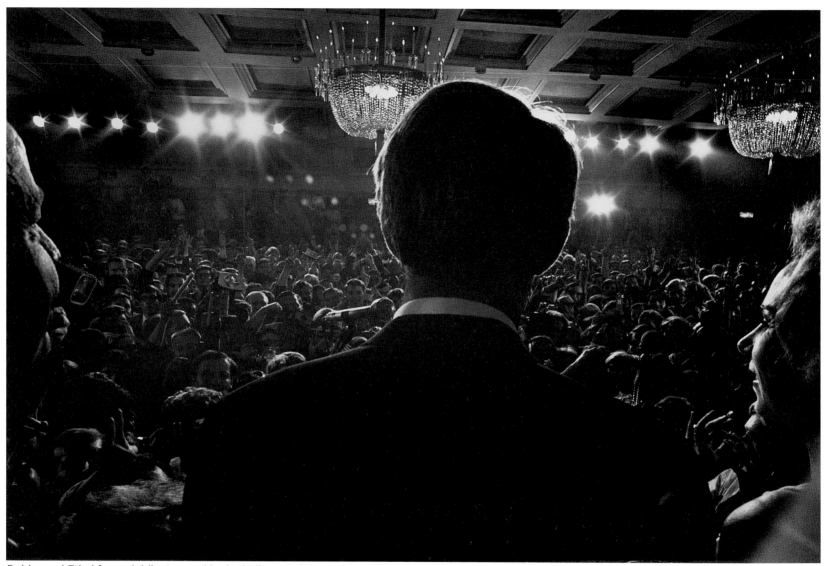

Bobby and Ethel face a jubilant crowd in the ballroom of the Ambassador Hotel after his victory in the California primary.

ON ELECTION DAY THERE WAS NO CAMPAIGNING TO BE DONE. I DON'T KNOW WHETHER IT WAS by law or custom, but the senator was not around the hotel. He had gone out to visit with friends at the beach, and we didn't bug him about going. We knew he needed a day off. By this time, he was beaten up by the campaign, and he looked it.

I called Pollard just to check in and see what they wanted me to do because the magazine was on deadline at this point, and I had to formulate a plan to get the film to New York City.

Pollard said, "This bunch of Republicans here have come to believe that if Bobby wins California he will be the next president. We are convinced of it. Nixon could never touch him in an election. We want you to stick as closely as possible to him tonight. Just stay with him."

Eight Shots Fired

AT THE AMBASSADOR HOTEL, A DREAM DENIED

That meant I had to shoot black-and-white film so that my photographs would make *Life*'s closing deadline. Color film presented more problems than they had time to deal with.

That evening, Jimmy Wilson, the CBS cameraman who lived almost next door to the senator in Virginia, told me that he was quitting because CBS felt he was getting too close to the candidate, and he was not objective anymore. They were going to move him to somebody else's campaign.

Wilson said, "I want to do the same thing that you do. I want to be as close as possible."

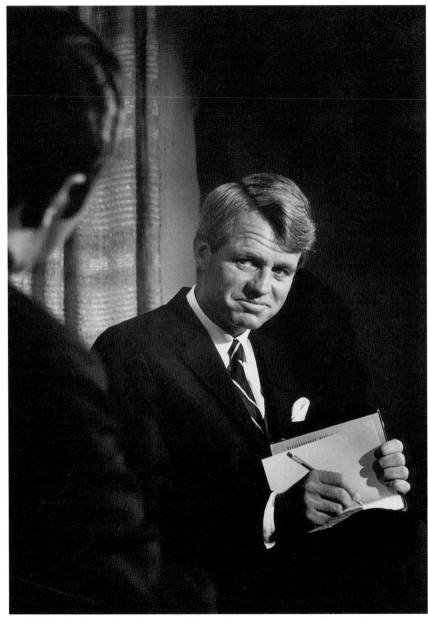

Signing an autograph for TV correspondent Sander Vanocur.

I said, "Well, let's ask him together," and we did. Bobby called Bill Barry over and told him, "These guys are sticking right with you tonight. They are in my immediate party."

We felt this would be the most politically significant night of the campaign. He had already won South Dakota, and a California victory would send his campaign into orbit.

Early that evening in the Kennedy suite, looking at a TV picture of an incredible mob scene in the ballroom of the Ambassador Hotel, I decided to cut my equipment to a minimum, as I knew I'd never be able to get a camera bag through that crowd. I pared down to two cameras, and stuck an extra lens and four rolls of film in my pockets. I knew that we were coming back to the suite afterward, and I would pick up my camera bag after the speech.

Upstairs in Bobby's suite earlier in the evening, friends and family watch election returns on TV.

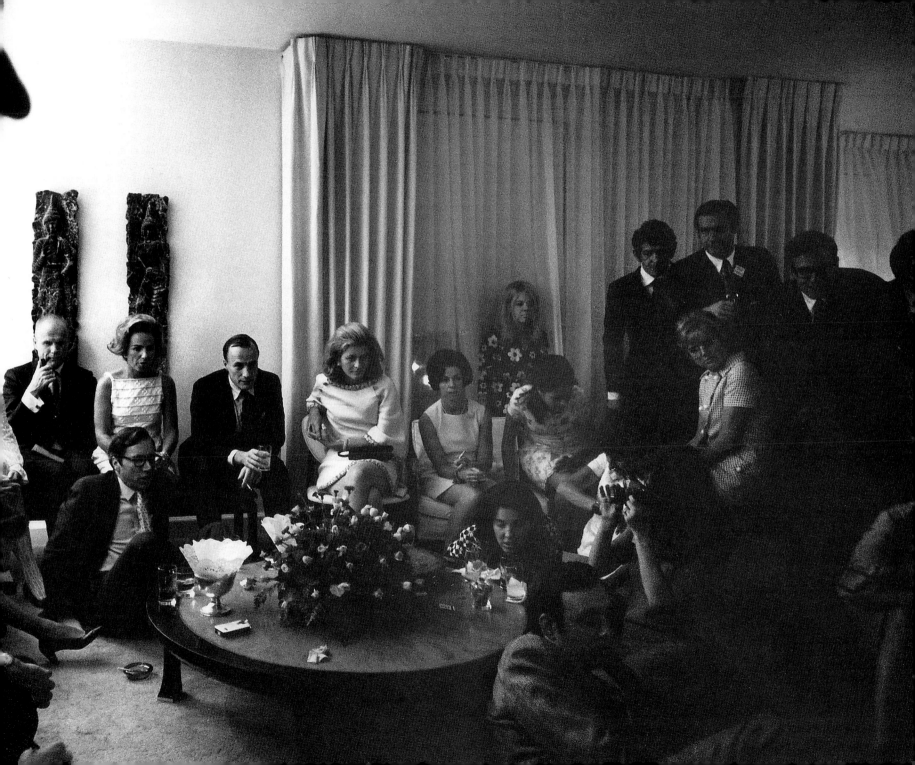

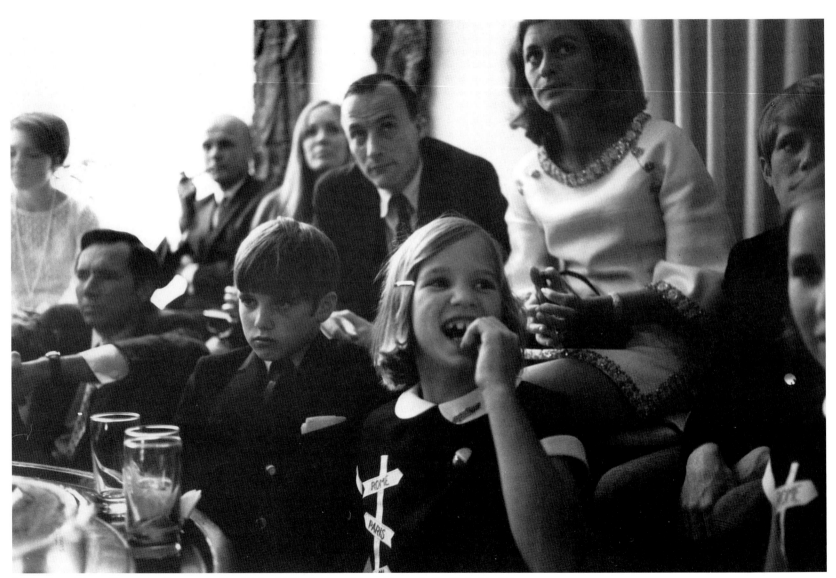

Michael and Kerry Kennedy (foreground) with David Hackett and Jean Kennedy Smith behind them.

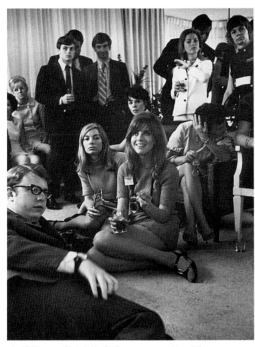

Jeff Greenfield (left foreground) with reporters and campaign staff in the Kennedy suite at the Ambassador Hotel.

Frank Mankiewicz and Pierre Salinger listen to election returns.

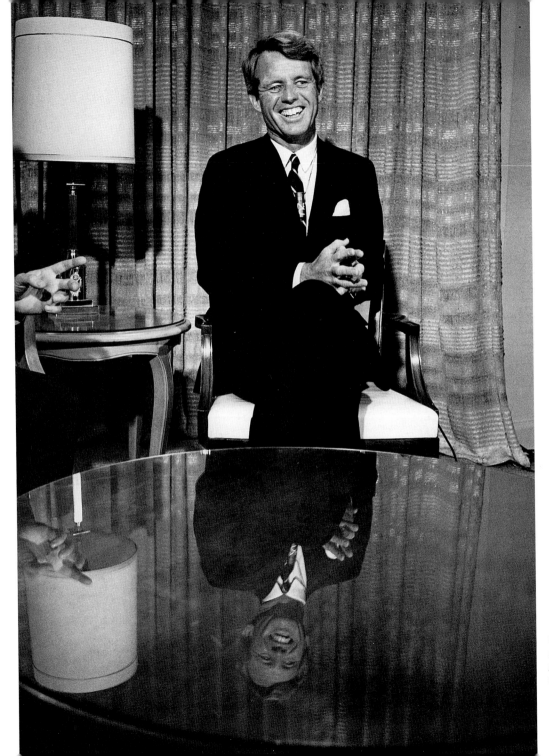

With two primary victories won, Bobby gives a few interviews before heading toward the ballroom.

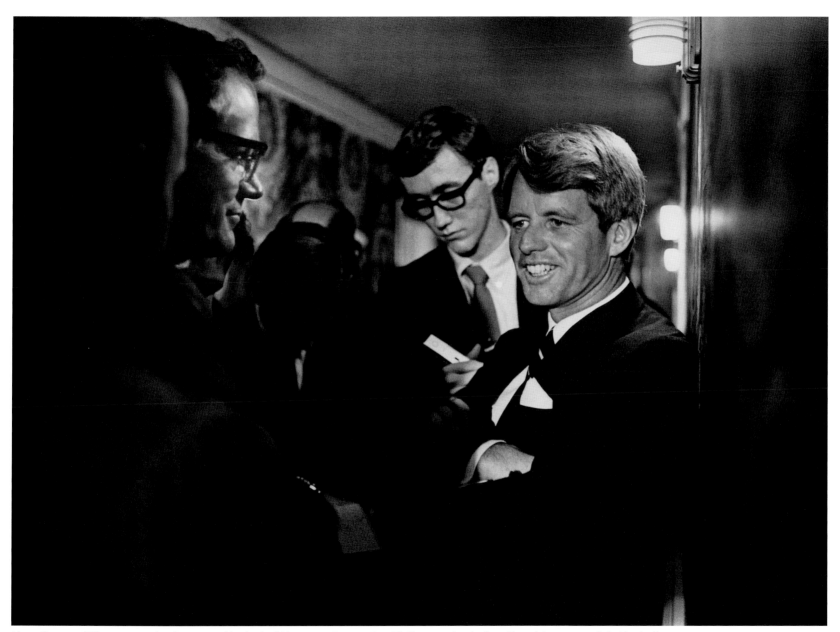

Hays Gorey of Time *magazine is among the last of the press to speak with the senator before the victory speech in the ballroom.*

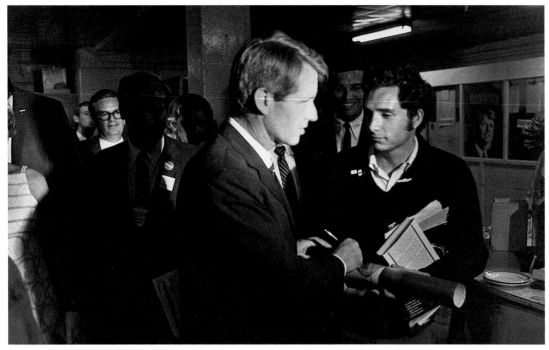

On the way through the kitchen to the ballroom, Bobby signs a rolled-up poster for a campaign volunteer.

That night, wherever the senator went, we were right in front of him in our usual wedge position. The primary election looked like a sure thing for Kennedy around 10:30 P.M. Then it was time to go face the mobs and accept victory. The senator, a small group of friends, Jimmy, his crew, and I all went down a back elevator through the kitchen, where Kennedy shook hands with a cook before going out into the ballroom. The crowd was even larger than we had anticipated—if we had been in the crowd that night, and not on the stage, we would not have been able to move, it was that tight.

Shaking the hand of a shy kitchen helper.

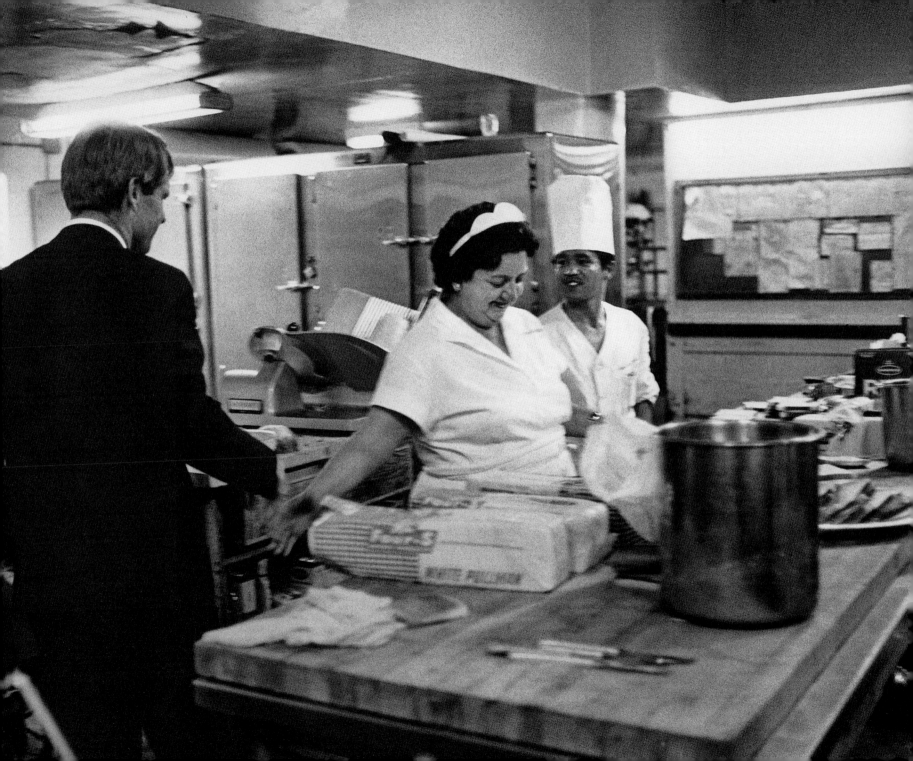

If we had been in the crowd that night, and not on the stage, we would not have been able to move, it was that tight.

We had to fight to get the senator onto the stage. I remember having an elbow-knocking session with Jesse Unruh, a state campaign coordinator and the Speaker of the California House of Representatives. That scene is preserved on film.

As the senator neared the end of his speech, and with a nod from Bill Barry, Jimmy and I headed off the stage toward a different exit. It was customary to never exit from the same place that you had entered, for security reasons. Never retrace your path.

We formed a wedge to get the senator out of the ballroom. Bill Barry had set the direction, toward a side door away from the kitchen, and said, "This way, senator," pointing toward an exit across the ballroom.

Kennedy replied, "No, Bill, I'm going that way," and he pointed toward the kitchen. Barry reiterated firmly, but Bobby said, "No Bill," turned to his right, and walked quickly into the kitchen entrance. This was the same entrance he had just come from. (He wanted to invite the press to a party at The Factory nightclub, and this was the quickest way to the press room.) We quickly reversed our direction, but by then others had gotten between the senator and his wedge.

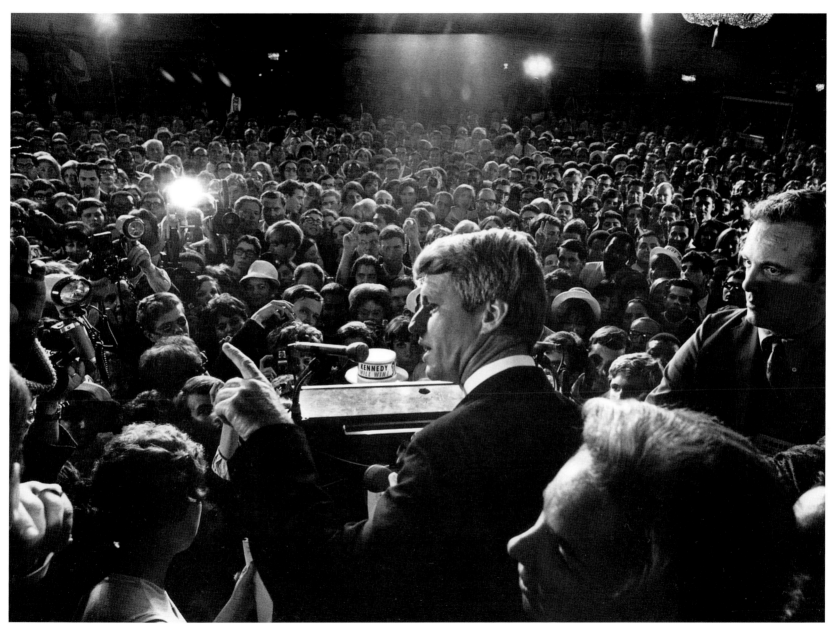

The victory speech in the ballroom. Bobby ended with the words, ". . . and now it's on to Chicago."

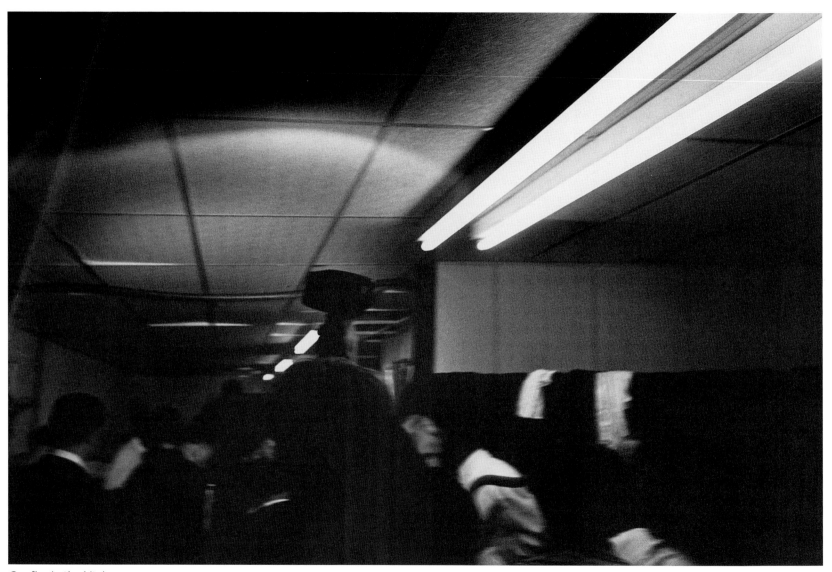

Gunfire in the kitchen.

The sound I will never forget was *bang, bang*, and then *bang, bang, bang, bang, bang, bang*. It was clearly eight shots. There were people going down in front of me. My camera accidentally went off.

This left us behind him, unable to protect him from the crowd, which surged in front of us almost immediately. A number of people were between us and the senator, and we scrambled to catch him. He was about twelve feet ahead, going through the swinging doors, when I heard what sounded like firecrackers. Jimmy froze. I grabbed him by the arm and pushed him forward, and said, "Jimmy, .25 caliber." (I was slightly off: they were .22 caliber). People ahead were falling or scrambling to get out of the way.

The sound I will never forget was *bang, bang*, and then *bang, bang, bang, bang, bang, bang*. It was clearly eight shots. There were people going down in front of me. My camera accidentally went off.

I kept shoving Jimmy forward into the darkness of the kitchen.

I first came upon Paul Schrade on the floor, bleeding from a head wound. The person taking care of Schrade was looking over his shoulder to the left. I photographed Schrade quickly, thinking that it was Bill Barry because he resembled him just a bit. It was sheer bedlam in the kitchen, but I was able to move about twelve feet forward.

We found the senator—fallen—bleeding—being held by a hotel busboy who was the last to shake his hand. Bobby's eyes were open and he was trying to speak. He was clenching and unclenching his right fist. In the corner, I could see Bill Barry, Rafer Johnson, Rosey Grier, and George Plimpton all piled up on somebody—I

assumed the gunman. Rosey was yelling, "Don't kill him. Don't kill him."

Two photographers ran past me, out of the room. One, a woman I knew from the campaign plane, screamed at me, "You can have it, you vultures!" I started to choke up, and froze.

Jimmy was crying and in shock, unable to continue filming. His soundman grabbed Jimmy's hand and held it on the trigger of the camera, and yelled at him, "Shoot, Jimmy, shoot." His lighting man was holding him up on the other side and had his light over his head. I could see the senator's face clearly, and the busboy, Juan Romero, holding his head. Right about then instinct took over. I remembered saying to myself as soon as I saw the senator on the floor, "OK

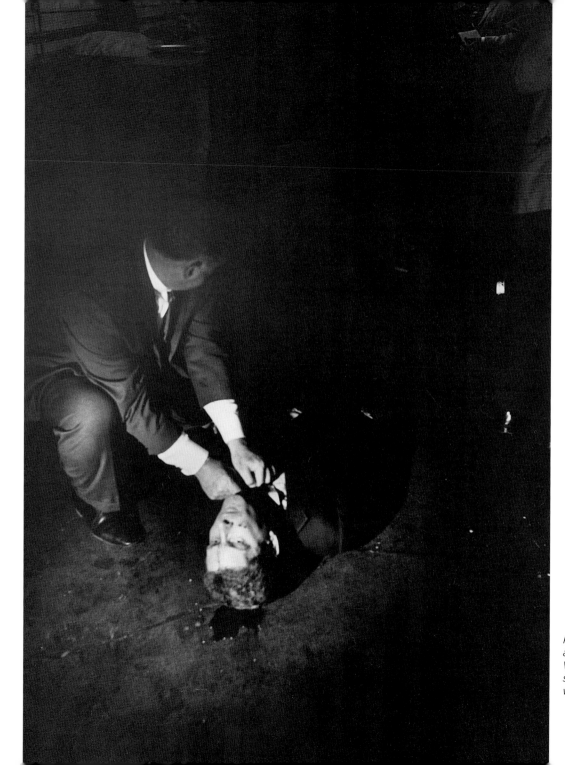

*Paul Schrade,
a United Auto
Workers official,
suffered a bullet
wound to the head.*

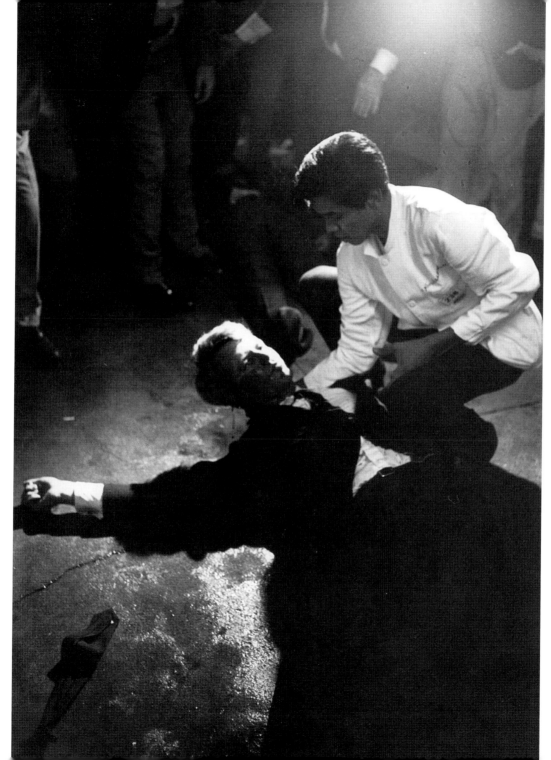

A few feet from Schrade lies Bobby, bleeding from a head wound. Juan Romero, a busboy who had been shaking his hand when Sirhan Sirhan fired the gun, attempts to raise the senator's head.

The entire contact sheet that recorded the scene in the ballroom just before the shooting, and right after in the kitchen.

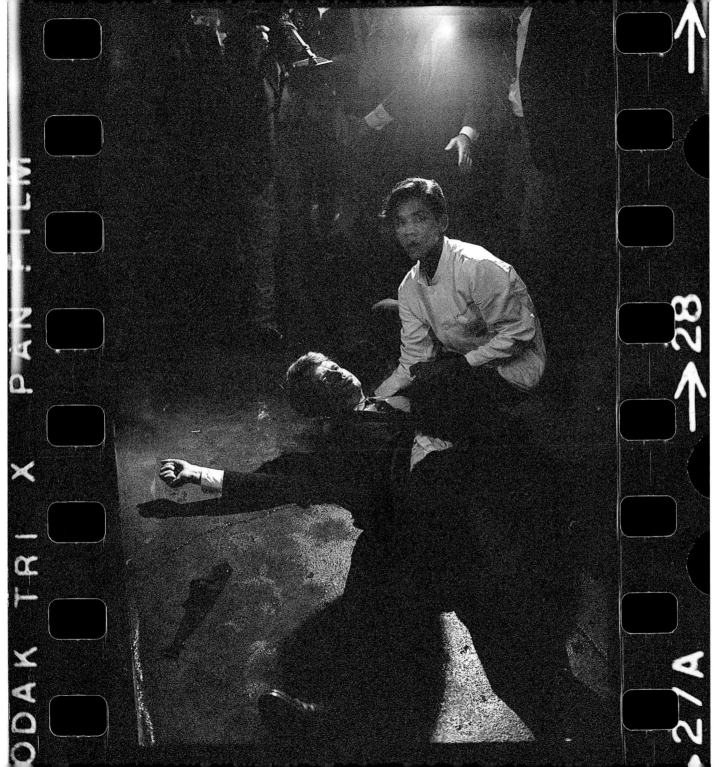

Busboy Juan Romero looks up in anguish.

141

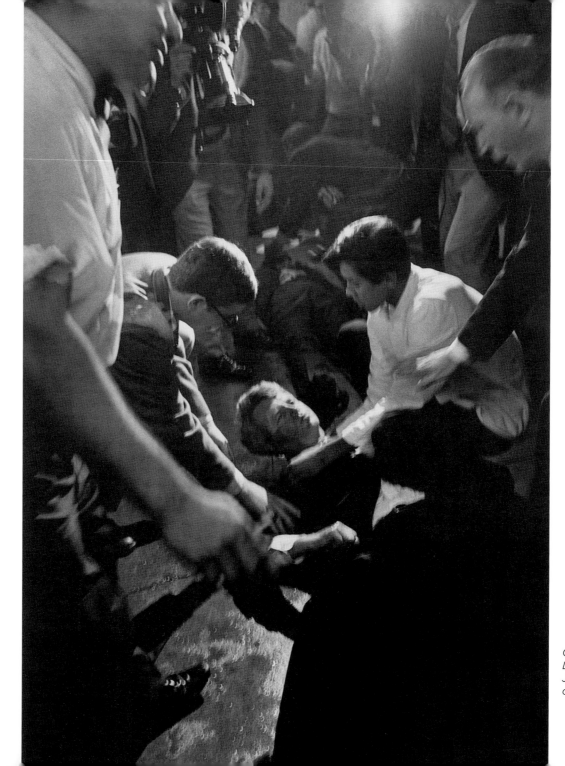

Others rush in to help.
Distraught cameraman
Jim Wilson is at the top
of the picture in tears.

142

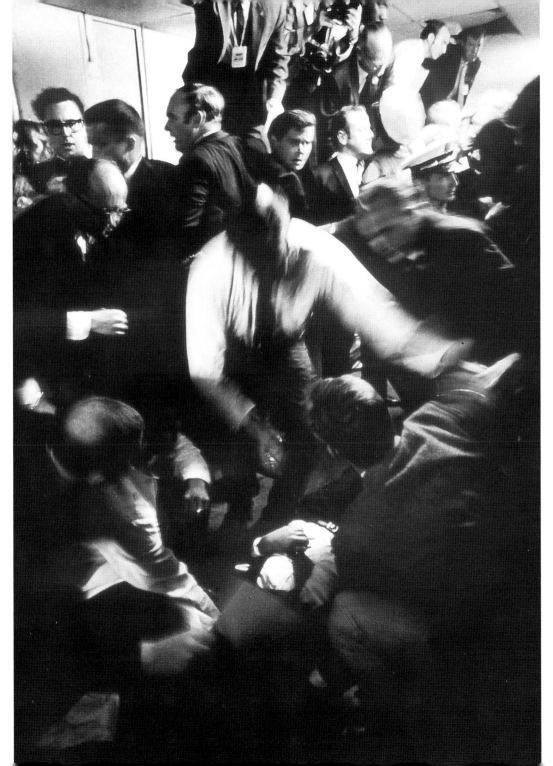

The scene turns to bedlam.

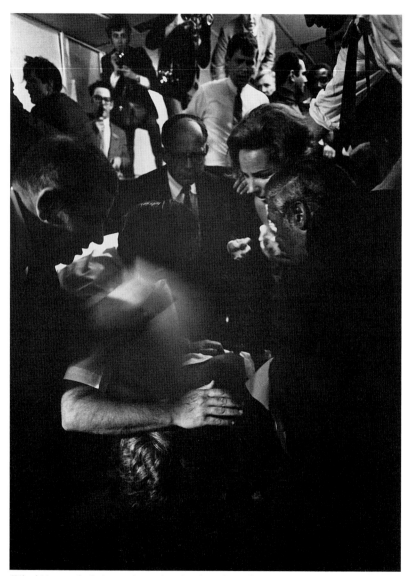

Ethel Kennedy is brought to her husband's side.

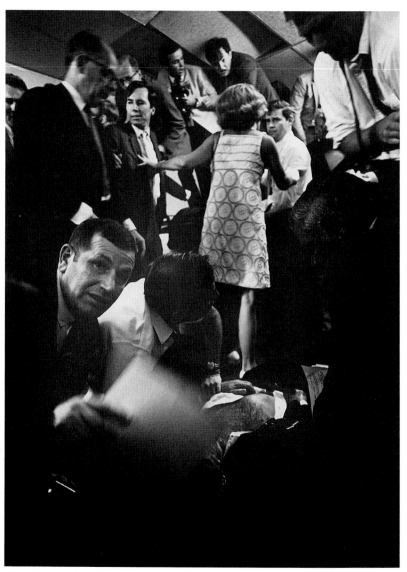

She tries to clear the room.

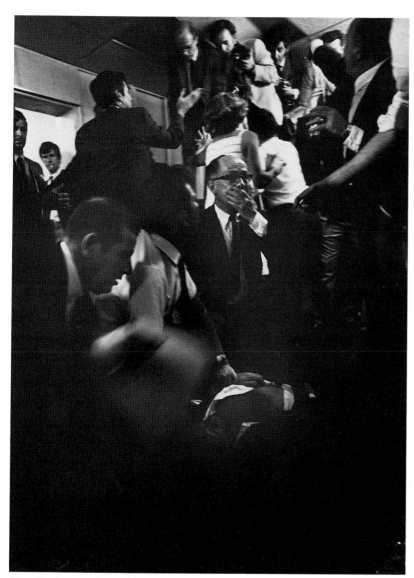

Horrified campaign adviser Fred Dutton.

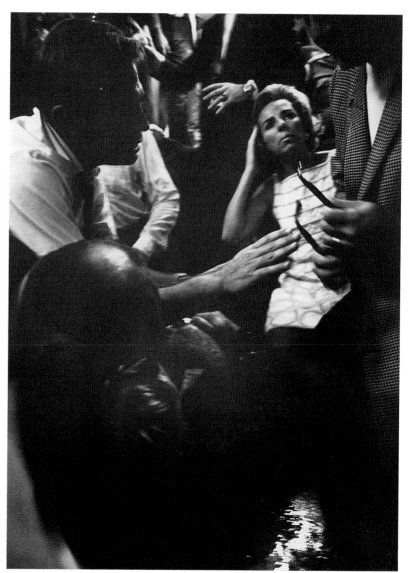

Bill Barry tries to remove a local reporter.

At this point, I feel it is time for me to back away. I move back and put my arms out to restrain the crowd. Once or twice, I reach down to trigger the camera hanging from my neck.

you've had ten year's training for a moment like this ... now go to work." Time slowed almost to a standstill. It was as though nobody else was in the room but the senator, the busboy, and myself. I went to Kennedy's feet because the lighting from Jimmy's movie light was better. I had no film to waste, and bracketed as I made two frames with my camera. The busboy looked up, begging for someone to help as I shot the third frame. By the fourth frame, people started crowding in. Jimmy had run out of film and was weeping over the senator. He shut down his light, took his Arriflex camera off his shoulder, and slammed it into the ground. He went furiously into the crowd to keep them back and collapsed shortly after that.

Ethel Kennedy was brought into the room. She wanted all photographers removed. Very deliberately, I helped hold back the crowd. At the

same time, however, and with a wide-angle lens on my camera, I began taking pictures from the hip. Nobody noticed me.

Those twenty-one minutes in that kitchen seemed like an eternity, but I had shot less than two rolls of film.

After the emergency medical technicians took Bobby out to the ambulance, I grabbed the rest of Jimmy's crew, and we happened upon an off-duty CBS cameraman who had extra film. We picked up Jimmy's camera, gave it to this other cameraman, and told him that we were going to the hospital.

Once outside the hotel, there were no cabs anywhere. We found a little old lady who had just gotten one. We asked her if we could share her cab, and she told us, "Take the cab, it's yours."

Outside Good Samaritan Hospital, where Bobby had been moved after being taken first

to another LA hospital, the street was solid with people, mainly press. I took a bow tie that I had in my pocket, put it on, hid the cameras under my jacket, took my press credentials off, and walked like I was in a hurry, right through the front door. No one stopped me.

Inside the hospital, I found out what floor the senator was on, took the elevator up, and found a hallway loaded with people. The first person that I recognized was John Glenn. And, finally, there were police, who had been absent from the Ambassador kitchen.

Then, I saw Bill Barry, Fred Dutton, Frank Mankiewicz, and George Plimpton. I knew that I was in the right place, with no other photographers around. I started taking pictures, careful to be quiet, and I shot until I was almost out of film. I went back downstairs and outside and photographed some of

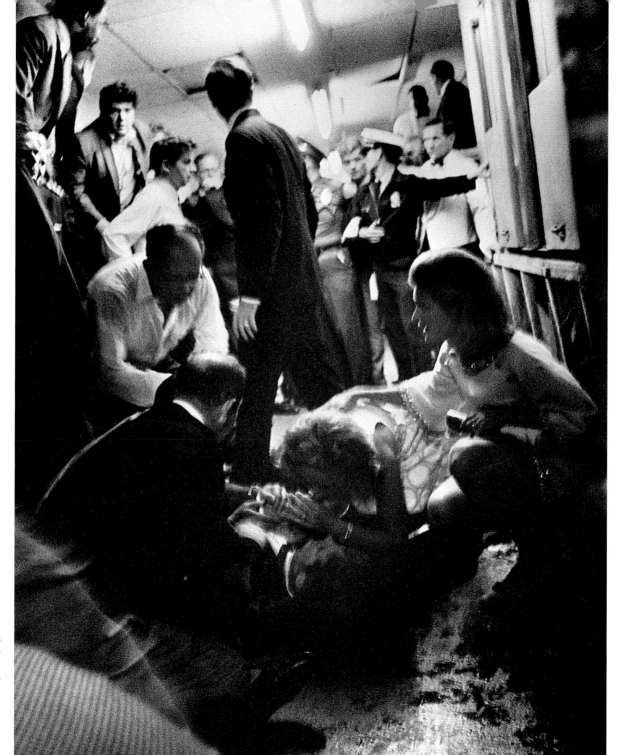

Ethel speaks to her husband. Jean Kennedy Smith, his sister, is to the right.

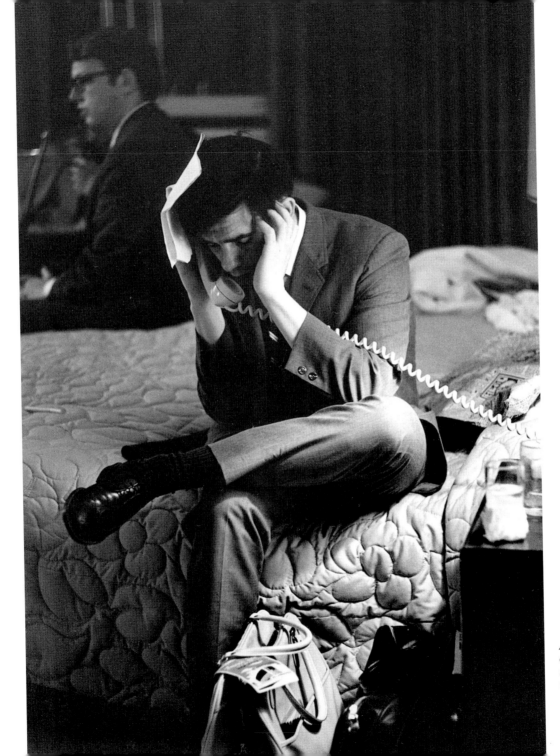

A campaign aide on the phone in the hotel suite, waiting for news.

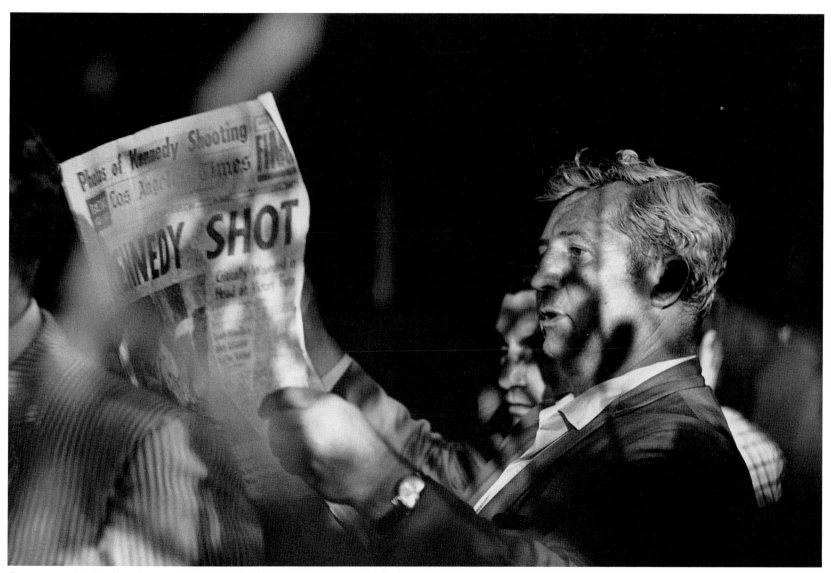

Cameraman Walter Dumbrow reads about the shooting outside Good Samaritan Hospital in an early morning edition newspaper.

[I] hid the cameras under my jacket, took my press credentials off, and walked like I was in a hurry, right through the front door. No one stopped me.

the crowd, including the reporter who already had a mugshot of Sirhan Sirhan. There were even McCarthy supporters outside.

I ran into a *Time* reporter and gave him the film to take back to the LA bureau of *Life,* then went back to the hotel to retrieve my camera bag from the suite. My bag was still there on the floor where I had left it. Two people were in the room, photographer Stanley Tretick and his wife, Maureen, sitting on the sofa holding hands and watching the TV. Stanley, who had been friends with both John and Bobby, was watching the loss of another Kennedy. Stanley had been doing a story for *Look* on the Kennedy family—a more intimate portrait of them.

I got more film from my hotel room and then went back to the hospital. It was now almost dawn. I was outside the Good Samaritan, and Frank Mankiewicz came out to tell the waiting press that the senator had died. I stayed

Reporters wait outside Good Samaritan Hospital.

at the hospital for as long as I could. It was at this point that I saw Julian Wasser, another photographer from *Time*. He told me that my film had gotten into the *Life* office, and that he had seen the contact sheets. He said, "I don't know what else you've got, but you do have one hell of a picture."

When news of the shooting spread, everyone from *Life*'s LA bureau showed up at the office. J. Eyerman, another *Life* staff photographer, opened the small darkroom in the bureau. When the film arrived, he asked the *Time* reporter for my film processing instructions.

Eyerman knew that I tended to underexpose my film, and it was his expertise in the darkroom that preserved the image of Bobby on the floor with the busboy.

I made pictures all the way back—St. Patrick's Cathedral in New York City, the funeral train from New York to Washington. At the cemetery, I held a candle—and cried.

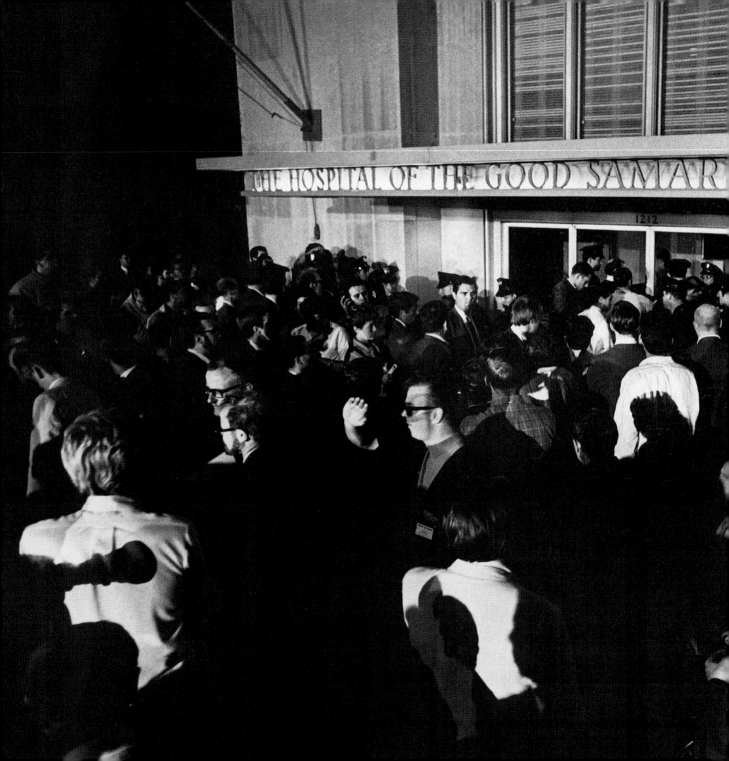

Press and campaign workers crowd the front entrance of the hospital.

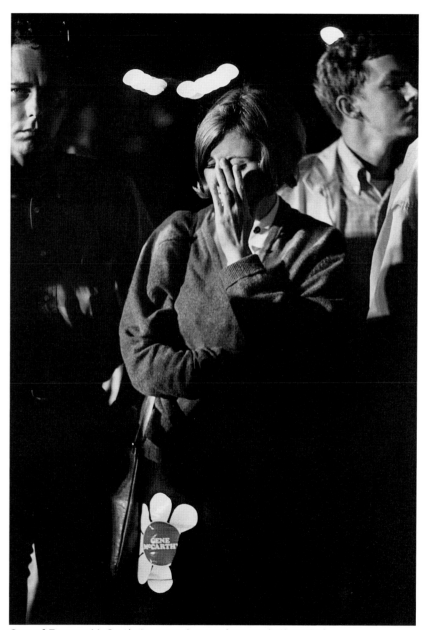

One of Eugene McCarthy's campaign workers at the hospital.

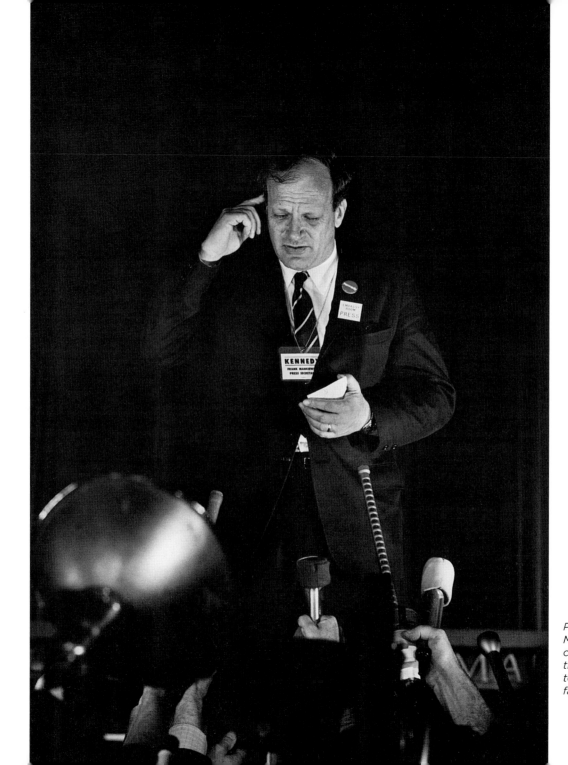

Press Secretary Frank Mankiewicz at a press conference outside the hospital, pointing to the place where the fatal bullet hit Bobby.

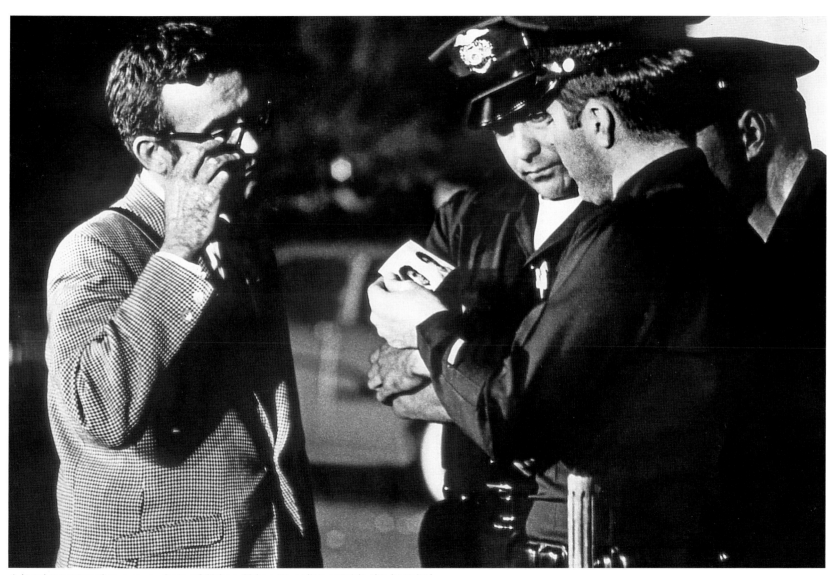

A local reporter shows mug shots of Sirhan Sirhan to police outside the hospital.

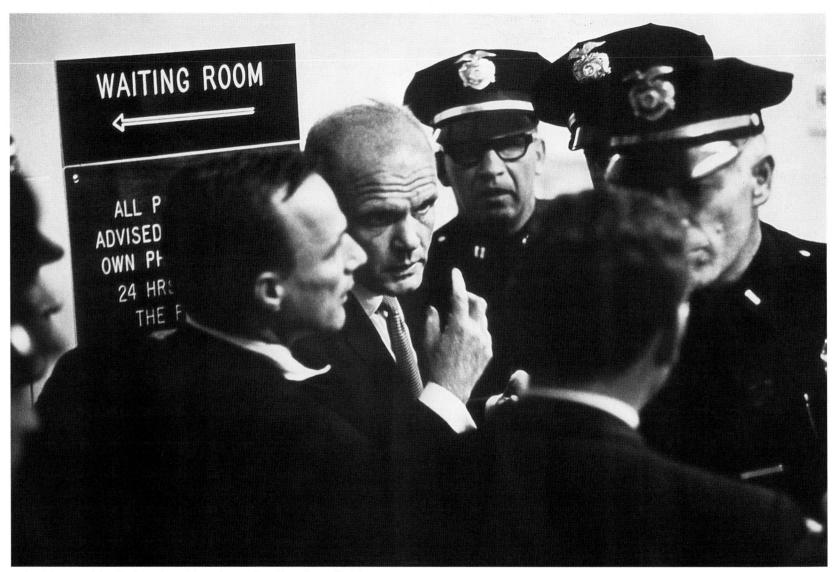

John Glenn and family friend David Hackett talk with police officials.

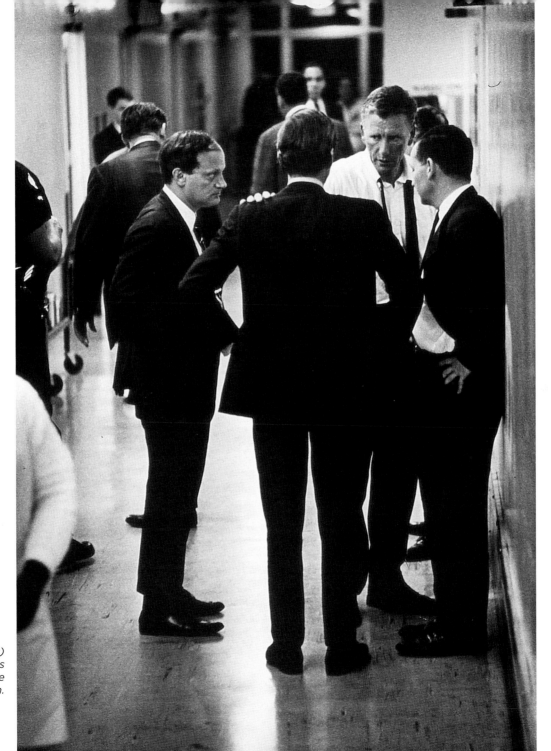

Bill Barry (in shirtsleeves) with campaign staffers in the hallway outside Bobby's room.

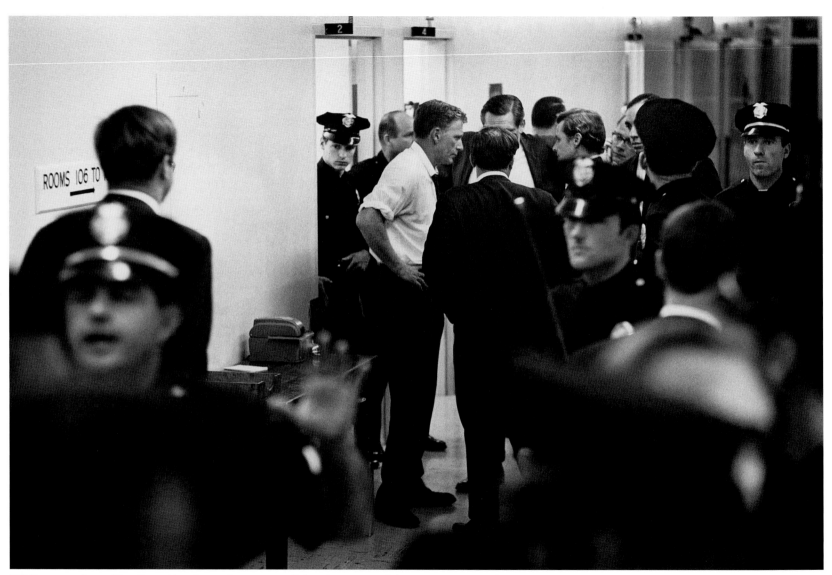

Bill Barry confers with others, then he walks away, realizing the extent of the senator's wounds.

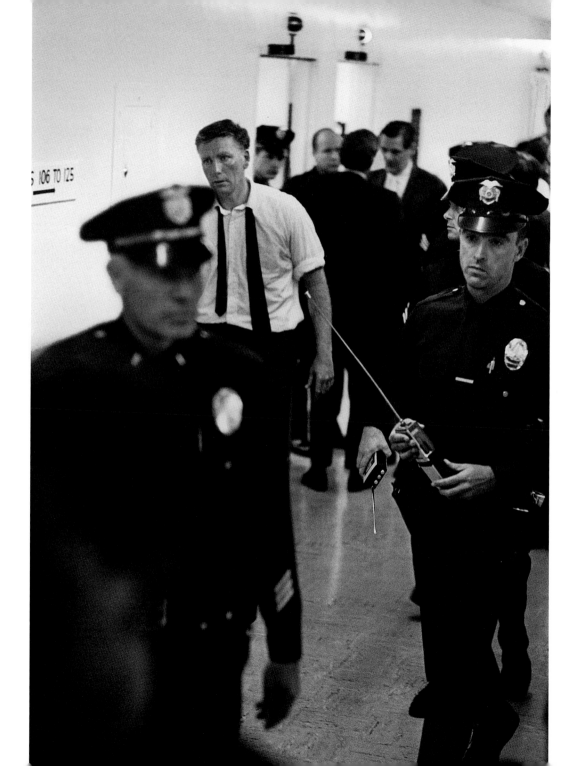

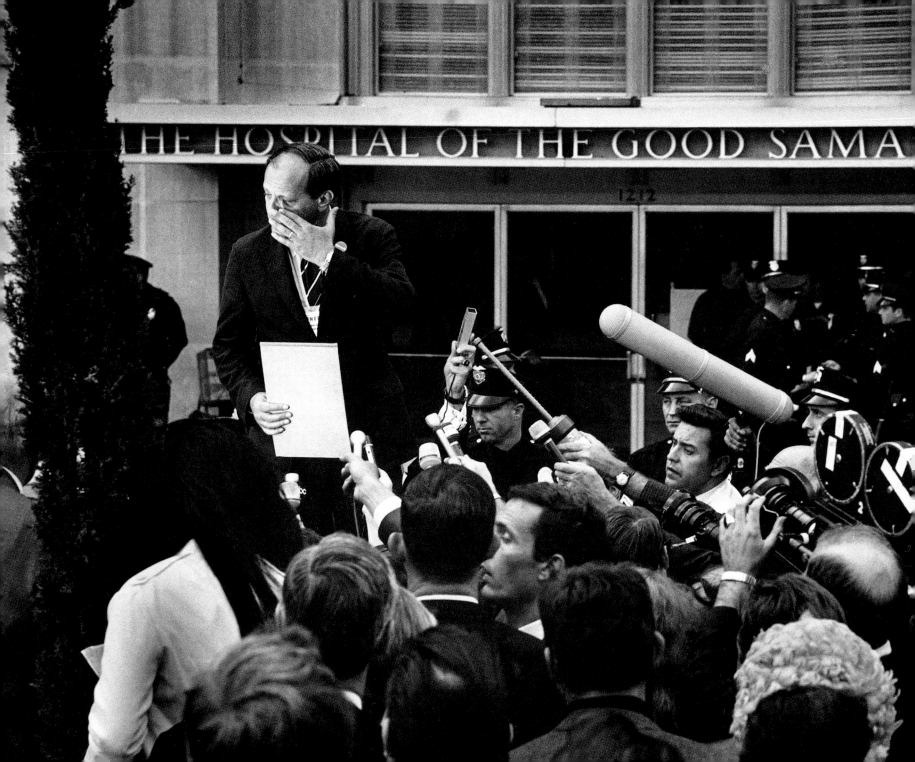

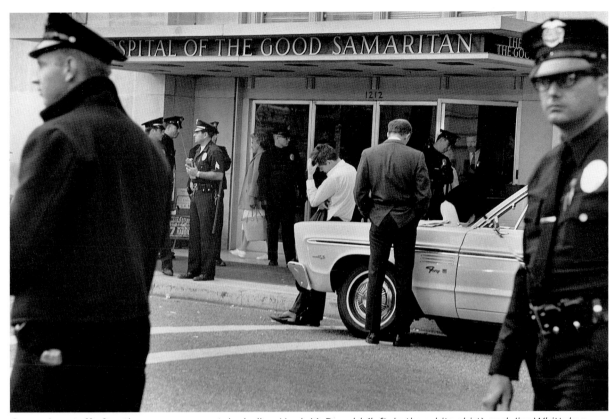

Campaign staff after the announcement, including Hugh McDonald (left, in the white shirt) and Jim Whittaker (right, in the suit).

Outside, Frank Mankiewicz makes the announcement that "Robert Kennedy died at 1:44 A.M. today, June 6, 1968."

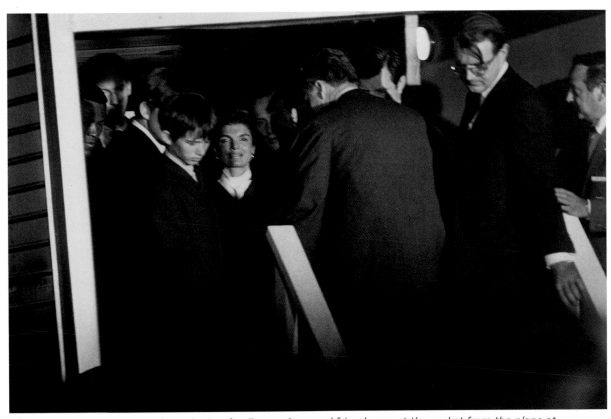

Bobby Jr., Jacqueline Kennedy, and other family members and friends escort the casket from the plane at LaGuardia Airport, New York.

President Johnson sends Air Force One to bring Bobby's body back to New York. The family is silhouetted against the plane's side by TV lights.

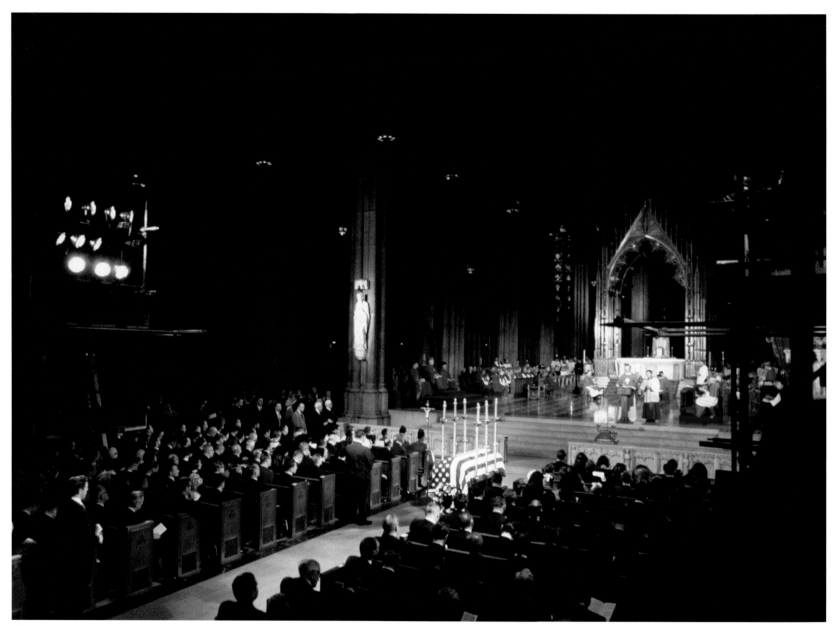

The funeral of Senator Robert F. Kennedy, St. Patrick's Cathedral, New York City, June 8, 1968.

LIFE GOT ME A SPECIAL NEW YORK CITY POLICE CREDENTIAL FOR INSIDE ACCESS TO ST. PATRICK'S
Cathedral and the funeral of Robert F. Kennedy. I couldn't comprehend the enormous impact his
death had on the people of New York. I had seen the huge crowds on the campaign trail, and also
in New York in 1966, but I did not expect New Yorkers to react in this way. I think that when he
left us, we lost hope. And I don't think it ever came back.

The evening before the funeral mass, I had seen people standing in line on the sidewalks a few blocks
from St. Patrick's on Fifth Avenue. I didn't know what they were waiting for. As I got closer, I realized
these people were lined up to get into the church—all kinds of people, and they stayed until 5 A.M. when
the church closed. His casket was inside, and the people of New York wanted to pay their respects.

I went in the press entrance and looked over the available press areas. I chose a photographing
position that I liked the best.

A Time It Was

THE NATION'S GRIEF IS REVISITED AS THOUSANDS COME OUT TO MOURN RFK

From where I stood, I had a clear view from the front of the church to the back. I set up the
long lens and waited. In between shooting, I was crying.

LBJ entered from a side entrance. He didn't walk up the aisle. But he had his wife, Lady Bird
Johnson, with him, and his Secret Service contingent. His place was right next to the coffin. I recog-
nized Gene McCarthy seated next to Barry Goldwater, then Richard Nixon and his wife, Pat. Coretta
Scott King was there, too. The service started, and I tried to shoot something significant. The light was
not powerful enough to allow high shutter speeds for the long lens. It was a difficult shoot because of
the TV lighting situation, and the photographs were not as sharp as I liked.

I don't remember when Jackie Kennedy entered the church, but I saw her walk by the casket with
her children, John and Caroline.

I don't even remember hearing Ted Kennedy's eulogy—I was using my eyes, and sound became
inconsequential. My job was to see, not to hear. I was seeing the widows of Bobby, Martin, and John.

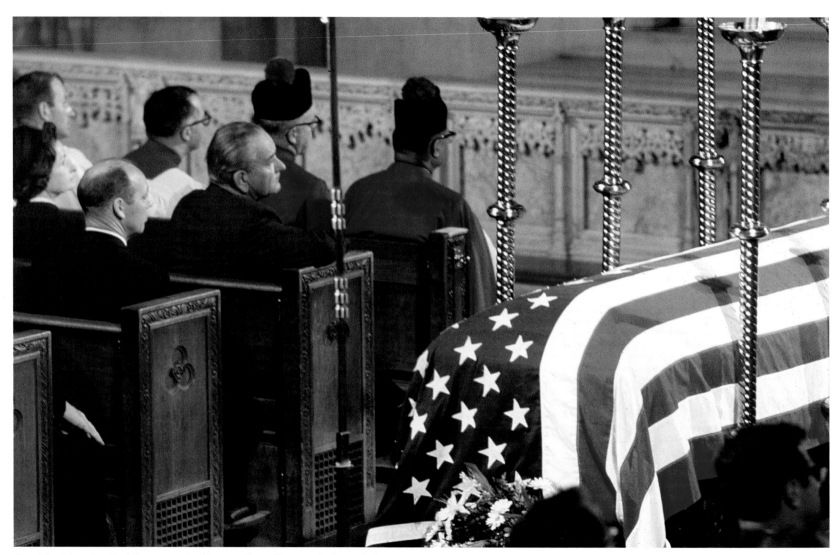

President Lyndon B. Johnson seated across from the senator's casket.

I think that
when he
left us, we
lost hope.
And I don't
think it ever
came back.

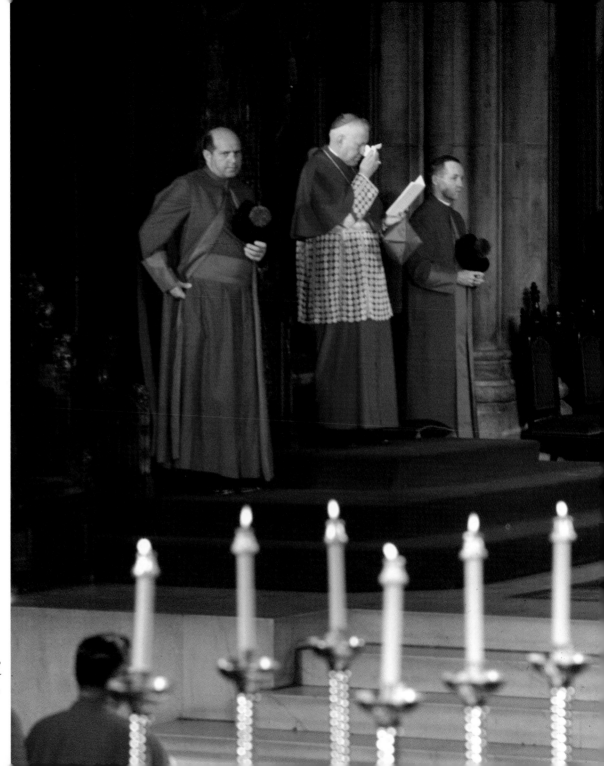

*Cardinal Cooke
wipes away a tear
during the mass.*

Senator Eugene McCarthy, who was Bobby's primary foe on the campaign trail, now grieves at his funeral.

Richard Nixon (right) and Jerry Brown directly behind him. Nixon would go on to win the presidential election in November 1968.

Coretta Scott King, widow of Dr. Martin Luther King.

Jacqueline Kennedy and her son, John Jr.

My job was to see, not to hear. I was seeing the widows of Bobby, Martin, and John.

Ethel Kennedy escorted by Senator Edward Kennedy.

I WAS AN INVITED GUEST ON THE FUNERAL TRAIN, which was a relief for me because then I could concentrate on what was happening, and I wouldn't have to shoot. I still brought my cameras, of course. The train was late in leaving New York—a twenty-one car train with about two thousand invited guests. When the train pulled out of the station, I was staring off blankly when Loudon Wainwright, the *Life* writer, came up behind me.

"Bill, I have some bad news for you," he said. "You're going to have to work. We had three other *Life* staff photographers who were supposed to be on the train, but none of them made it."

I just turned to him and said, "Hey thanks, Loudon, it's a lot better than sitting here crying for four or five hours."

I went between two cars and hung out there. A window to the outside was open, and I could lean out and shoot. If I happened to be crying, the wind from the train would dry up the tears.

As soon as we hit New Jersey, suddenly there were people alongside the tracks and that scene was the same the entire way to Washington, D.C. People lined the tracks the entire length of that trip. That was the only thing I photographed while on the train.

The people lining the tracks were a cross-section of America—everybody you could imagine. You could see wealth, you could see poverty, old, young, women, men, black, white—I just remember the grief, and the sadness on everyone's face. It was an unbelievable scene.

A salute and a handful of flowers as the train passes by.

A formal police salute meets the funeral train, twenty-one cars long, in Trenton, New Jersey.

172

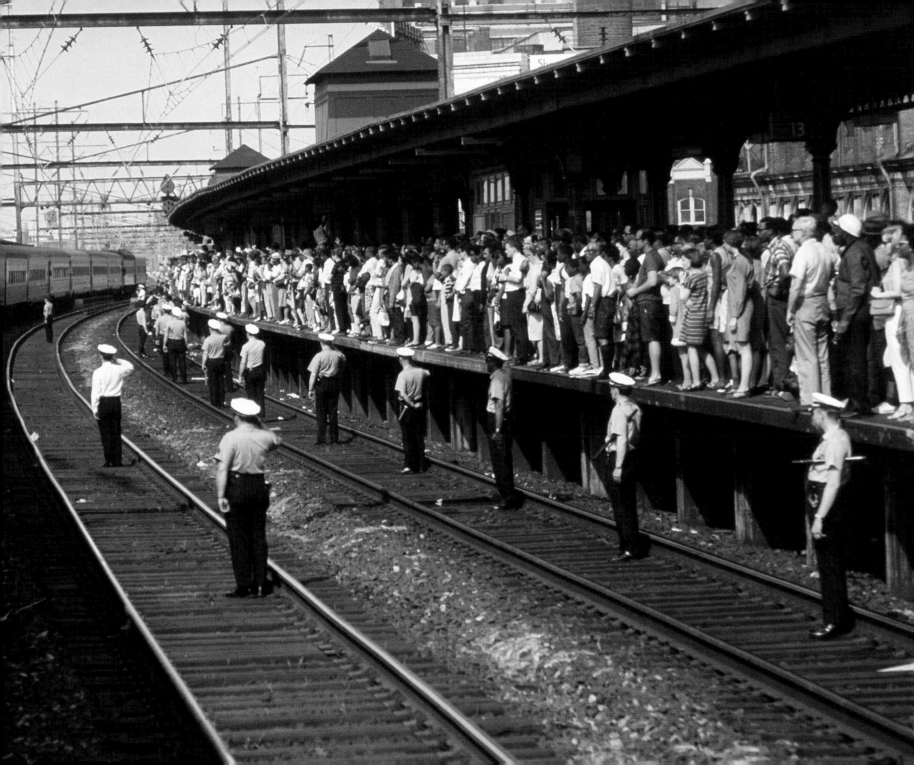

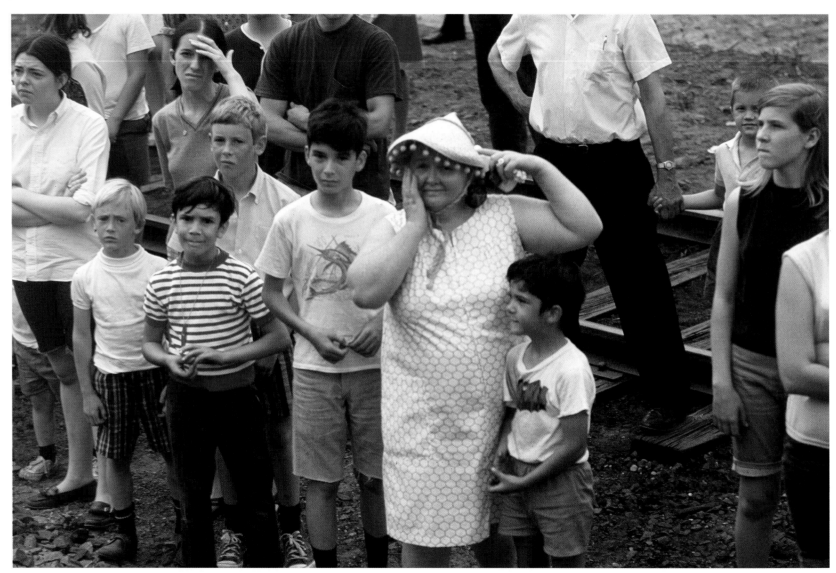

People line the tracks along the entire route of the train, from New York to Washinton, D.C., their faces showing grief and disbelief.

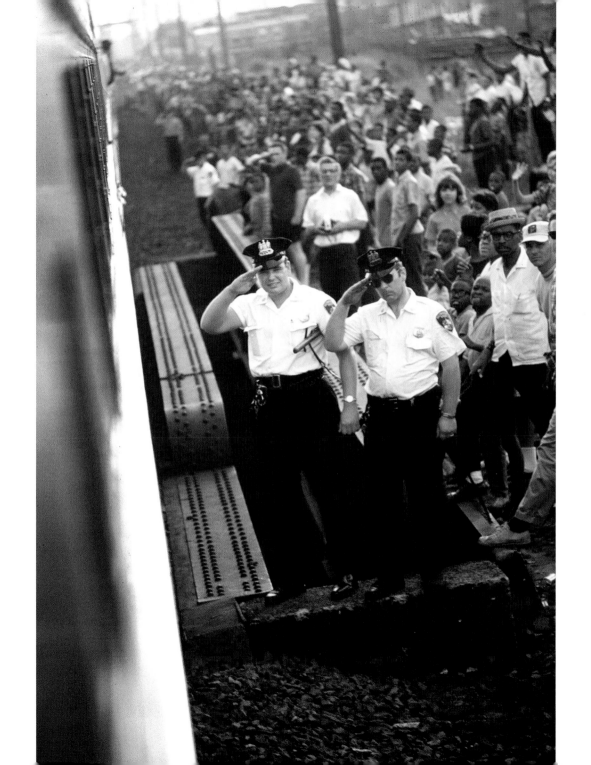

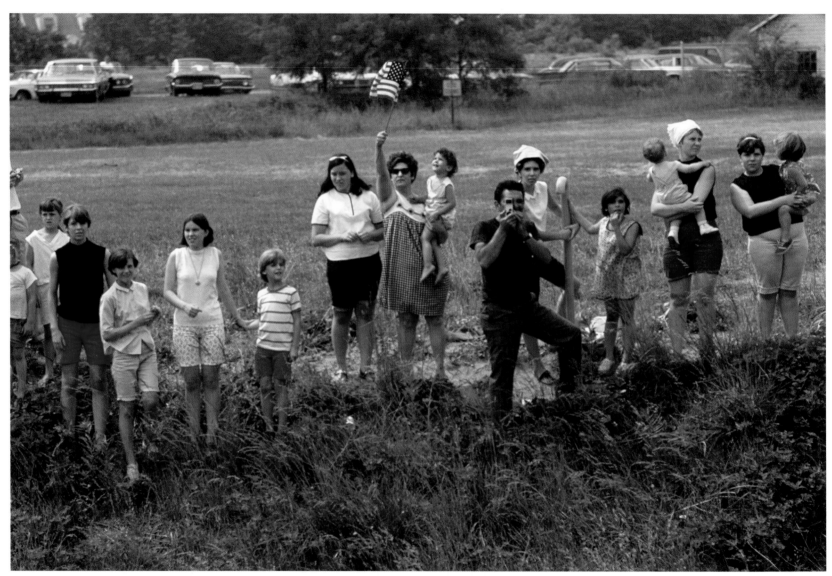

A woman waves a small American flag.

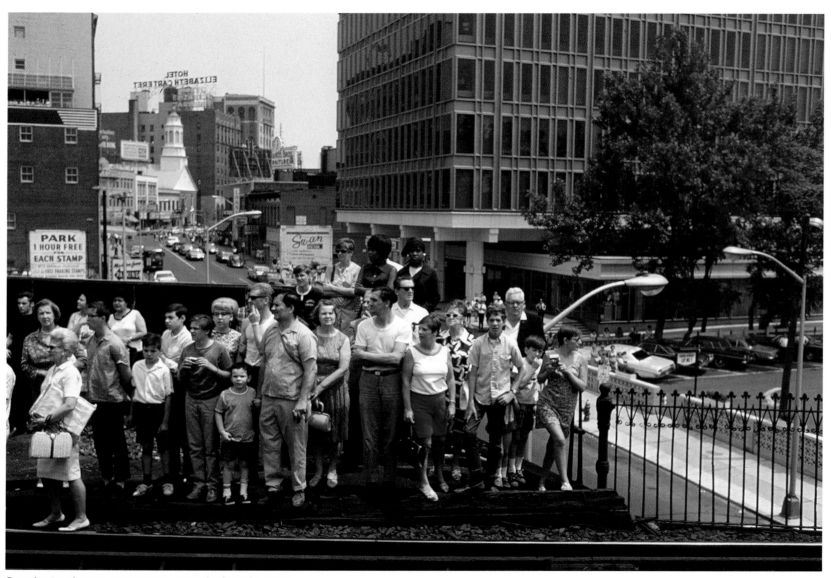

People stand on an overpass to get a look at the train.

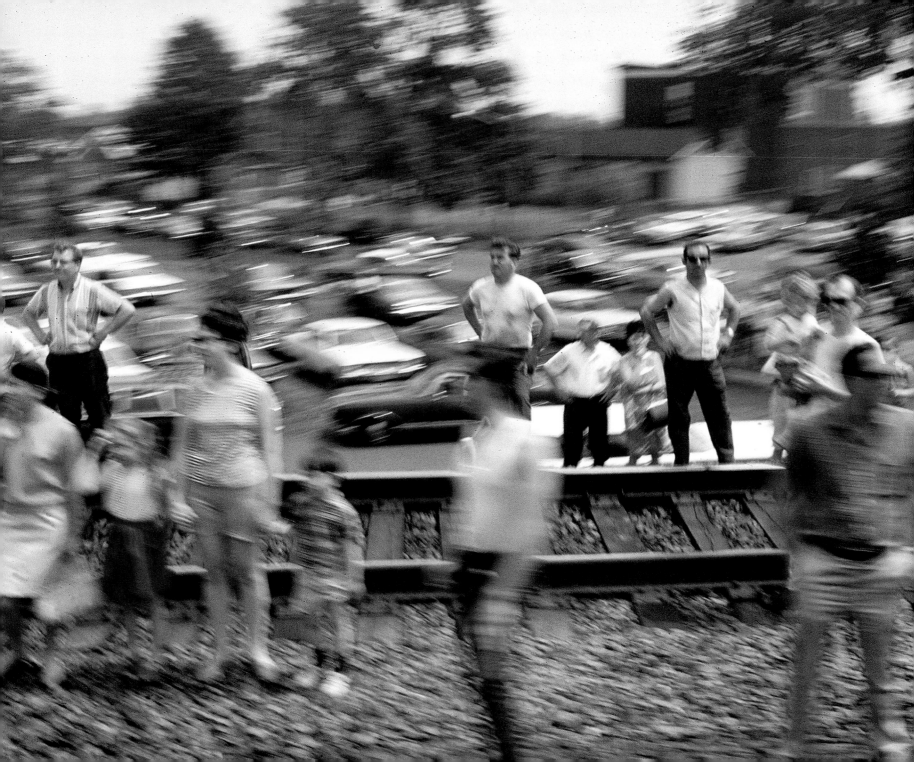

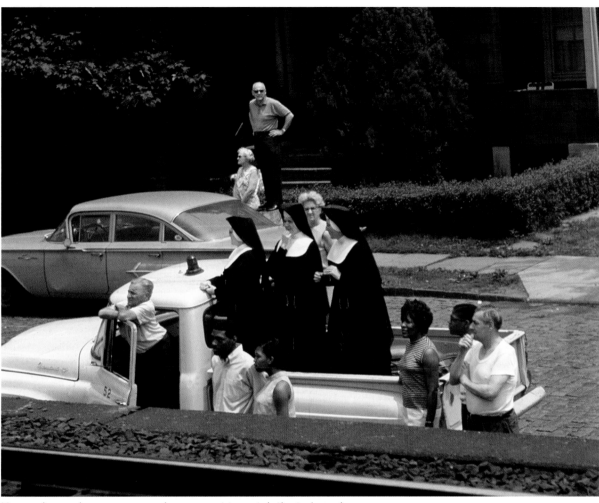

No one knows how many people came out to watch the train go by.

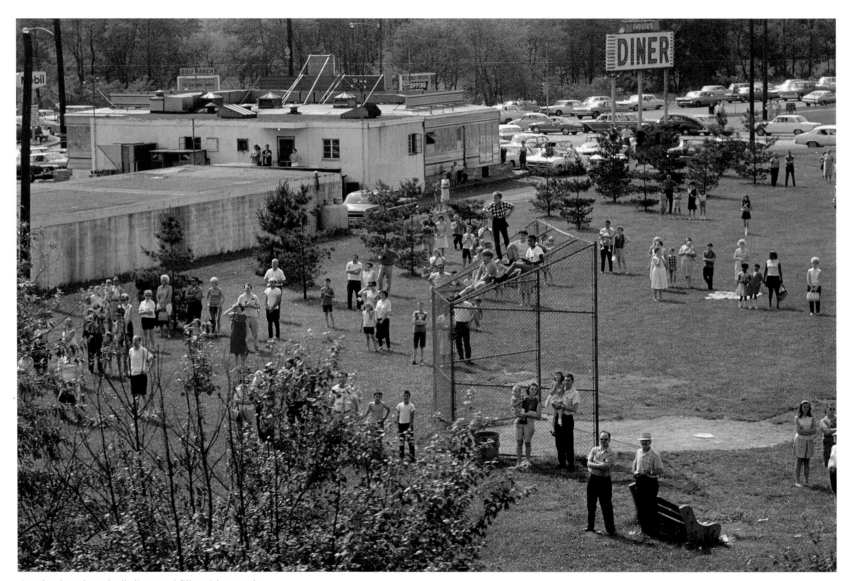

A suburban baseball diamond fills with people.

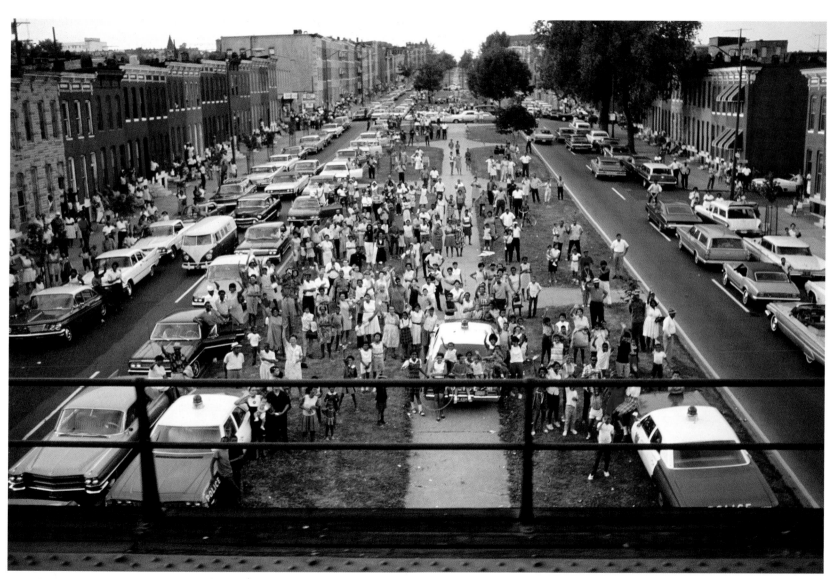

An urban street becomes a viewing area as people stand, watch, and wave.

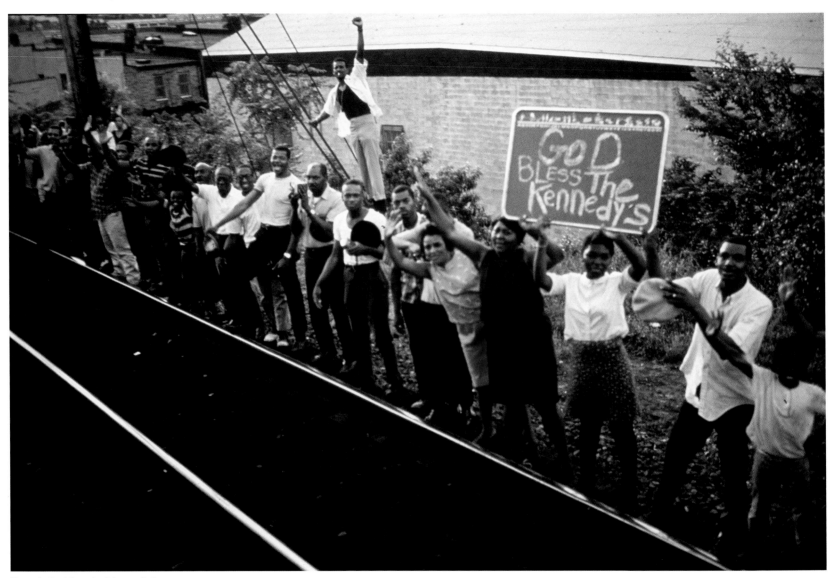

People hold a chalkboard sign.

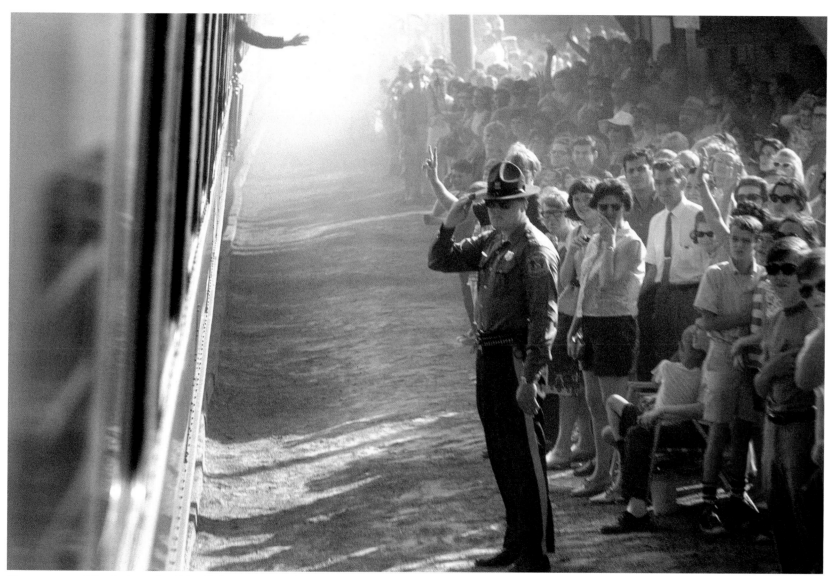

Mourners greet the train on its 226 mile journey. In Wilmington, a Delaware state trooper salutes.

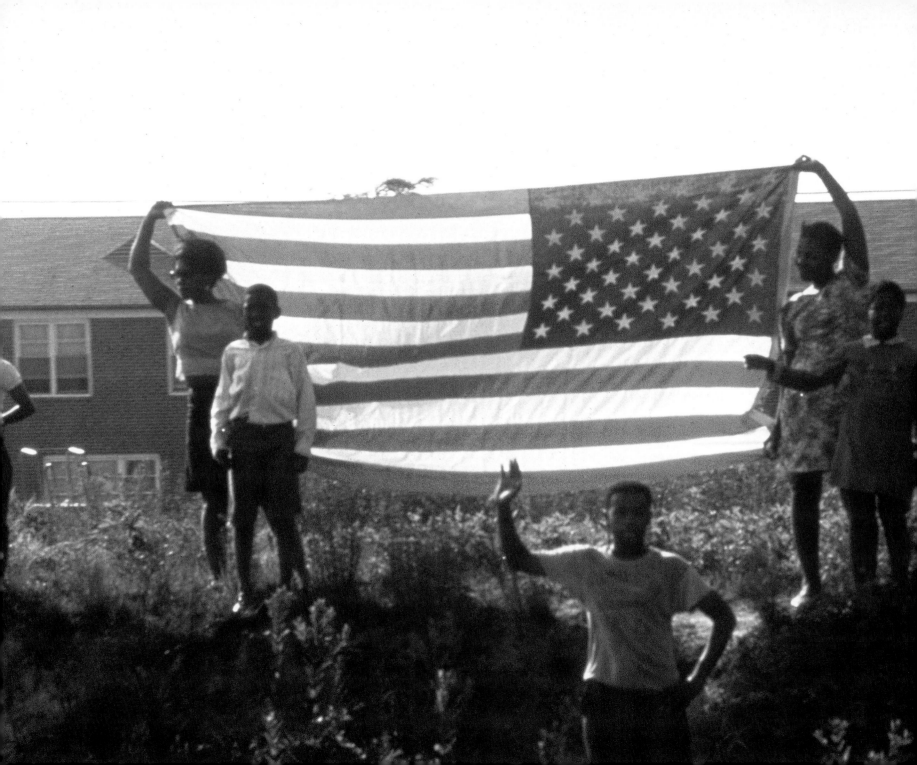

You could see wealth, you could see poverty, old, young, women, men, black, white—I just remember the grief, and the sadness.

The reversed flag, a sign of distress.

THE TRAIN ARRIVED VERY LATE INTO WASHINGTON, after dark. It had been delayed almost five hours, and the arrival time was shortly after 9 P.M.

The waiting hearse was parked at Union Station with the rest of the motorcade that was to go to Arlington National Cemetery. Across the street from the station was a bus for the press. During the campaign, the press bus traditionally had always followed the photographers' car, which had always followed the candidate's car. This time the photographers and the rest of Bobby's traveling press piled into one bus. Everybody realized that this was the final ride.

Lined up directly behind the hearse at Union Station was the presidential limousine. As the motorcade started to move out, the hearse moved, too, but the presidential limousine was slow in starting off. Someone on the press bus recognized the opportunity and immediately screamed at the bus driver, "We're supposed to pull in right behind the hearse! That's where we always go, right behind the candidate!" And the bus driver, not knowing any better, pulled in behind the hearse, effectively cutting off the presidential limousine. So, now a furious Lyndon Johnson was following the press.

The hearse moved slowly into traffic with the press bus right on its tail. We rode this way for about four or five minutes, until there was slow-down in the traffic ahead. Suddenly a trench-coated man ran up and banged on the door while the bus was moving. The driver opened the door. The man, large in stature, and adamant about his mission, jumped onboard the bus, and started yelling, "You've got to back off and let the presidential limousine in front of you." As one voice, the entire busload of press started screaming at this guy who we now all realized was one of the president's Secret Service detail, "No, this is where we belong. Our position has always been directly behind the candidate and we're staying!"

The beleaguered agent ran back to the limousine.

We held position, following the hearse, and gained a brief respite from our grief.

A few minutes later, the same thing happened again, except it was a different agent this time, also wearing a long black trench coat. Again, he banged on the door. Again, the door opened, and the same exact conversation between the agent and the press ensued. Again, he was summarily ejected from the bus, while the press cheered.

Not long after that, three agents in long black trench coats approached the bus. The door was opened, they boarded, and one of them put his hand firmly on the steering wheel. The driver just turned and looked at all of us with a helpless look. With that, we surrendered our position.

We had had our game with LBJ and made our point. The president's limousine pulled around the press bus and took the position behind the hearse, red lights blinking. The bus slowly pulled back into the motorcade and continued on the way to Arlington National Cemetery. The senator would have loved the way the press rallied and held their last stand for him against LBJ. Up the hillside in Arlington Cemetery, light shone on the Custis-Lee Mansion, and directly below that was the lighted gravesite, the final resting place of Robert F. Kennedy.

When we finally arrived at the burial site, military guards handed out several thousand candles, but I didn't take one. I thought I might be shooting, but when I looked at the scene, I realized that *Life* had other photographers there. I decided I wasn't going to shoot this, and I found a place to stand and just watch. I went behind a tree, and standing there was the NBC cameraman, Stu Ruby, who had been on the campaign all along. He was holding his camera face down and wasn't shooting. I said, "Stu, your producer is looking all over for you."

Stu said, "I know, screw him. I'm not shooting this."

He handed me a candle and lit it. We both stood there holding them, and watched as the campaign finally ended.

The motorcade approaches Arlington National Cemetery with the Custis-Lee Mansion visible in the distance.

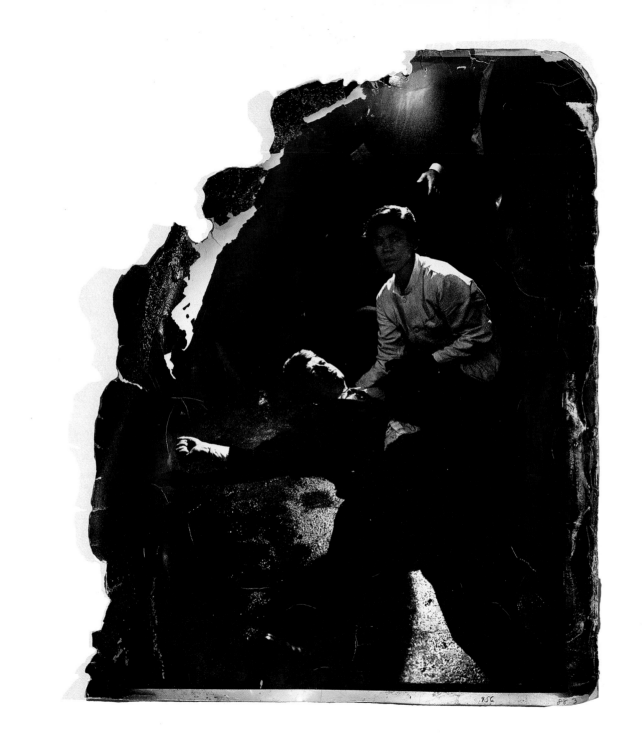

Epilogue

BURNED INTO MEMORY

TWO DAYS AFTER THE FUNERAL, POLLARD CALLED ME into his office and asked me what I wanted to do. He could see that I needed a break.

I thought about it for a few minutes and realized I wasn't happy dealing with people anymore. He asked me where I wanted to go, and I said, "the mountains, any mountains." He told me to come back the next day and talk about it. I went home and went to bed. At 3 A.M., my phone rang. It was Pollard, still in the office, a normal thing at *Life* in those days. He said he had something, a lovely story on wild horses in the mountains of Wyoming and Montana.

I got up and walked across town to see him. He gave me a little note. It said, "There are wild horses in the Prior Mountains," and was signed by Don Jackson, one of the *Life* writers.

"When do you want me back?" I asked. "When you feel like it," he said.

I had one more request: "Dick, can I buy a pickup truck?" Without hesitation, he approved it.

I made my travel arrangements, flew to LA, and drove to Montana. Three months later I came back with pictures that eventually ran twelve pages in *Life*. But it was a lot longer before I got involved in any more political campaigns.

I moved to Los Angeles about a year after the 1968 campaign. I don't know why except that I wanted to be in the west, and working out of *Life*'s LA bureau was a way to do that. Jimmy Wilson, the former CBS cameraman, also moved to LA. He left Virginia and formed a film production company called Apocalypse Productions. Hugh McDonald, a campaign aide to the senator, died a year later. I remember that he blamed himself for possibly allowing the assassin to enter the hotel.

More than 22,000 American servicemen were killed in Vietnam from the time that Bobby Kennedy would have been president until the U.S. withdrew their forces in 1973. At least 90,000 South Vietnamese military personnel also died during that time. Unknown is the number of North and South Vietnamese civilians and North Vietnamese military that were killed because of the war.

Life, the weekly magazine, ceased publication in 1972. Doris O'Neill, the head of *Life*'s picture collection, called me at around that time. She said that they were destroying many of the large pictures in the files and thought I might like to have the original print of the assassination photograph—the only print that *Life* ever engraved from. It was a large print, 16 by 20 inches. Without hesitation, I told her I would fly to New York and pick it up.

I could never hang that print on the wall, and put it behind the sofa in my home in Laurel Canyon. A few years later, a canyon fire totally destroyed my house. The day after the fire I found most of my things in ruin. The sofa was burned, but still in place. I looked behind it, and there was the picture. The sofa had protected it from most of the fire. It had burned around the edges, but the image on film was preserved, burned into memory.

After the death of the senator, Life *published this special issue about the Kennedys, November 1968.*

BILL EPPRIDGE
KENNEDY
PRESS
LIFE

POLICE DEPARTMENT
CITY OF NEW YORK
WORKING PRESS
EXPIRES DECEMBER 31, 1968
N. 3683
THE BEARER Bill Eppridge
REPRESENTING Life
CITY EDITOR
IS ENTITLED TO PASS POLICE AND
FIRE LINES WHEREVER FORMED
(Subject to conditions)
THIS CARD WILL NOT BE DISPLAYED
PURPOSE

PRESS
KENNEDY CAMPAIGN
VIAJANDO JUNTOS

LIFE
BILL EPPRIDGE

Eppridge
ARLINGTON NATIONAL CEMETERY
JUNE 8, 1968
PRESS — PHOTO

KENNEDY
PRESS

BILL EPPRIDGE - LIFE
KENNEDY CAMPAIGN
NEWS
CALIFORNIA PRIMARY

Ambassador Hotel
LOS ANGELES, CALIFORNIA

FUNERAL MASS
Senator Robert F. Kennedy
PRESS
277

This book is dedicated to Robert F. Kennedy, who would have changed this country. Viajamos juntos.

PROJECT MANAGER: Deborah Aaronson
DESIGNER: Melanie deForest-Malloy
EDITOR: Esther de Hollander
PRODUCTION MANAGER: Anet Sirna-Bruder

Library of Congress Cataloging-in-Publication Data:

Eppridge, Bill.
A time it was / by Bill Eppridge ; introduction by John E. Frook.
 p. cm.
ISBN 978-0-8109-7122-6
1. Kennedy, John F. (John Fitzgerald), 1917-1963—Pictorial works. 2.
Presidents—United States—Pictorial works. 3. Legislators—
United States—Pictorial works. I. Title.

E842.1.E67 2008
973.922092--dc22

2008004458

Text and photographs copyright © 2008 William E. Eppridge
Essay copyright © 2008 Pete Hamill
Foreword copyright © 2008 John Ellard Frook

The photographs by Bill Eppridge on these pages are used by permission
of The Life Picture Collection, copyright © Time, Inc.: 2; 6; 10; 11 (top
left); 27; 28; 30–49; 57; 73 (top right); 108; 113; 118–23; 125–163;
172–173; 182–183; 184–185.

Abrams books are available at special discounts when purchased in
quantity for premiums and promotions as well as fundraising or
educational use. Special editions can also be created to specification. For
details, contact specialmarkets@hnabooks.com or the address below.

Printed and bound in the U.S.A.
10 9 8 7 6 5 4 3 2 1

HNA ■■■■■
harry n. abrams, inc.
a subsidiary of La Martinière Groupe

115 West 18th Street
New York, NY 10011
www.hnabooks.com

Acknowledgments

This book would not have happened without my wife and partner, Adrienne Aurichio, who helped me with my words and saw through my eyes to bring this book to life. I cannot thank her enough. I also want to thank Melanie deForest-Malloy, who designed this book and put her heart and soul into it under a tight schedule. My gratitude goes to her family for putting aside their needs while she helped me with mine. Special thanks and appreciation to Pete Hamill for his beautiful essay.

There are many people who helped me as a photographer in my career with *Life* magazine, but there are a few who deserve a special mention. Roy Rowan, who brought me into the fold of that American institution. Dick Pollard, Phil Kunhardt, Richard Stolley, and Loudon Wainwright, all great journalists who generously shared their knowledge. Cliff Edom, Angus McDougal, Yoichi Okamoto, and Eddie and Alyssa Adams, my mentors and friends. Bill Garrett, who gave me my start at *National Geographic*. John and Norma Frook, whose humor and patience made some anxious moments a bit lighter. My family, for their love and support throughout my career. Ryan Fischer-Harbage, whose enthusiasm brought this to fruition. Judy Twersky, who has been invaluable to this endeavor. And the following, who all contributed to the effort involved in this project: Mark Savoia and Cathy Vanaria of Connecticut Photographics, who generously gave up their weekends to help. Regina Feiler, Daniel P. Donnelly, and Cornelis Verwaal of the Life Picture Collection—they are the caretakers of many of the historic photographs in this book. Mary Jane Lundgren, Bobbi Baker Burrows, and Russell Burrows; Shelly Katz and Epson; Bill Pekala and Ron Taniwaki of Nikon.

The outstanding team at Abrams: Deborah Aaronson, Esther de Hollander, Anet Sirna-Bruder, Michelle Ishay, Jennifer Brunn, David Prager, and Laura Tam.

My compadres on the Kennedy campaign who shared the joy and the sorrow: Sylvia Wright, Jimmy Wilson, Walter Dumbrow, Stu Ruby, Bert Berinsky, Stanley Tretick, Jerry Bruno, Dick Tuck, Fred Dutton, Frank Mankiewicz, and Bill Barry.

Finally, a great deal of thanks to the *Life* staff photographers of the original weekly magazine, some who came before me, and some who were my compatriots in the sixties—they were all an inspiration.